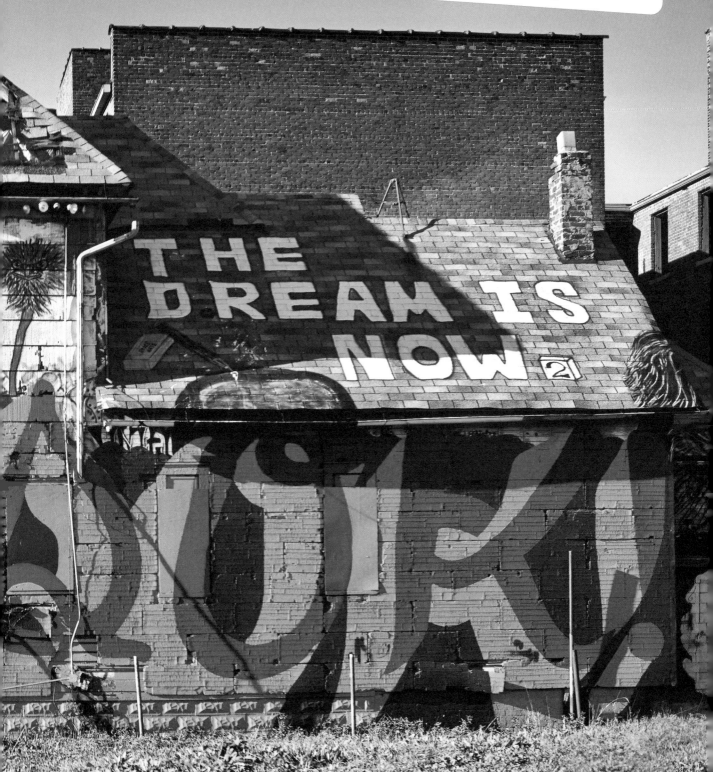

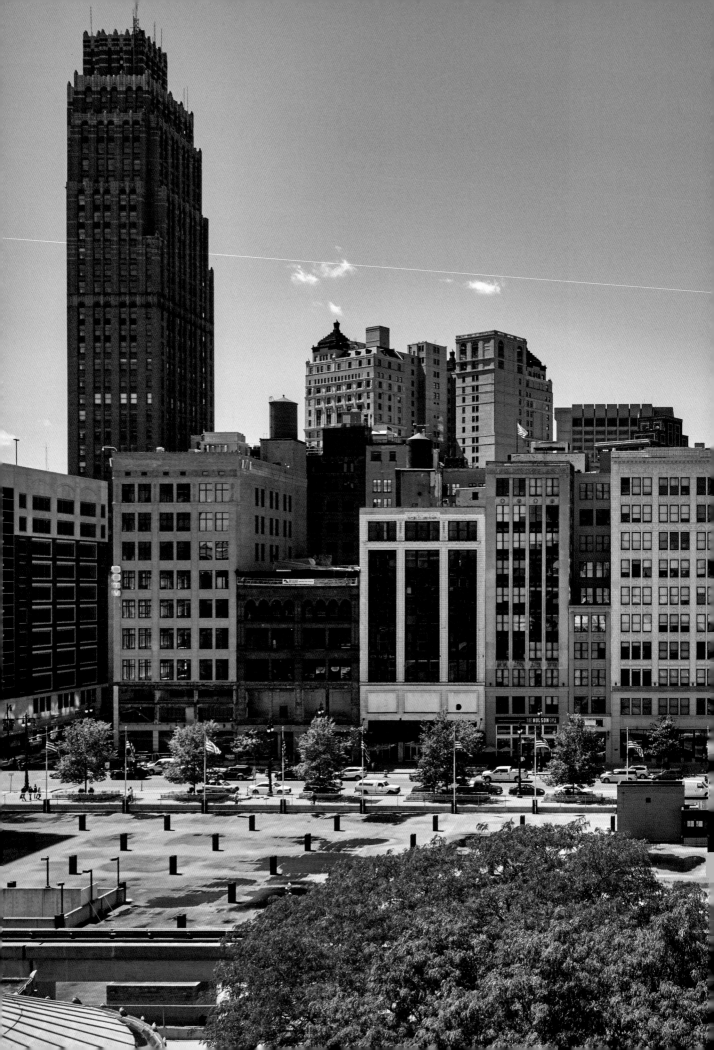

DETROIT

THE DREAM IS NOW

MICHEL ARNAUD

**THE DESIGN, ART, AND RESURGENCE
OF AN AMERICAN CITY**

INTRODUCTION BY MATTHEW CLAYSON
ESSAYS BY LYNN CRAWFORD, SARAH F. COX, AND JENNIFER A. CONLIN

ABRAMS, NEW YORK

CONTENTS

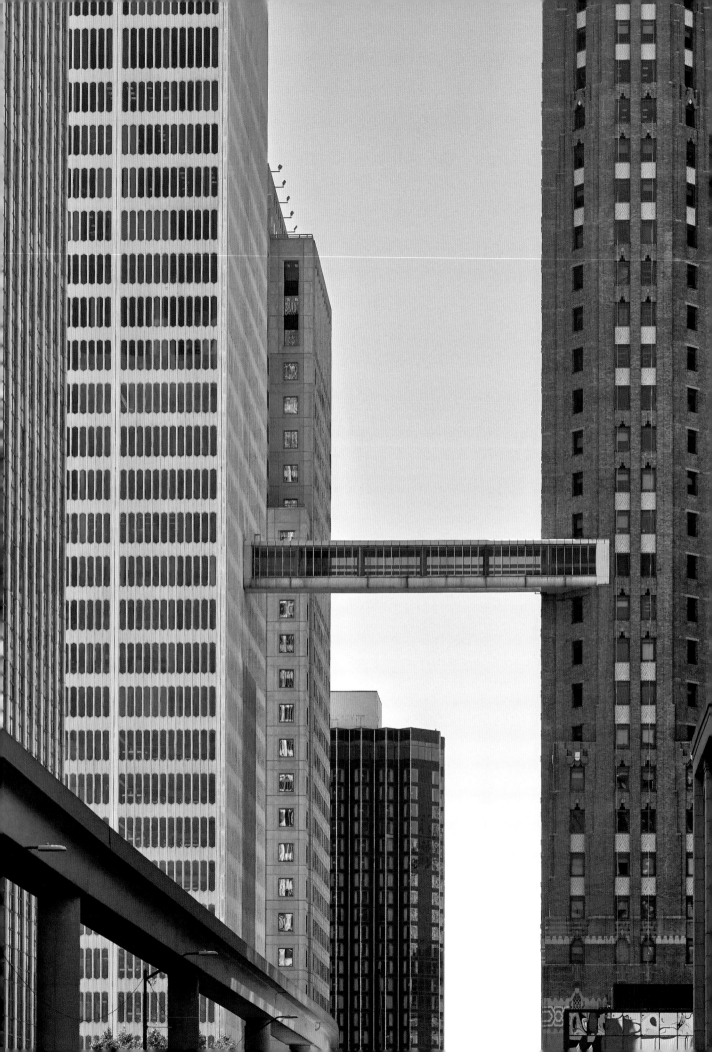

INTRODUCTION

MATTHEW CLAYSON

Detroit, 2007. An unlikely time to lay the seeds of a creative renaissance. After hosting several successful sporting championships, including the Major League Baseball All-Star Game, Super Bowl XL, and the NCAA Final Four series, we found ourselves worshipping at the altar of sport, large publicly funded stadiums, and flashy events. Our automotive industry continued to ride on the dwindling fumes of the sport utility vehicle boom of the late 1990s. Our political elite sowed the seeds of corruption via a series of unorthodox dealings and strategic blunders that landed many out of office and behind bars. Against this backdrop, our artists, designers, and technologists quietly toiled in the shadows, gradually building upon a decades-old legacy that played a fundamental role in transforming our homes, our workplaces, our communities and our civilization.

It was business as usual, and few foresaw the impending, blow-by-blow crises of 2008 through 2012; a series of economic, political, and social events that rocked the foundations of Detroit to its core. Few, except for a group of business, NGO, and civic leaders convened by Business Leaders for Michigan and charged with the task of developing a comprehensive, asset-based strategy for transforming metropolitan Detroit's economy.

Nationally, creative industries were the rage. Academics, speakers, and experts were making the rounds, engaged by chambers of commerce, economic development agencies, and the like to deliver pep talks, take civic leaders through a variety of gimmicky workshops, and launch Cool Cities strategies.

To that extent, various mayors and governors launched creative industries and innovation initiatives, all geared to identifying specific areas where strategic investments in urban environments could be made to attract increasingly coveted, new creative talent. Somewhat predictably, leadership circles in Detroit took note, and the aforementioned core group convened by Business Leaders for Michigan identified the creative industries as a key area of economic opportunity.

Detroit stood out from its peers as an outlier in this endeavor. Unlike many older industrial cities in the nation's north and central areas, Detroit did not have a shortage of creative talent. It was home to some of the highest quantities and concentrations of fine artists in the country. It is the city that gave the world Motown, techno, and garage rock. It perfected R&B, punk, and hip-hop. It was the nation's traditional center for industrial design, the city that invented the field, and home to the country's highest concentration of commercial and industrial designers. It was, and remains, the heart of global automotive advertising and digital media, whose automakers account for more than a third of all national media and advertising buys.

—

A skywalk pedestrian bridge links the Guardian Building and One Woodward Avenue.

It is the metropolitan area that is home to the College for Creative Studies and Cranbrook—two world-class educational institutions with deep roots in the American Arts and Crafts movement—whose graduates include Knoll, Bertoia, Eames, Girard, Rapson. It housed the practices of Eero and Eliel Saarinen, Yamasaki, Kahn (Albert), Kessler, Birkerts, Eames. It is home to some of the world's oldest industrial design and architectural firms, including Sundberg-Ferar and SmithGroupJJR. Its teachers, architects, graduates, and designers are responsible for many of the world's structural icons, including St. Louis's Gateway Arch, the original World Trade Center, the TWA Flight Center at JFK, the Rouge assembly complex, the Eames Chair, the Buick Y-Job (the world's first concept car), the Herman Miller Action Office (the world's first modular office system), and the Bertoia Chair. Countless iconic advertising campaigns gestated in the Motor City, including "See the USA in Your Chevrolet," Pontiac's "We Build Excitement," Mazda's "Zoom, Zoom, Zoom," and "Built Ford Tough."

Talent was not the issue preventing Detroit from realizing the full economic and social potential of its creative industries. The issues: lack of appreciation of the creative community, limited access to resources, inequity of opportunity and access, and not enough collaboration.

Early on, the group convened by Business Leaders for Michigan identified these issues as critical areas that needed addressing. Shepherded by leadership from the College for Creative Studies, this group set forth a series of recommendations focused on advancing the economic output and social impact of the region's creative community. Recommendations included launching an initiative to serve as a regional champion for the creative industries—the Detroit Creative Corridor Center (DC3); launching a targeted business and enterprise acceleration program under the DC3 charged with the task of expanding economic opportunity for early-stage creative enterprises and individuals located within the city of Detroit; developing targeted programming and partnerships focused on recognizing and appreciating Detroit's role as a global center of design, creativity, and innovation, which includes the Detroit Design Festival and Culture Lab Detroit; and launching a strategy focused on co-locating and growing creative enterprises in a series of loosely designated districts within the city limits.

Importantly, these measures comprised the first formal effort that officially endorsed the region's creative community as a bona fide strategic and competitive advantage. This was the region's collective awakening— formally articulating something that was always intrinsic and routinely taken for granted: Detroit's ability to inspire, design, engineer, mass-produce, and mass-market—all bookended by creative enterprises and individuals—fundamentally transformed how civilization lives, works, and moves.

Back to 2007. In that year, Detroit rediscovered its creative roots, building a foundation that enabled Detroit to weather social, political, and economic crisis upon crisis, and reinvigorating the soul of a city chronically irritated by a cycle of deindustrialization, automation, suburbanization, globalization, racial polarization, pessimism, and cynicism.

Soon after the 2007 convening of the Business Leaders for Michigan, major foundations launched groundbreaking initiatives to support and retain the city's creative talent: Kresge Arts in Detroit, a series of fellowships rewarding both established and emerging artists; Knight Arts Challenge and the subsequent Knight Cities Challenge, providing artists, designers, technologists, and innovators with start-up capital for new and impactful projects; Art X Detroit: Kresge Arts Experience, a monthlong celebration of arts in Detroit's Midtown neighborhoods; Dlectricity, Detroit's Nuit Blanche; and countless neighborhood arts festivals, fairs, showcases, openings, and installations.

Despite a series of well-documented economic challenges and bankruptcies, corporate and philanthropic interests doubled down on the region's cultural sector, stabilizing the world-class Detroit Symphony Orchestra, Detroit Institute of Arts, Michigan Opera Theatre, and Music Hall Center for the Performing Arts. And the city, somewhat intentionally due to more pressing issues, got out of the way, engendering an environment where artists were free to experiment, explore, and develop large-scale and controversial works examining the multitude of challenges facing the people of Detroit, and by proxy, the people of our world. The voices of

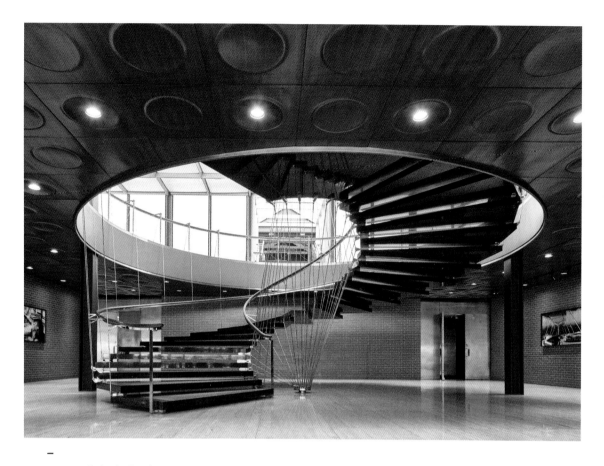

A suspended spiral staircase at the General Motors Technical Center in Warren, Michigan.

longtime Detroit-based artists were amplified outside of their spheres of influence; a steady influx of new artists both collaborated with and challenged them.

With newfound investment, support, connectivity, and relevance, creative practitioners, initiatives, installations, enterprises, and communities—many of which are documented in *Detroit: The Dream Is Now*—flourished. As inaugural executive director of the DC3, I was introduced to many people featured in this book; my team worked closely with various global partners to share the work of these individuals and entities with an international network of peers who amplified and energized the body of work coming out of Detroit. We worked with the city's economic development agency, the Detroit Economic Growth Corporation, to attract Campbell Ewald and Shinola to the city's core. We referred individuals in our Creative Ventures Business Accelerator Program to Ponyride so that they could have the space and flexibility to grow their operations. We supported community-planned, district-wide open houses in Eastern Market for the Detroit Design Festival that attracted tens of thousands while articulating the delicate balance between the functions of a working food market, creative practitioners, and increasing demand for housing and commercial space surrounding the city core. And we led the effort to have Detroit designated as the first UNESCO City of Design in the United States, placing Detroit in a network of design cities that includes Berlin; Graz, Austria; Saint-Étienne, France; Bilbao, Spain; Turin, Italy; Montreal; Buenos Aires; Kobe, Japan; Seoul; Shenzhen, China; and others.

Detroit in 2017 is a city of creativity, design, and innovation. It is also a city of chronic conflict, challenge, and change. Fully empowered and appreciated, Detroit's creative community is addressing these issues candidly and controversially. It articulates Detroit's soul, shares the relevance of that soul with the world at large, and reinforces Detroit's status as one of the world's greatest creative capitals.

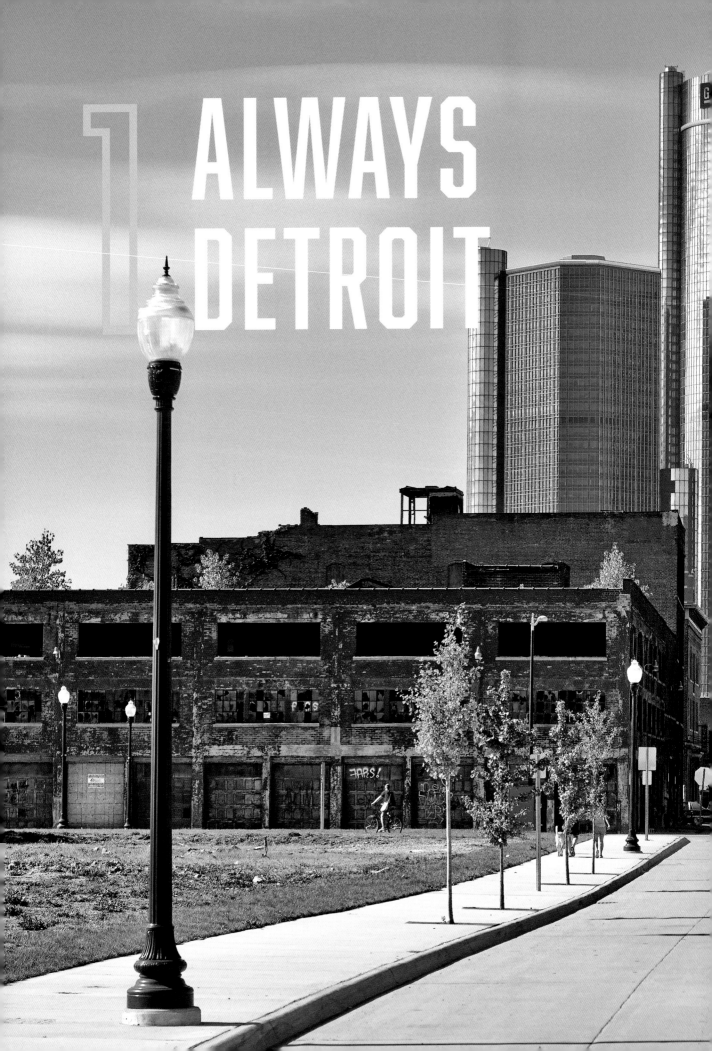

1 ALWAYS DETROIT

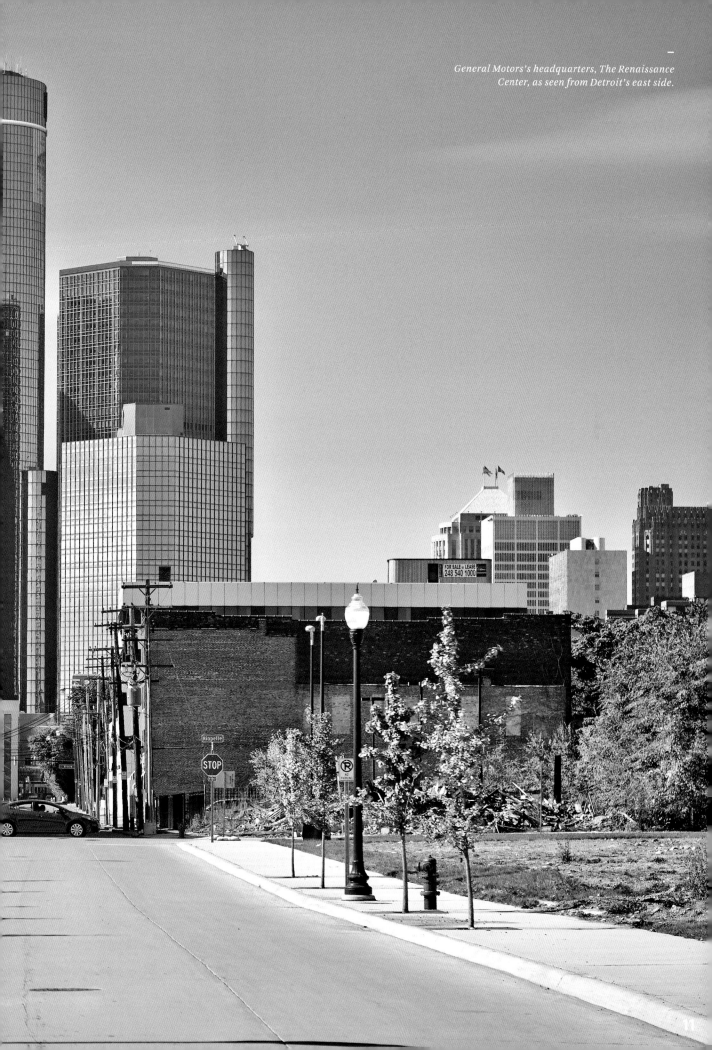

General Motors's headquarters, The Renaissance Center, as seen from Detroit's east side.

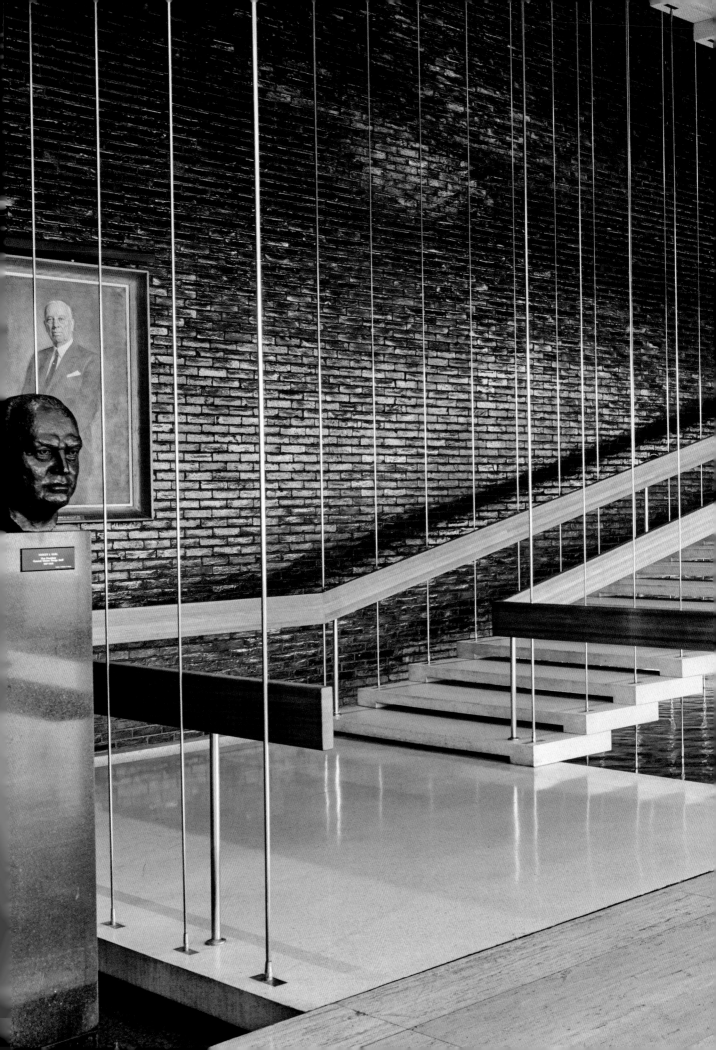

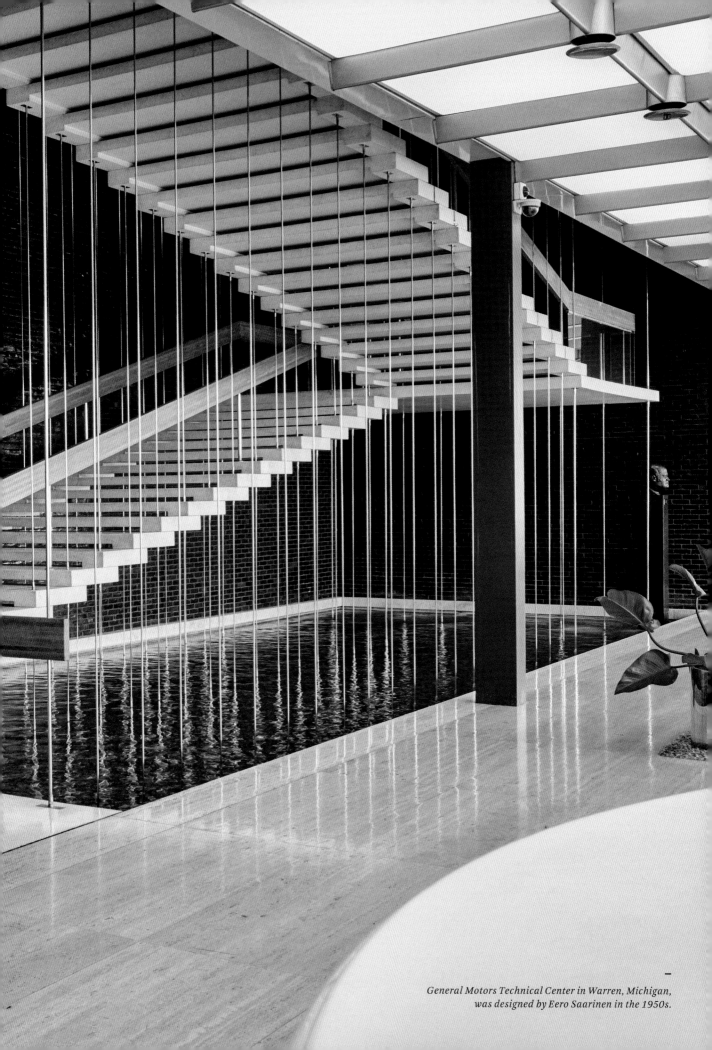

General Motors Technical Center in Warren, Michigan, was designed by Eero Saarinen in the 1950s.

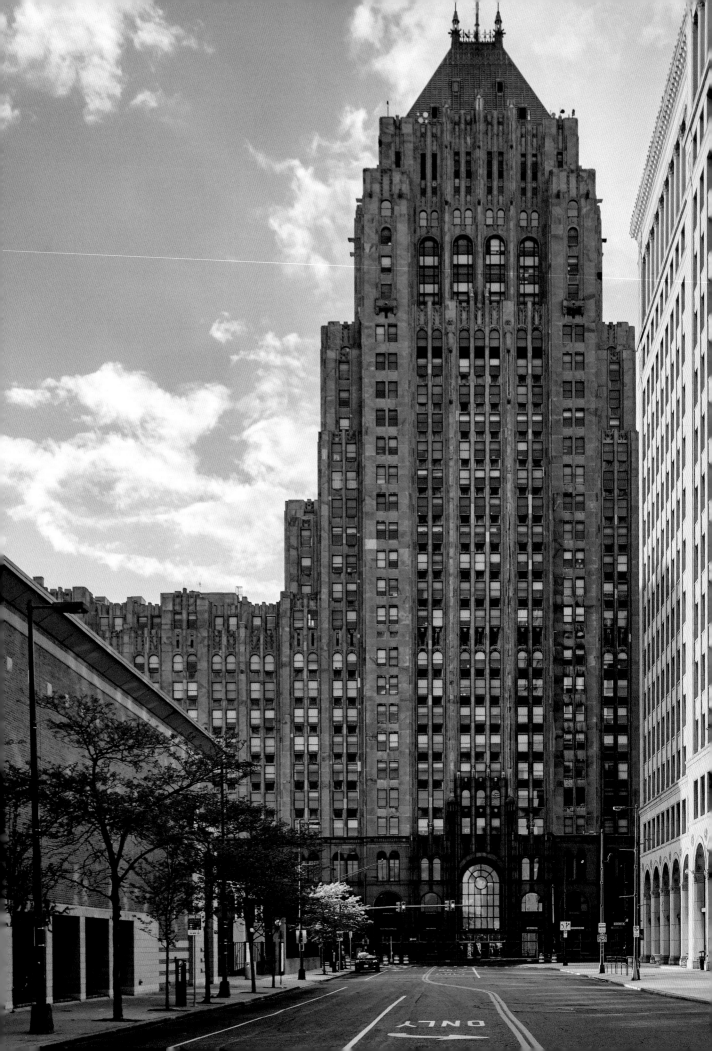

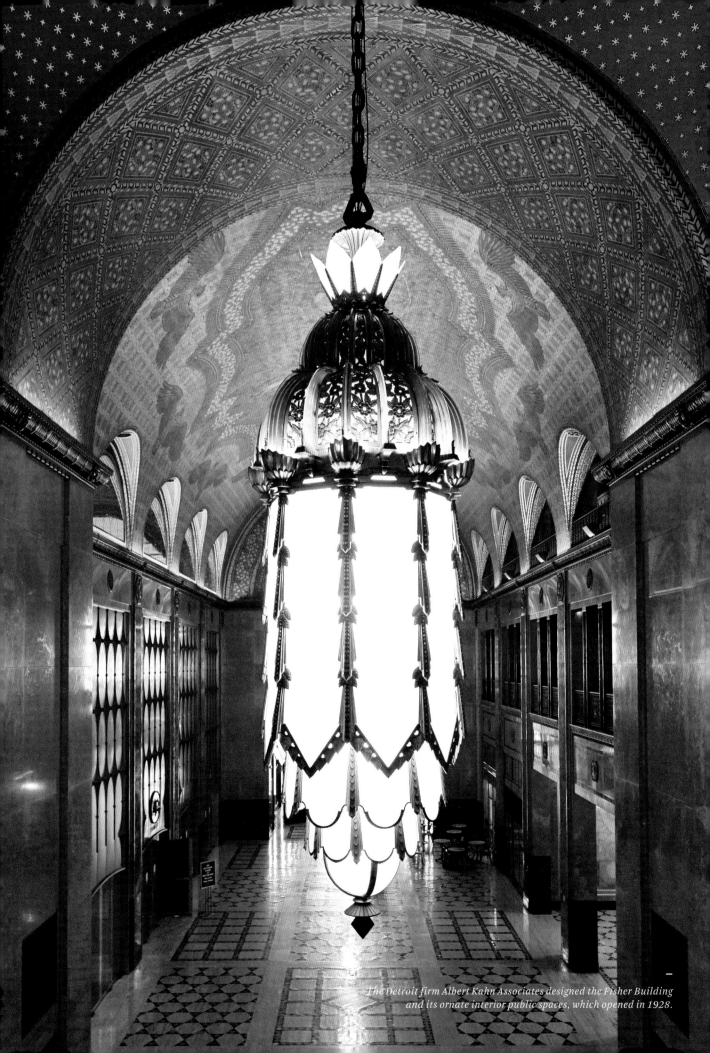

The Detroit firm Albert Kahn Associates designed the Fisher Building and its ornate interior public spaces, which opened in 1928.

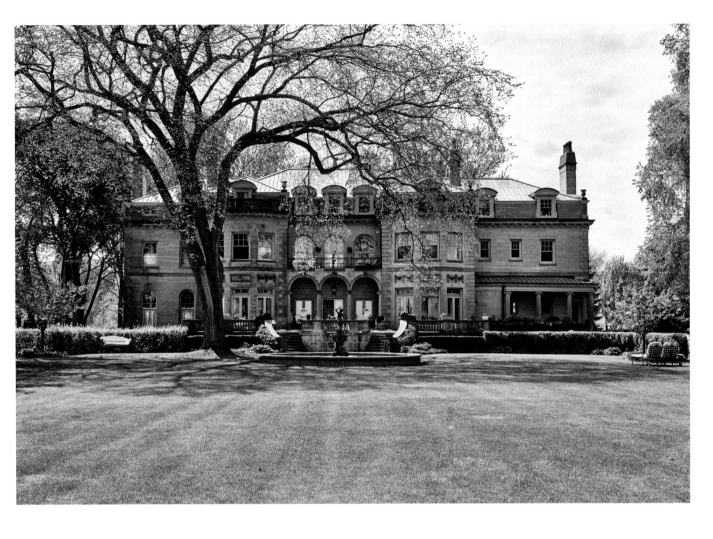

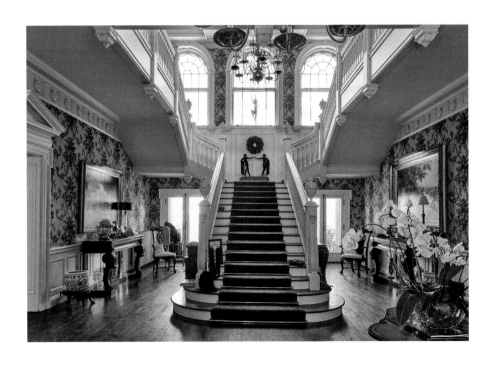

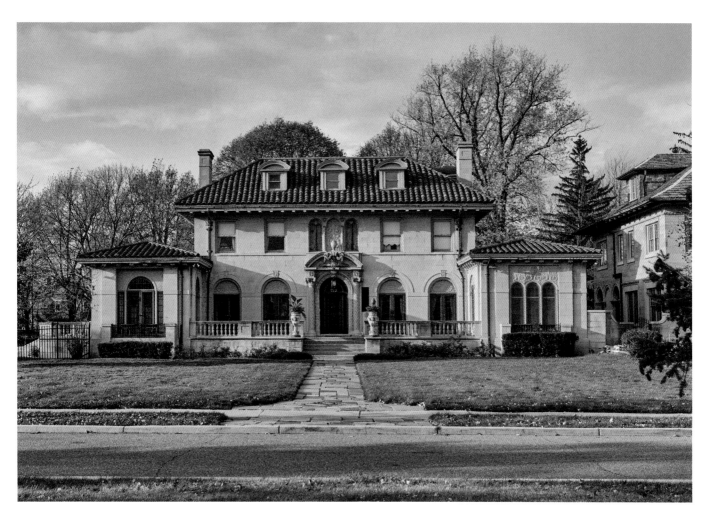

—

Berry Gordy, Motown record label founder, once owned this Italian Renaissance mansion in the Boston-Edison neighborhood.

The Georgian Revival J. B. Ford residence was moved from its original location in Indian Village to Windmill Pointe in 1928.

The interior of the Ford mansion (now owned by Richard and Jane Manoogian) includes a sweeping center staircase in the foyer.

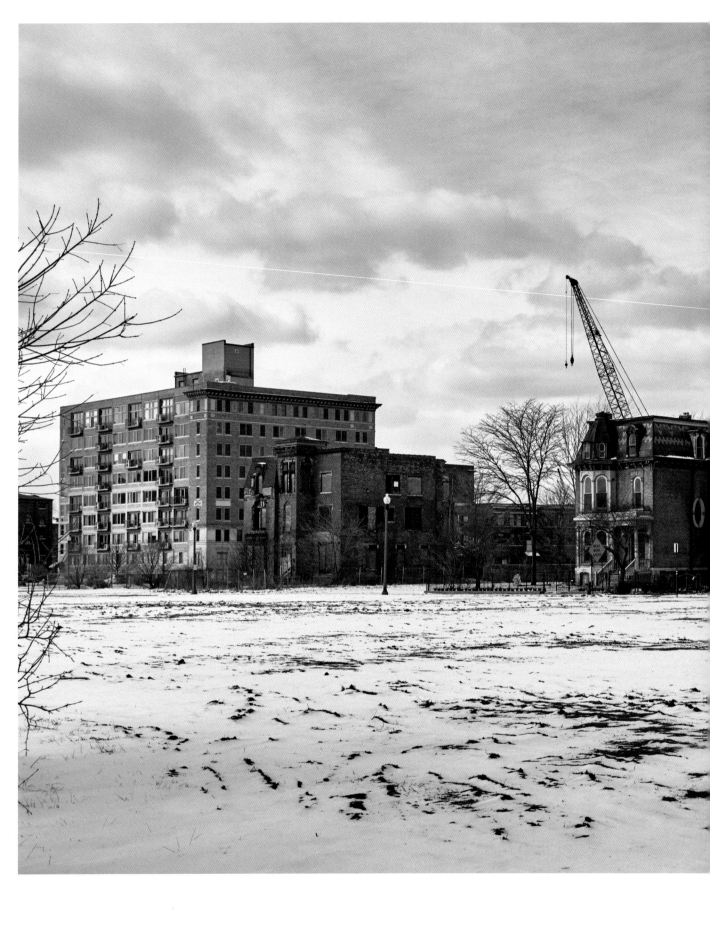

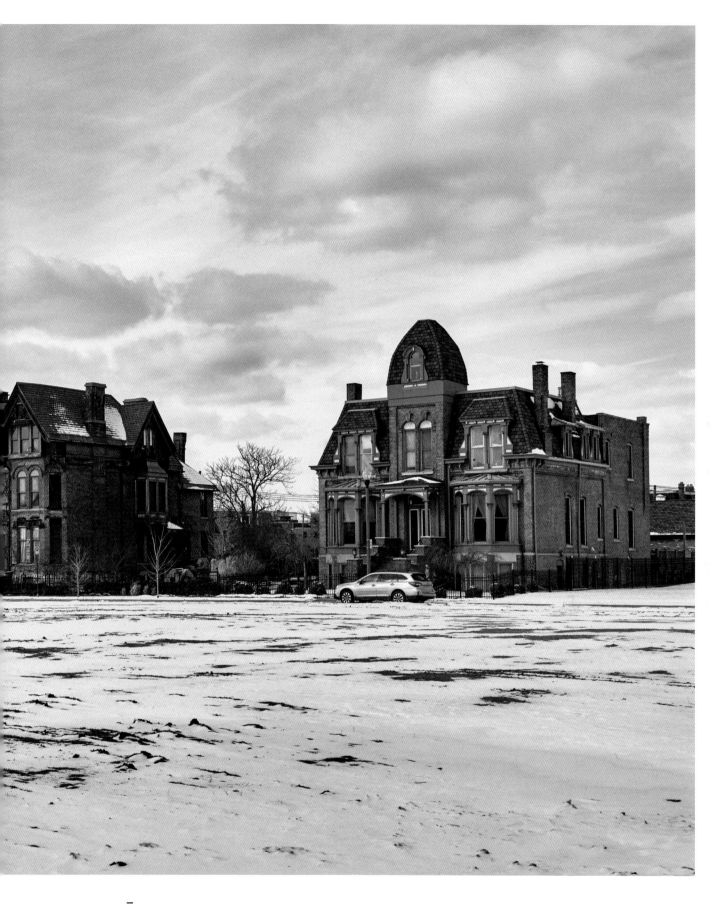

The Brush Park neighborhood boasts several examples of French Second Empire architecture: the Frederick Butler House, built in 1882, and the John P. Fiske House, 1876.

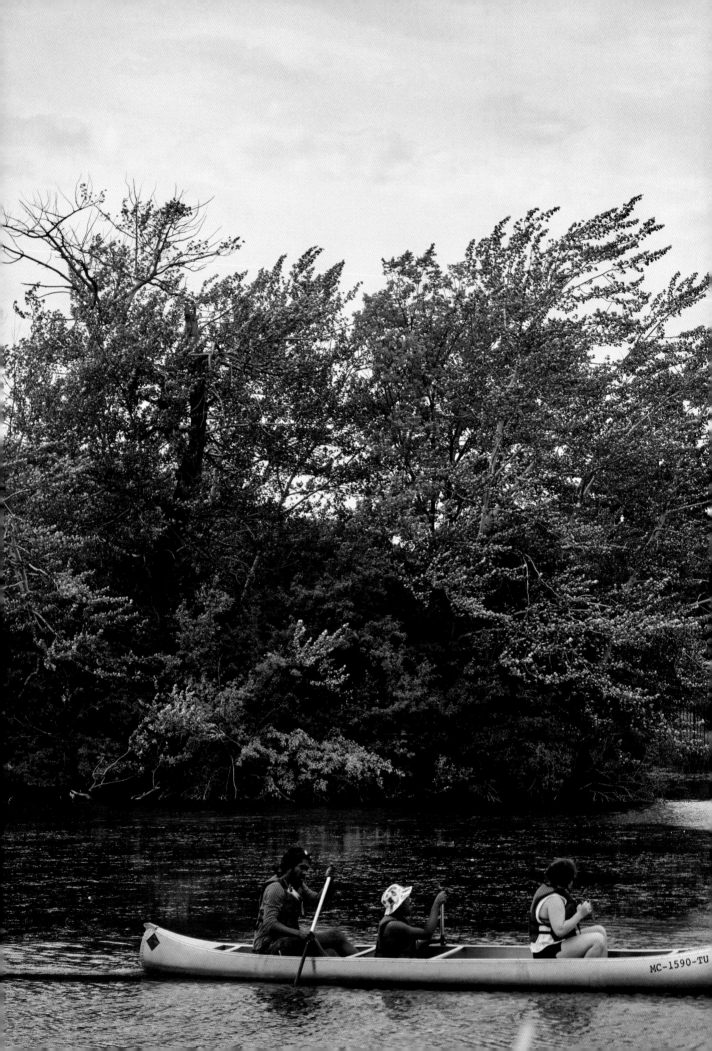

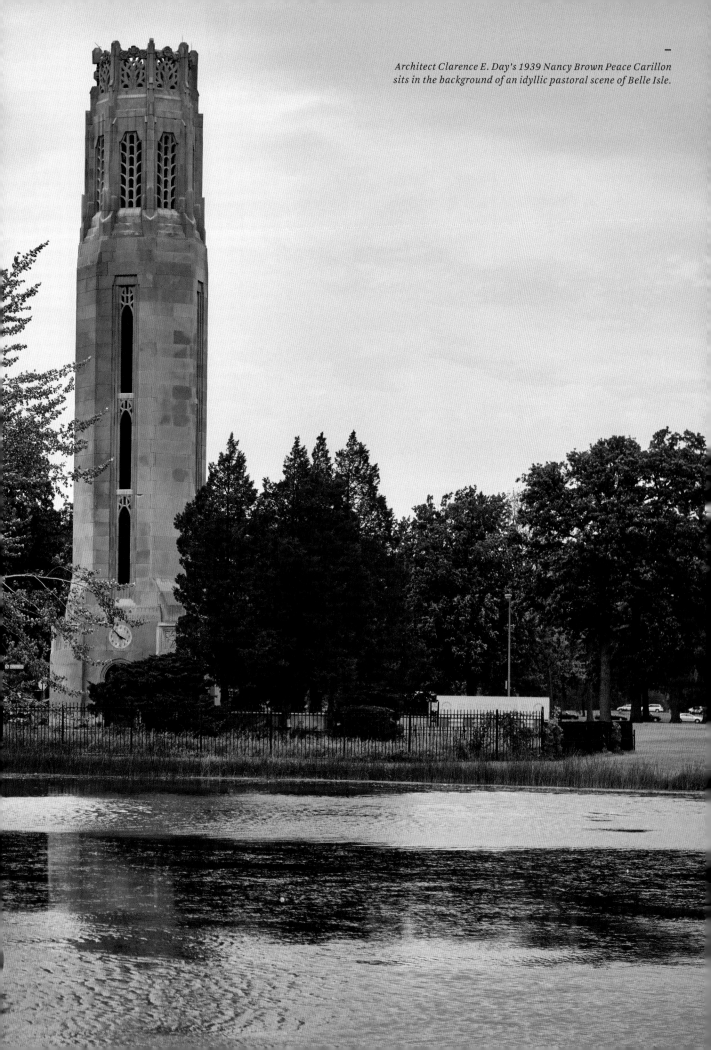

Architect Clarence E. Day's 1939 Nancy Brown Peace Carillon sits in the background of an idyllic pastoral scene of Belle Isle.

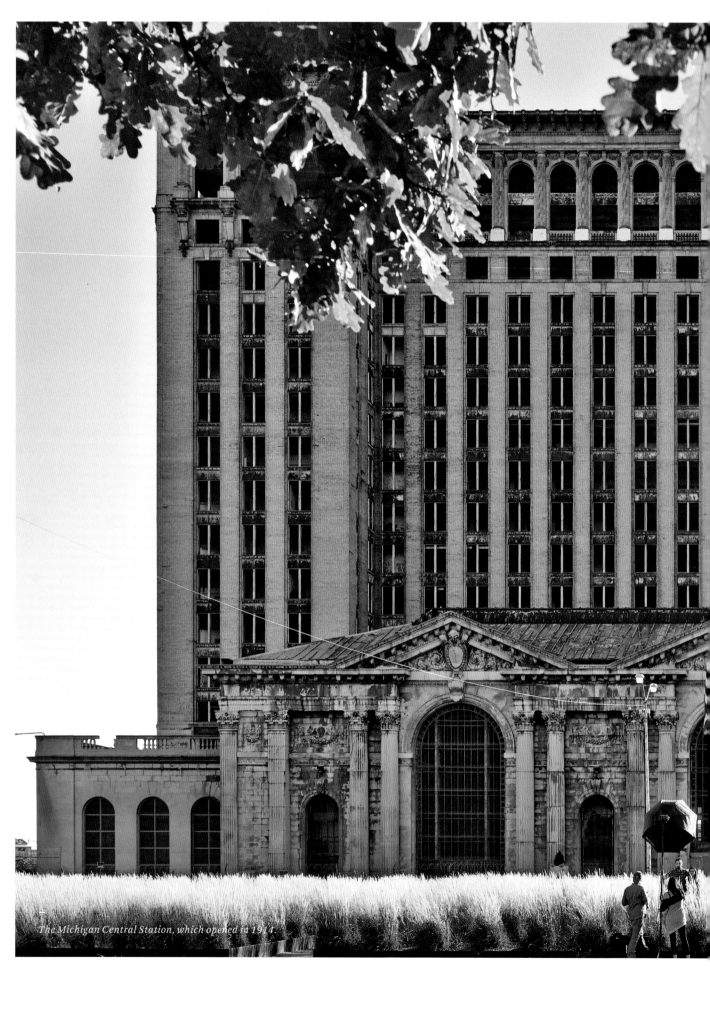

The Michigan Central Station, which opened in 1914.

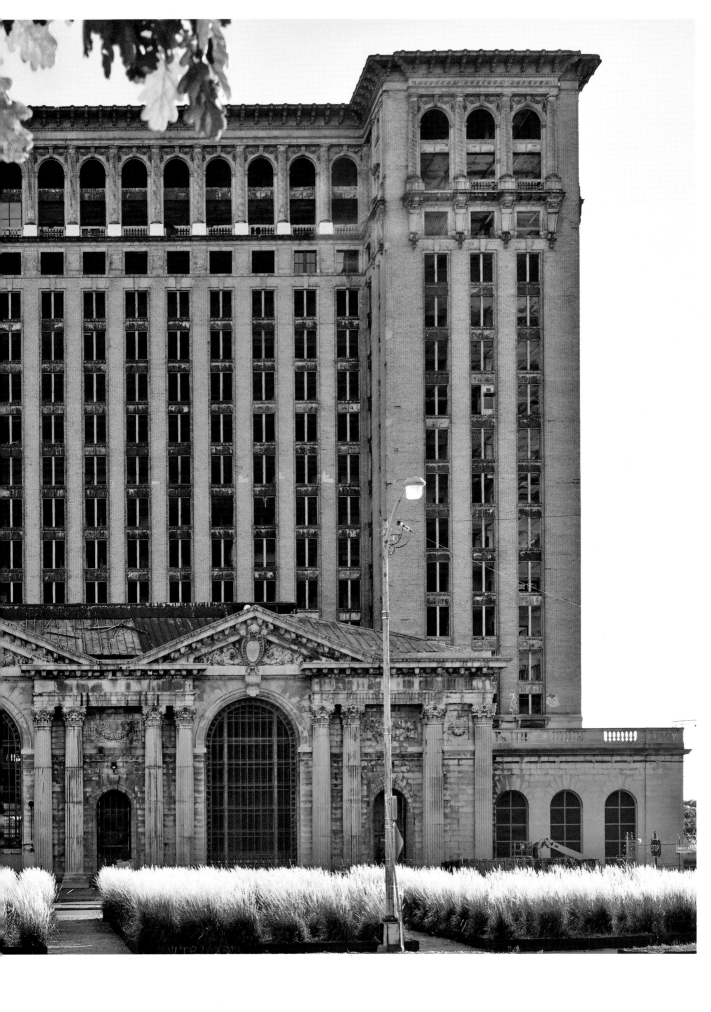

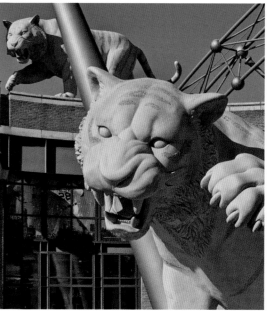

Comerica Park, built in 2000, replaced Tiger Stadium.

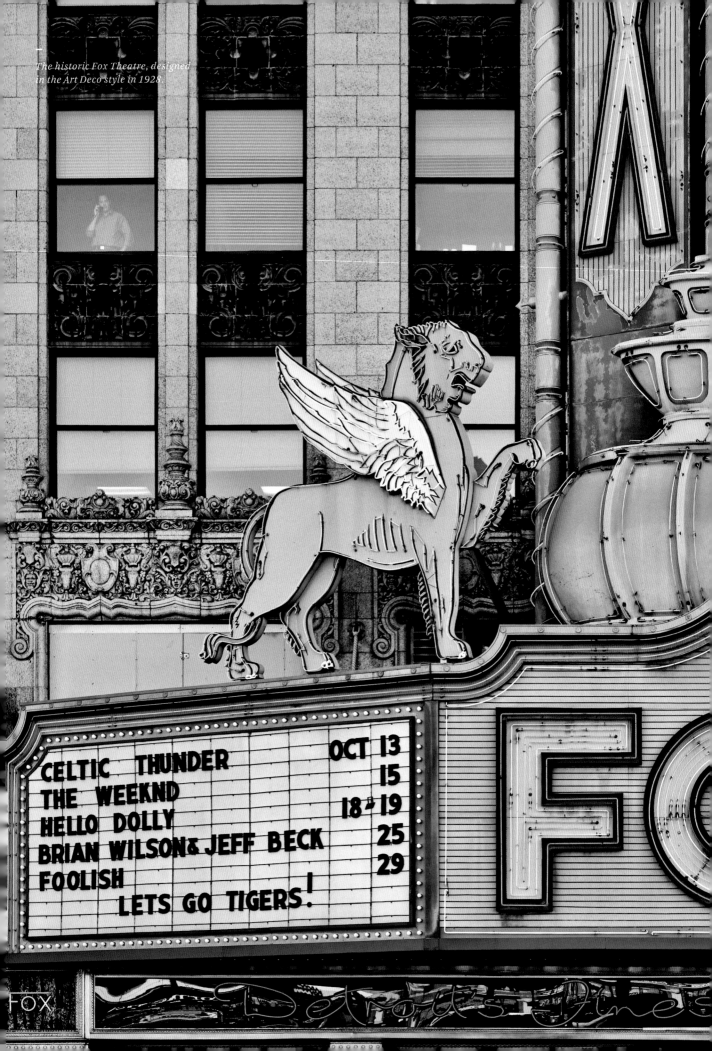

The historic Fox Theatre, designed in the Art Deco style in 1928.

CELTIC THUNDER OCT 13
THE WEEKND 15
HELLO DOLLY 18 & 19
BRIAN WILSON & JEFF BECK 25
FOOLISH 29
 LETS GO TIGERS!

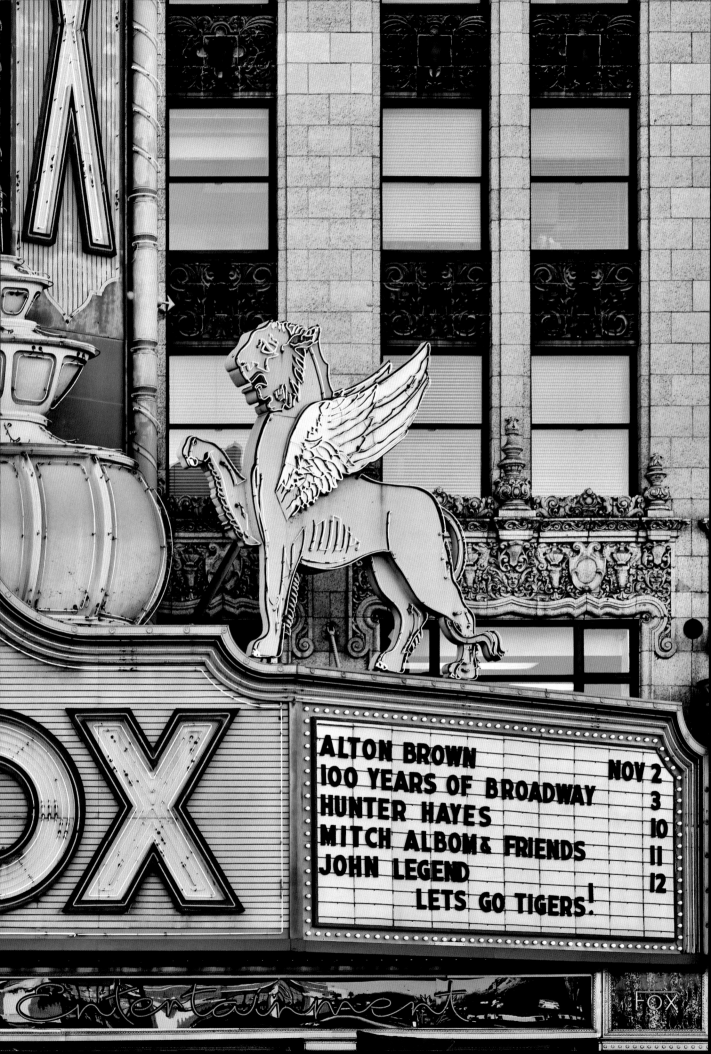

ALTON BROWN NOV 2
100 YEARS OF BROADWAY 3
HUNTER HAYES 10
MITCH ALBOM& FRIENDS 11
JOHN LEGEND 12
 LETS GO TIGERS!

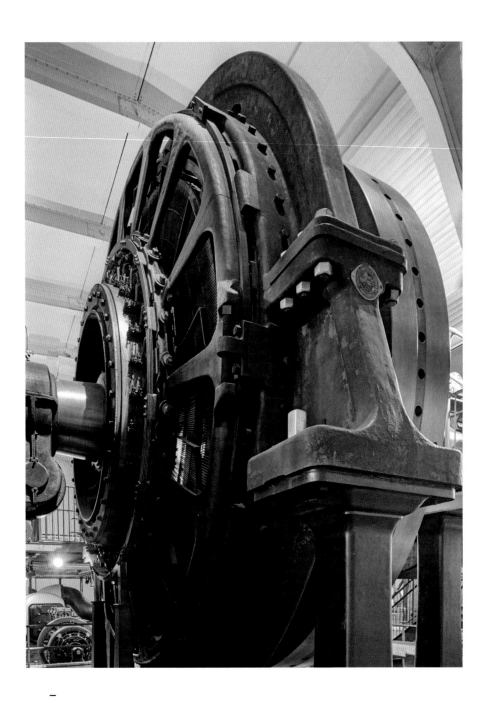

ABOVE

*Part of a gas-steam engine that was used in 1916 to generate
electricity in the Ford Motor Company's plant in Highland Park
on view at the Henry Ford Museum.*

OPPOSITE

*An exhibition at the Henry Ford Museum of a 1924 Model T that
has been "exploded," or pulled apart to reveal its components.*

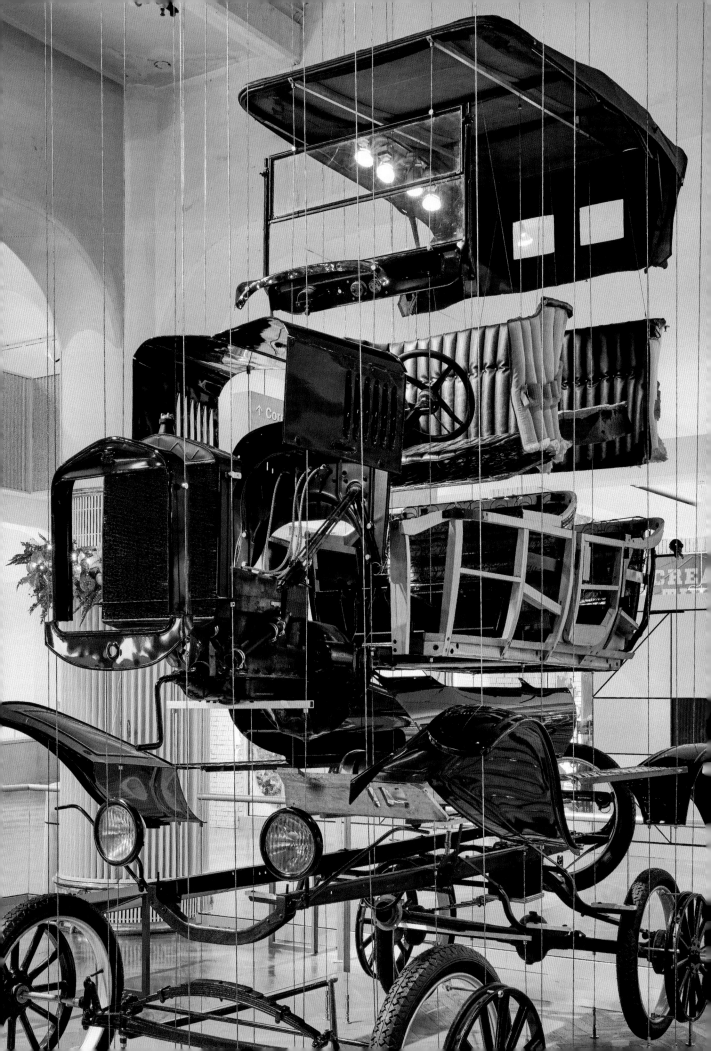

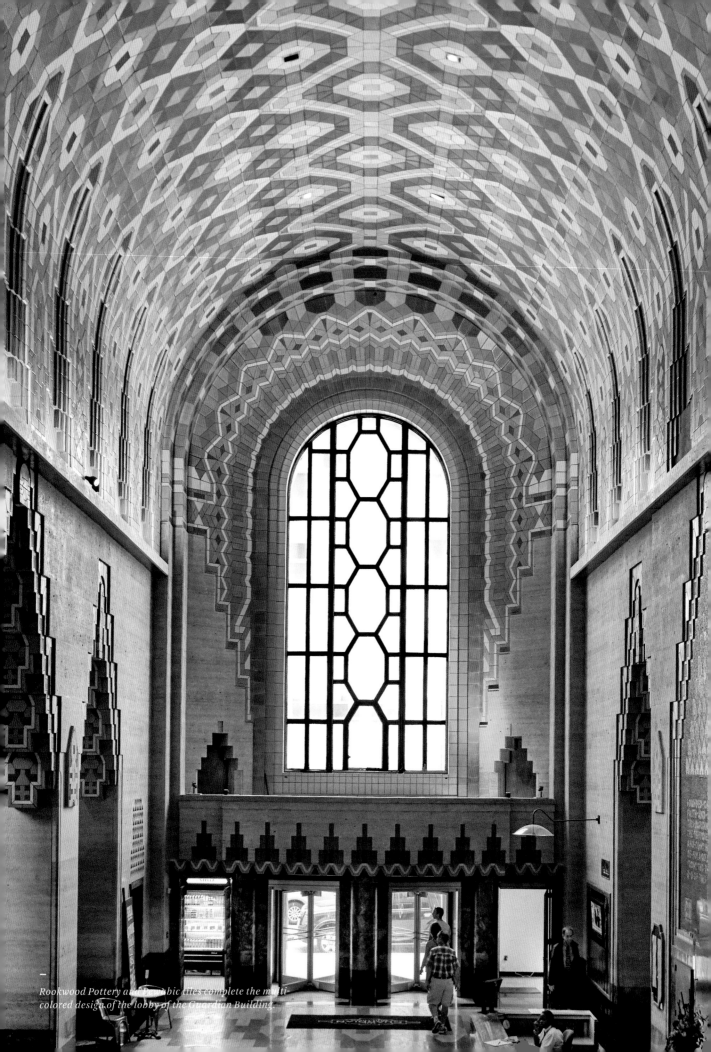

Rookwood Pottery and Pewabic tiles complete the multi-colored design of the lobby of the Guardian Building.

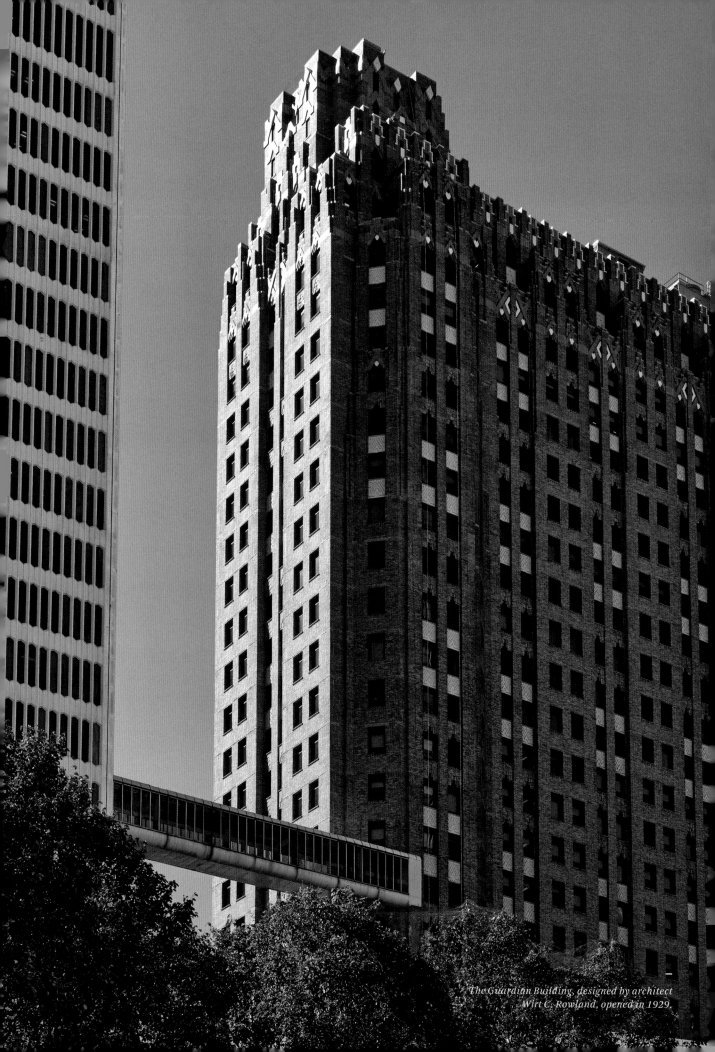

The Guardian Building, designed by architect
Wirt C. Rowland, opened in 1929.

2 THE ART SCENE

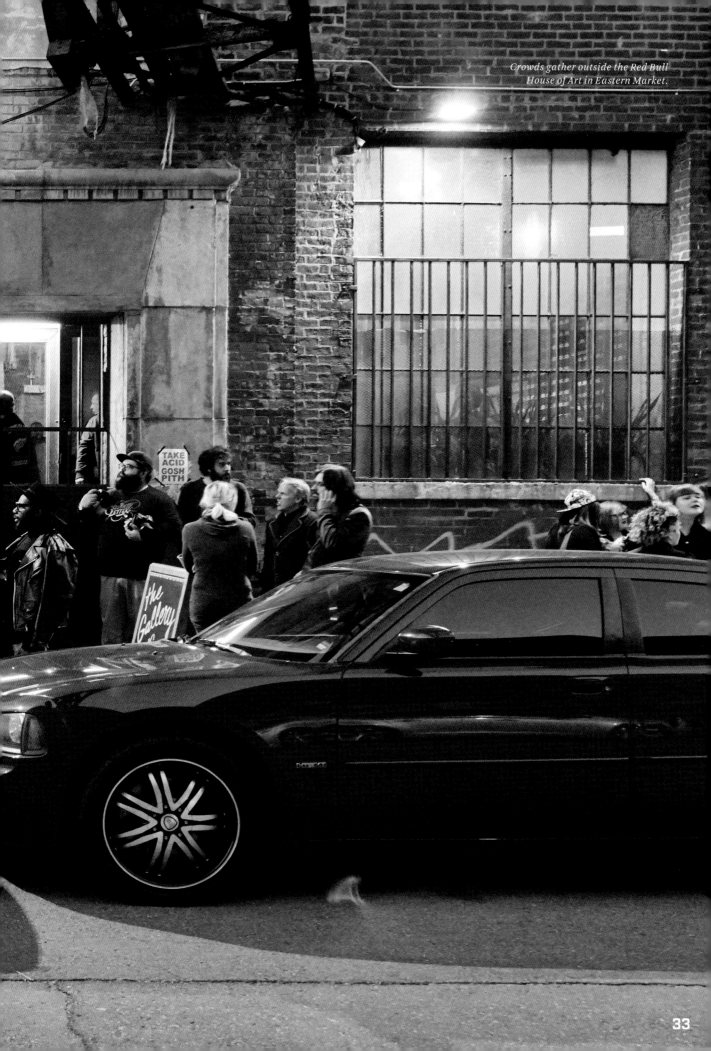

Crowds gather outside the Red Bull
House of Art in Eastern Market.

"LOOK WITH ALL YOUR EYES, LOOK"

-

Essay by

LYNN CRAWFORD

"Stella, take those binoculars out of the case and bring 'em here for me."
L. B. Jeffries, Rear Window

MY FIRST MUSEUM VISIT was a 1975 field trip from my Flint high school to the Detroit Institute of Arts (the DIA). The occasion was the exhibition *Impressionist and Post-Impressionist Paintings from the USSR,* from the Hermitage and the State Russian Museum, Leningrad.

Everything about the day was new and striking: the majestic museum itself (I had never seen, let alone been inside, a building like that), lunch in Rivera Court, and especially touring a show of paintings by Caravaggio, Rubens, Gauguin—people I had never heard of (or imagined existed). I was fifteen. The experience changed my life and cemented a place in my head and heart for Detroit as an art destination. No wonder when I moved to the city, in 1993, I expected a fertile art scene and was not disappointed.

Eventually.

At that time, some of the coolest cultural spots did not flow into the streets but were in discrete pockets; you had to understand the city, and its metro region, to find them. Once I did some scouting, I was rewarded by what I discovered: a powerful, diverse selection of art being made and shown in and around Detroit. But the artists and venues were under the radar and, in many cases, disconnected from one another. These dynamics were central a few years later, in early 2000, when I started to engage with Marsha Miro and others in discussions about establishing a contemporary art museum (which would be the Museum of Contemporary Art Detroit, or MOCAD, opened in 2006). While the main goal of MOCAD was to bring contemporary work from around the country and the world to Detroit, we also wanted to establish a place that could be a centrally located hub for various forms of artistic production already thriving here.

Another thing about 1993: Media coverage of and word about Detroit were fragmented, negative, and flat-out erroneous—dangerous, mean, dull; it was OK to make the town, and its people, the butt of jokes. There was an imaginary Detroit in the news that had little or nothing to do with the city I was getting to know and love. This disconnect added to the undercover feel of living and working here.

Fast-forward to 2017. There is an exciting, radiant, impossible-to-miss art scene percolating throughout the city. National and international media outlets are turning a serious eye to this development in Detroit. Much of the coverage, however, seems to suggest this surge of activity is new to the last few years. My art education started in 1975 at the DIA but continued on throughout the mid- and late 1990s with the Heidelberg Project, using abandoned homes and yards as creative, humorous responses to the devastation of the 1967 rebellion; Olayami Dabls's African Bead Museum, weaving African history and heritage into urban Detroit; contemporary artist Susanne Hilberry in Birmingham (where I was introduced to Elizabeth Murray, Richard Artschwager); REVOLUTION in Ferndale (Peter Williams, Kara Walker); various African and African American artists at the N'Namdi Center for Contemporary Art in Detroit (Ed Clark, Howardena Pindell, Allie McGhee). These are just a handful of places, among others, that laid a foundation for my education and, I believe, laid the foundation for the artistic surge we're experiencing today. This often-ignored connection between now and the past two to three decades is a topic many Detroiters are sensitive to.

I was recently at a party and saw someone wearing this T-shirt: Detroit = Renaissance: NOT.

It was the hit of the night.

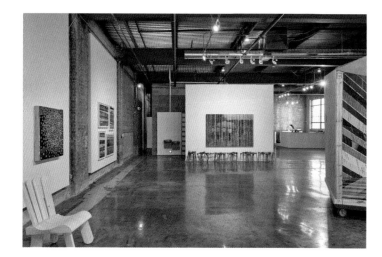

The opening exhibition of the Wasserman Gallery featured a collaboration between architect Nick Gelpi and painter Markus Linnenbrink.

This brings me to why I opened this essay with a line from my favorite film, *Rear Window*, and why Detroit, particularly its art scene, reminds me of it. Not because of the murder or the sexual voyeurism.

But because of what happens when you start to examine something. When you stop accepting the same old same old and instead give it a careful look. *Rear Window* cautions against careless impressions. L. B. Jeffries, the newspaper photographer played by James Stewart, initially views his home digs as dull. For years, Detroit was portrayed as a big, dead, empty city. Both impressions are powerful and inaccurate.

There were always interesting things going on in Jeffries's apartment complex—he just did not see them. In the same way, this new wave of fresh artists in Detroit is dramatic (and welcome) but follows a tradition of intellectual and spiritual artistic production that has not been carefully attended to (i.e., documented).

Current Detroit artists and art spaces have a special set of binoculars, and they all lead to something different and interesting. Artists turn to, among other things, landscapes (urban, industrial, pastoral), things conceptual and political, and people. The people! Take Désirée Kelly's arresting social commentary; the skillful abstraction of Allie McGhee; Tylonn Sawyer's sensitive portraits radiating complex gradations of depth and energy (I can think of no better example of the great line by Jules Verne, "Look with all your eyes, look").

The spaces themselves include some of the previously mentioned galleries and art spots as well as relatively recent ones, such as MOCAD, the fantastic Eastern Market murals, galleries that show international contemporary art such as Young World (a vast, rough space—no electricity or bathrooms—in a neighborhood not part of Detroit's upswing), and the elegant, forward-thinking Playground Detroit (in a space located close to Downtown).

Is there something that connects works made and seen in Detroit? Maybe. I might venture: starting from scratch, weaving together the heart and the head. I might add optimism, a feeling of can-do without following established rules and procedures. A sense ultimately expressed best by what George N'Namdi refers to as "urban soul." [1]

Detroit continues to be an art scene in process. While there is, arguably, a Detroit aesthetic, or vibe, ultimately, any kind of art being made and shown anywhere is being made and shown in Detroit.

1. Lee DeVito, "George N'Namdi talks 'psychological gentrification,'" *Detroit Metro Times*, July 23, 2014, http://www.metrotimes.com/detroit/george-nnamdi-talks-psychological-gentrification/Content?oid=2202773.

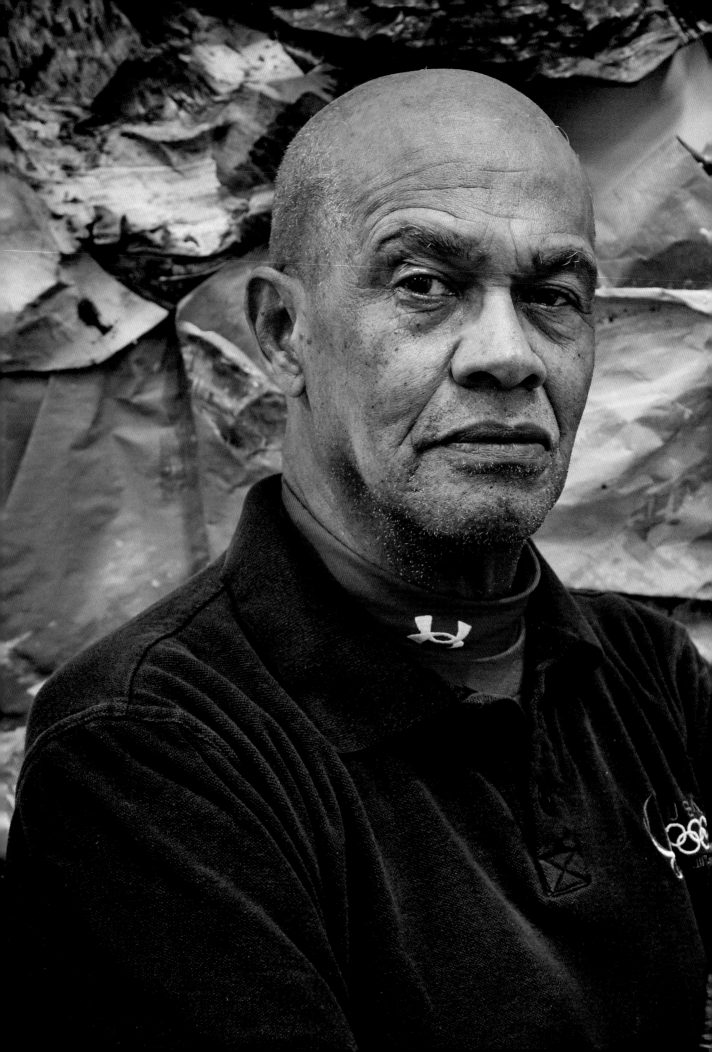

ALLIE MCGHEE

Artist Allie McGhee has been in the same art studio for almost twenty years. The freestanding building where he works is close to the entrance of Belle Isle on the city's east side. He occupies three spaces: a lightless ground-floor gallery, a second-floor area where he makes his art, and a storage space. McGhee shows his artwork in galleries throughout the Detroit metropolitan area. His painting process is physically demanding, but in the studio he has the opportunity to spread out and work on more than one painting at the same time.

—

Portrait of the artist in his studio.

"WE MOVED HERE BECAUSE IT WAS SAID THE STREETS OF DETROIT WERE PAVED WITH GOLD."

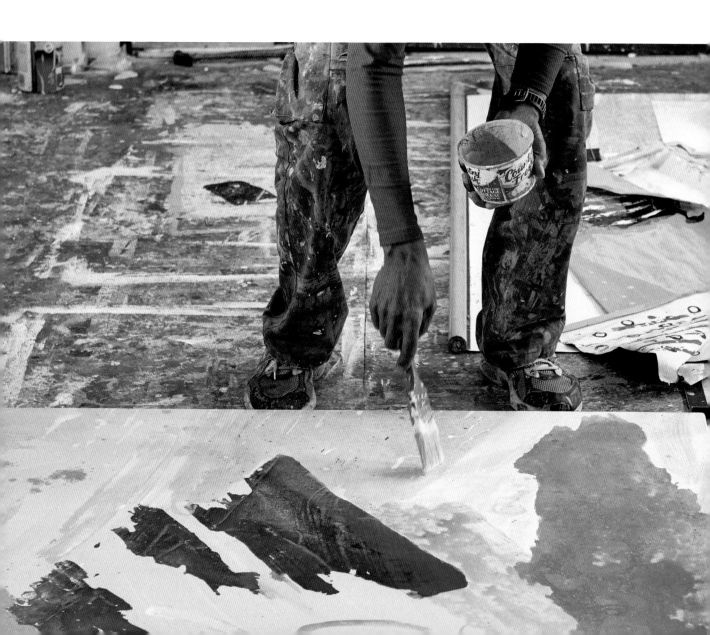

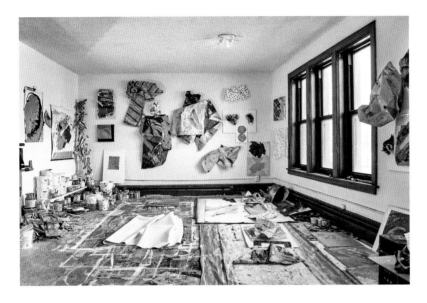

—

Interview with

ALLIE MCGHEE

MICHEL ARNAUD: *Are you from Detroit?*

ALLIE MCGHEE: My family moved here during the fifties. I was about ten years old. We moved here because it was said the streets of Detroit were paved with gold. It was the height of the automobile industry, and people working in these plants were making more money than attorneys and doctors. At the time, it was the so-called Paris of the West. That growth went on until the sixties, when everything started going south. Things went on dribbling away, up until the recent bankruptcy in 2013. Actually, now people are starting to see a possible future in Detroit, so some are coming back. It is happening faster than people thought it would happen.

MA: *I've met quite a few people who are actually moving back from the suburbs to Midtown or Downtown.*

AM: That's exactly what's happening. The city is so vibrant. It was a sad time when it started dwindling down. The city became just a warm piece of charcoal instead of a fire. Now we're trying to reignite the city

and it's a great thing. And look at my studio. My friends from New York, they're saying, "Man, how do you manage it?" I've been renting for twenty years. Look at my view—the sun comes up and bathes my studio. It would be hard to get me out of here.

MA: *Tell me about your new paintings.*

AM: I call them "crushed" paintings because they begin in the traditional manner on a rectangular format. I usually paint one side aggressively and one side passively. Then I can fold the two together compositionally and have an exciting experience when I'm moving the work around, moving the paint around, so to speak. Because they're painted on both sides, one side is equally as exciting as the other, but it's against the wall. That's why I'm starting to put them in a position so that you can experience the whole thing, away from the wall with the shadows. It pushes the work to a new dimension.

THE GRAND RIVER CREATIVE CORRIDOR

Grand River Avenue runs from Downtown to the west side. On both sides of the busy thoroughfare there is a concentration of street art, murals, and graffiti by artists such as Désirée Kelly, Sabrina Nelson, and Brian Glass, who is also known by his tag, Sintex. Derek Weaver, who managed the building at 4731 Grand River Avenue—a communal art studio—started and organized the Grand River Creative Corridor. To date, there are more than one hundred murals on fifteen buildings in the neighborhood. There is also an outdoor gallery on a corner that pays homage to Diego Rivera and Frida Kahlo. The artwork has made the area visually vital and color-filled. Detroit is, after all, the car town, and much of the street art can be viewed on the road.

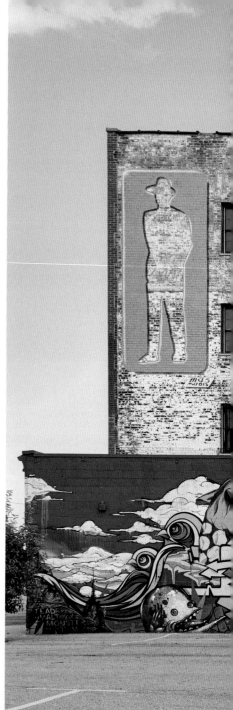

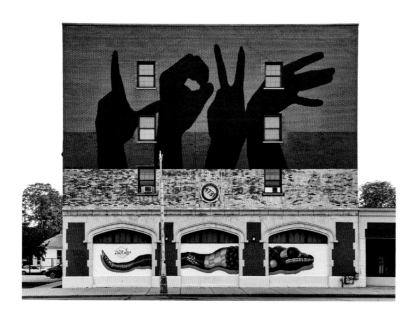

—

The street side of the 4731 Grand River Avenue building displays a painting by graffiti artist Michael Owen from his Love series above a mural of a mythical sea creature by Toronto-based artist birdO that fits into the storefront windows.

A mural collaboration by three Detroit painters—Malt, Tead, and Monster Steve—stretches along the side of 4731 Grand River Avenue. John Sauve's Man in the City *and a work by Banksy titled* Andre the Giant *are above.*

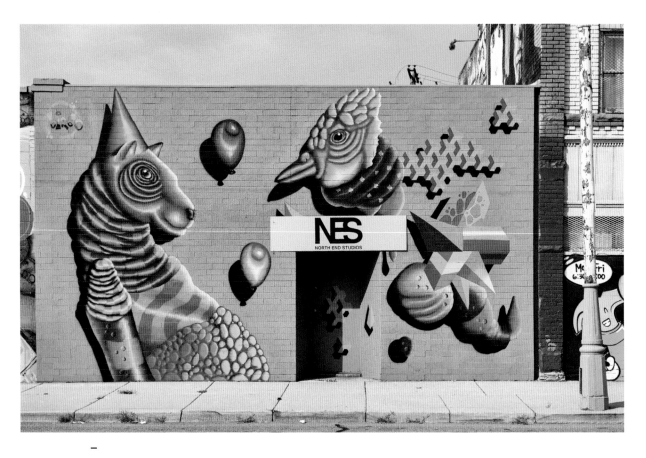

—

birdO also reimagined the façade of North End Studios at 4254 Grand River Avenue.

—

Désirée Kelly's Abe in Shades *mural.*

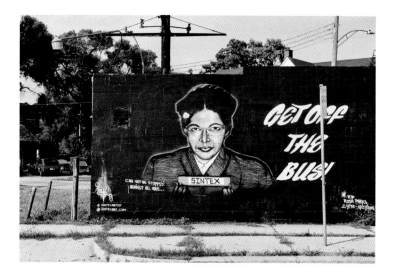

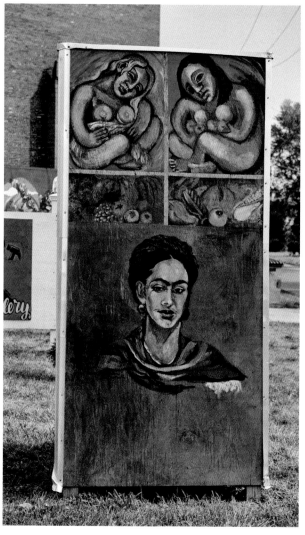

A painting of Frida Kahlo by Sabrina Nelson in
the outdoor gallery on Grand River Avenue.

ABOVE

Sintex's portrait of Rosa Parks called Get Off
the Bus is located on the northwest corner of
Grand River and Rosa Parks Boulevard.

BELOW

A wall of paintings by Baltimore artist Gaia
and local artist Brian Glass, known as Sintex.

DÉSIRÉE KELLY

Désirée Kelly grew up in Detroit and was an art major at Wayne State University. She has shown her work, which includes paintings and street art, throughout the city, including in the Grand River Creative Corridor, at an exhibition at Kuzzo's Chicken & Waffles restaurant, at the Red Bull House of Art, and at dPOP!, an interior design company. Mixing her strong drawing skills with painterly gestures, she remasters portraits of historical figures, celebrities, and personalities such as Abraham Lincoln, Barack Obama, and Picasso in a fresh, humorous, and contemporary way.

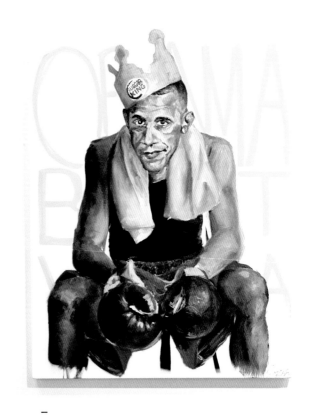

—

A portrait of Barack Obama.

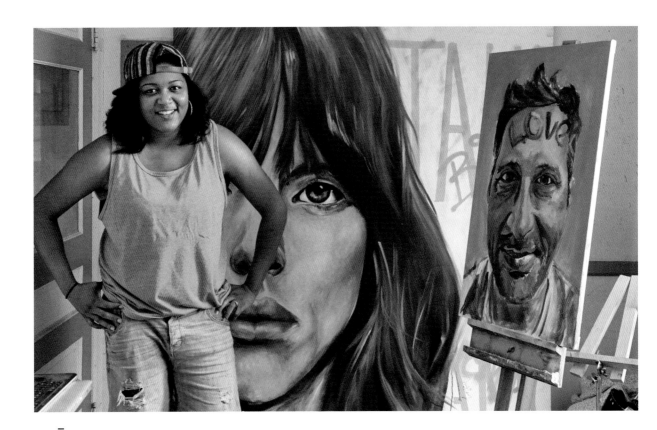

—

The artist in her studio.

Completed paintings of French philosophers Jean-Paul Sartre and Albert Camus share a space in Kelly's home studio.

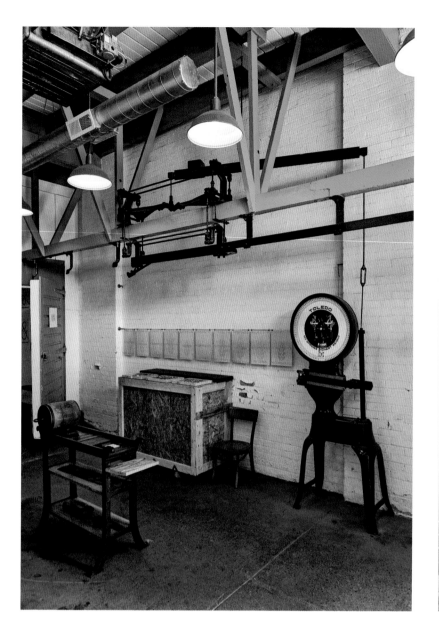

ABOVE

The entrance of the letterpress studio.

ABOVE, LEFT

A vintage scale from the days when the building was a veal-processing facility and tables holding framed examples of the press's work. The rack on the ceiling, now painted green to match the front door, was once used to move meat.

LEFT

The front room of the studio displays printed projects including posters.

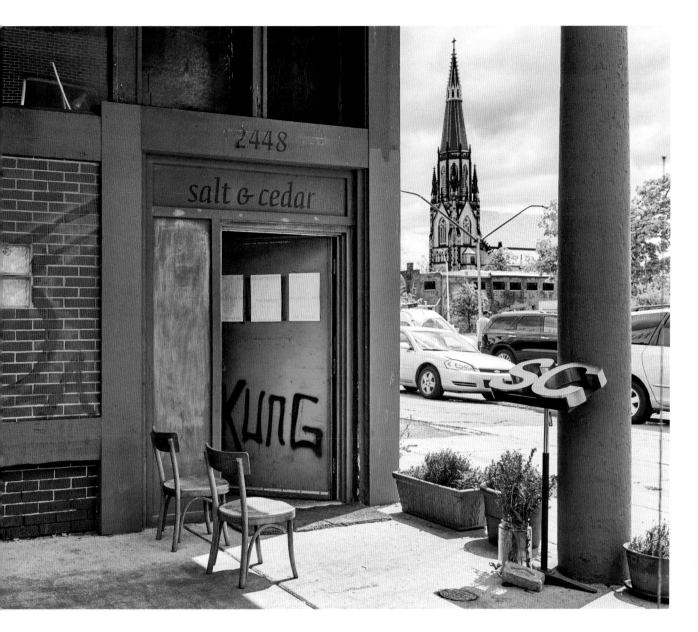

SALT & CEDAR
LETTERPRESS

Almost a year after moving to Detroit, Megan O'Connell founded Salt & Cedar, an independent letterpress studio. She felt that an expansive and emergent artist-driven initiative was needed in the city. One inspiration for the name was the fact that these two humble substances are used to preserve other materials. O'Connell works with artists, businesses, and institutions such as the Museum of Modern Art in New York City and MOCAD to create limited-edition posters, books, and other printed forms, as well as her own art. She hosts dinners, film screenings, readings, panel discussions, and other special events at the loft studio, which is located on a back street on the edge of Eastern Market. The space is a magical setting where ideas, artistry, and community meet.

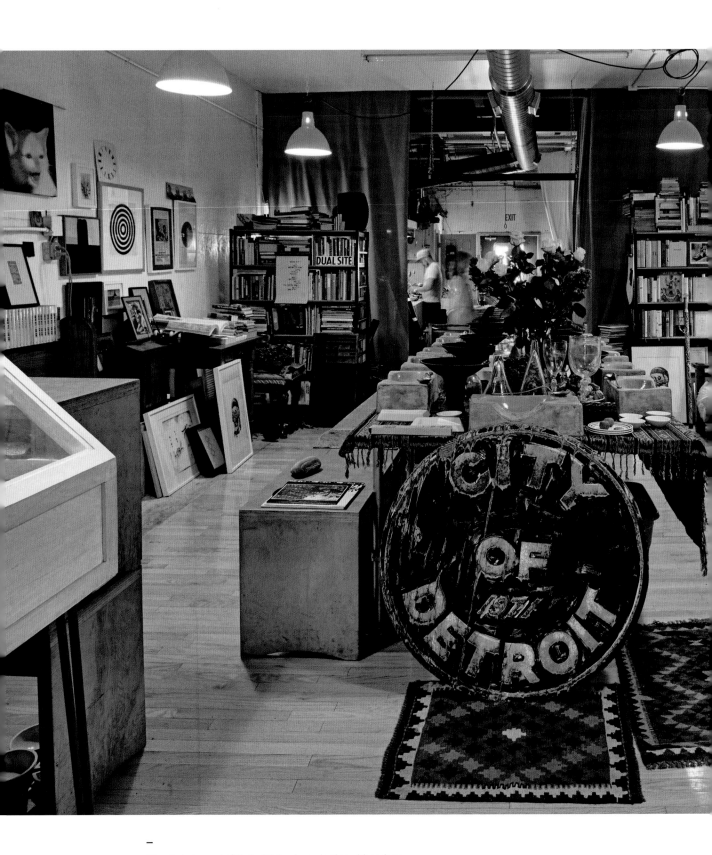

The dining area is filled with books and other objets d'art.
A long church pew is against one wall.

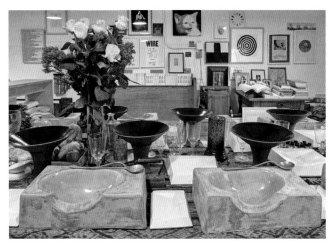

—
The table is set for one of the elaborate dinner parties that O'Connell hosts. Her collection of unconventional plates, bowls, and silverware creates a unique impression.

THE HEIDELBERG PROJECT

Imagine an entire residential block taken over and incorporated into what began as a single artistic vision. That is how the Heidelberg Project, now a nonprofit that focuses on art production, art and educational programs, and community development, began over thirty years ago. The Heidelberg Project was named for the street where founder and artist Tyree Guyton lived. Guyton's interventions at one time included at least eight abandoned houses; each had a different visual theme. Guyton accumulated things such as records, stuffed animals, and other detritus of modern life and literally stuck them on these buildings. He also painted polka-dot patterns on one of the houses and on the street itself. His assistants were the neighborhood children. A few years ago, arson destroyed several of the houses. Recently, Guyton has taken the same creative tendency for repetitive imagery and moved on to an empty building in Brush Park in Midtown, covering it with paintings of shoes. While the Heidelberg Project has been placed in the outsider art genre, its enthusiasm, energy, and effort spill beyond definition and boundaries; it has become a community project to reclaim the neighborhood that receives international attention and 275,000 visitors a year. In 2016, Tyree Guyton announced that he would begin to slowly take down the artworks on Heidelberg Street.

—

The title of this work is Giant Steps. *Paintings of shoes on boards of all sizes were placed on an abandoned building next to the Heidelberg Project office in Midtown.*

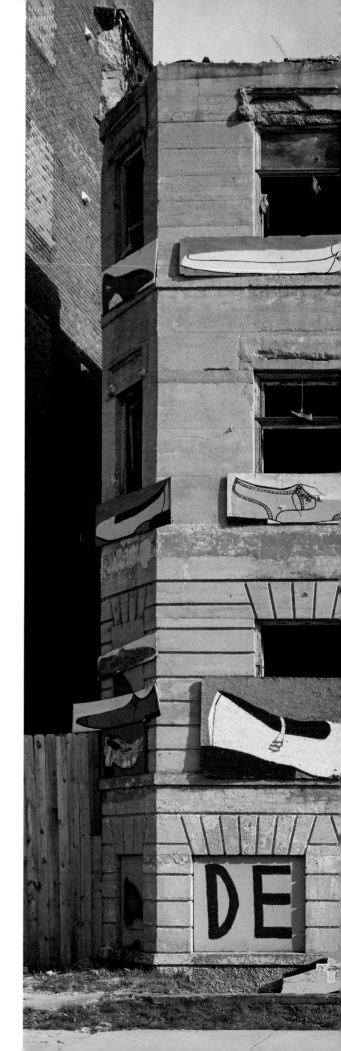

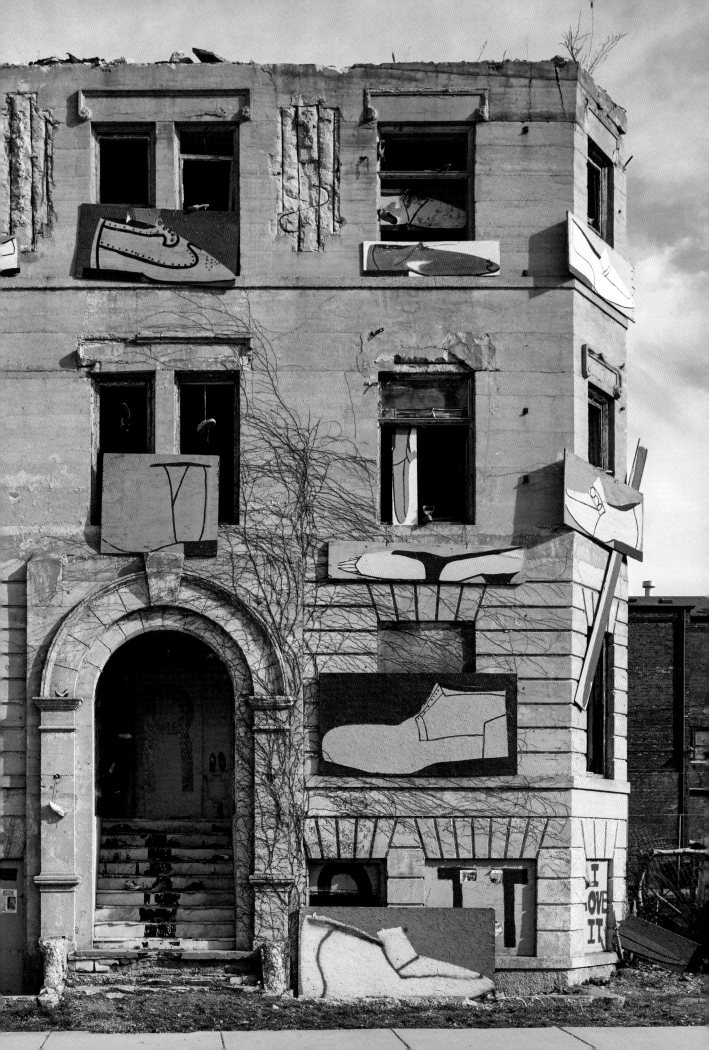

—

Planted on the grassy corner of the Heidelberg Street Project is CODEPINK's Ode to the Gas Guzzling Hummer.

The artworks titled Faces in the Hood *were painted on car hoods.*

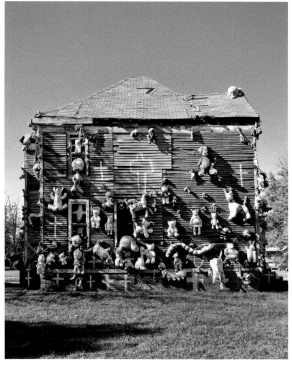

—

ABOVE

The house on Heidelberg Street that Guyton covered in stuffed animals, titled Party Animal House, *was destroyed by arson in 2013.*

LEFT

Another house on the block, covered in records and entitled House of Soul, *was also burned down in 2013.*

LISA SPINDLER

Lisa Spindler's 4,500-square-foot loft is located in a former warehouse in Corktown on the Detroit River waterfront. When Spindler—an artist, collector, photographer, and Detroit native—took over the space in 2013, she stripped the concrete columns and ceiling down to their original surfaces and kept the wooden floors. She installed high-end, gallery-style lighting. A wall of windows not only provides a spectacular view of the river but fills the room with natural light. The space, which is known as the Spindler Project, displays her own experimental photographic art and her collections of fashion, furniture, and Detroit memorabilia. Although the Spindler Project is not a gallery, Spindler will on occasion offer local artists the chance to show their work on a museum scale in a private setting.

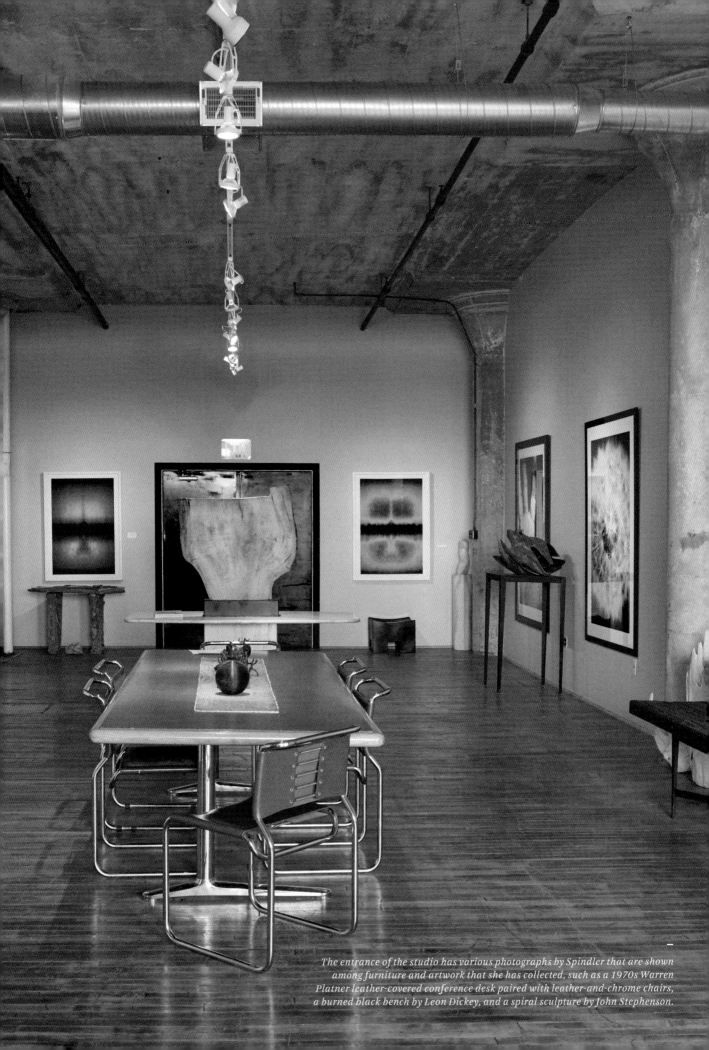

The entrance of the studio has various photographs by Spindler that are shown among furniture and artwork that she has collected, such as a 1970s Warren Platner leather-covered conference desk paired with leather-and-chrome chairs, a burned black bench by Leon Dickey, and a spiral sculpture by John Stephenson.

Interview with
LISA SPINDLER

MICHEL ARNAUD: *Tell us about you, this space, Detroit.*

LISA SPINDLER: This building is an old warehouse located in Corktown, Downtown Detroit, about a block from the Detroit River. It is an old storage building that was built in the early 1900s.

I was very taken by the energy of the space when I walked in. The combination of the natural light coming through all the windows, the concrete ceilings, the wood floors—it felt like a temple. All I could imagine in those first few seconds was if the space was mine, how beautiful it would be to fill it with music and art.

I signed the lease the day the city filed for bankruptcy, and I never even asked if there was running water. I knew by my instinctual feeling that I needed to save the space from being lost to someone who didn't understand it. There was no question. I went from a 200-square-foot office into this 4,500-square-foot space. The only thing that I could afford to do when I moved in here was strip the place, clean it, and install really good lighting.

What it's turned out to be is what I call the Spindler Project. It is a space where creative ideas take place. It's not a gallery; it's not open to the public; it houses my photography archives and collections of important artifacts in design, art, and furniture that I've collected over the years. Many of the objects are both industrial and organic, and artifacts of Detroit's past that I feel are important to share. My current project involves the collection of the work of an artist named Rock N Roll. I feel he is one of the most important artists coming out of Detroit. His work is a fascinating collage of everything Detroit is: music, design, art, pop culture, et cetera. He is Detroit.

MA: *Being from Detroit, you have seen so many changes. What do you think about what's going on now?*

LS: It is the soul of the people who have made this city unique and incredible. Whether it's the musicians, the artists, or the people who have lived here their whole lives. With the influx of people from all around the world, it is important that the soul of Detroit remain and is preserved. It's the authenticity of what was here, what was real, and as long as it's respected, I think it will be good.

I ask people why they're coming here, why are they excited. The response I have heard more than once is that there's some vibration that they can feel in the city.

Two years ago, I couldn't get people to come here to shoot a job. Nobody wanted to come to Detroit. Now people can't wait to come here or come back.

MA: *Do you think people are ready for these changes?*

LS: Older people never thought they'd see it in their lifetimes—that the city would come back. People in the suburbs are starting to come downtown. I knew things were changing last summer when I saw a beautiful, young, long-haired European girl riding a bike in a mini skirt with boots, just around the corner in a rough area. I never would have seen someone riding their bike downtown ten years ago

I have to say that it's really nice to see people walking around in the streets and to actually have traffic where we didn't have any. In 1989, I remember being downtown in my studio. It was snowing and I could hear my own footsteps walking. There was no other sound at all—just the snow and myself. It was a ghost town. I remember how desolate and lonely it was.

It took some people with vision to get together and start investing—to take that risk.

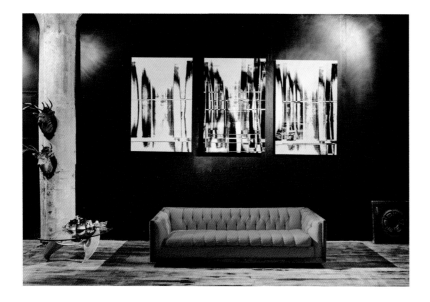

Spindler's three studies of an elevator door are hung over a vintage red couch. Plaster deer heads by Detroit sneaker artist Eric Lowry, aka El Cappy, are displayed above a 1960s propeller table by Knut Hesterberg.

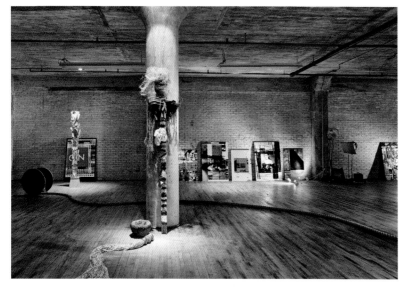

A view of an installation of the sculpture artwork of Leon Dickey hosted by the Spindler Project. On the walls in the background are Spindler's industrial images.

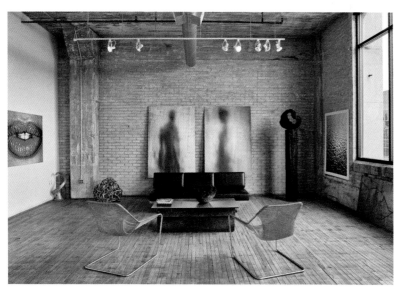

Works by Spindler—including Red Lips (printed on aluminum), a self-portrait from the Shadow Study series, and Water on Glass—are surrounded by two Paulistano metal mesh chairs by Brazilian designer Paulo Mendes da Rocha. A concrete prototype, Vine, leans against the wall, and a burned sculpture by Leon Dickey sits in the corner.

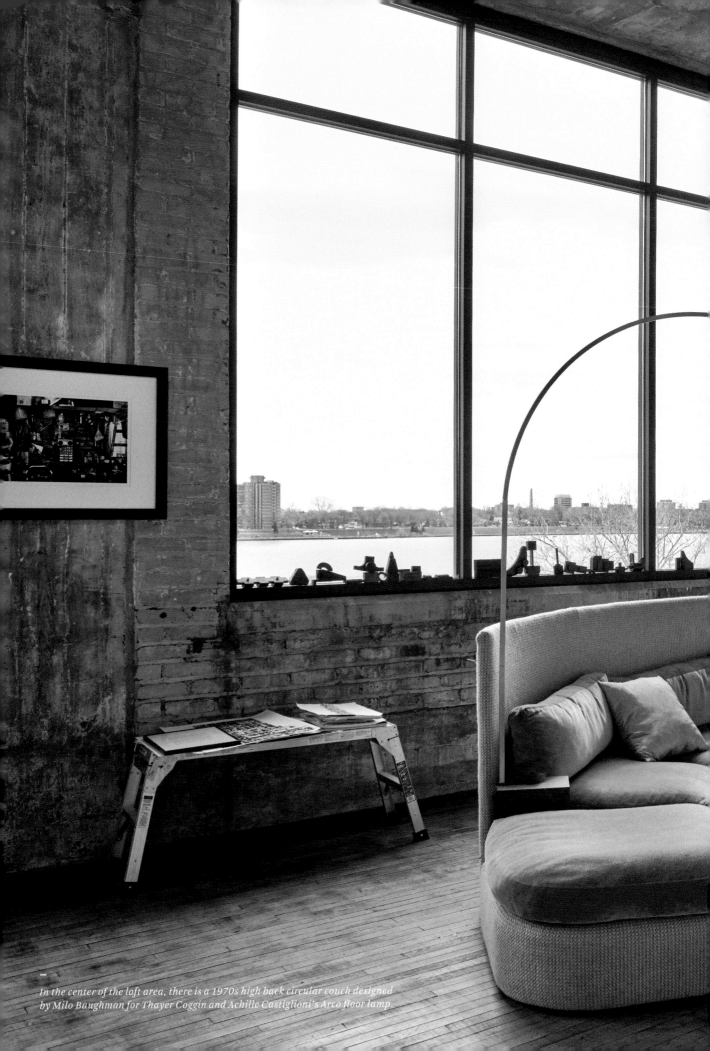

In the center of the loft area, there is a 1970s high back circular couch designed by Milo Baughman for Thayer Coggin and Achille Castiglioni's Arco floor lamp.

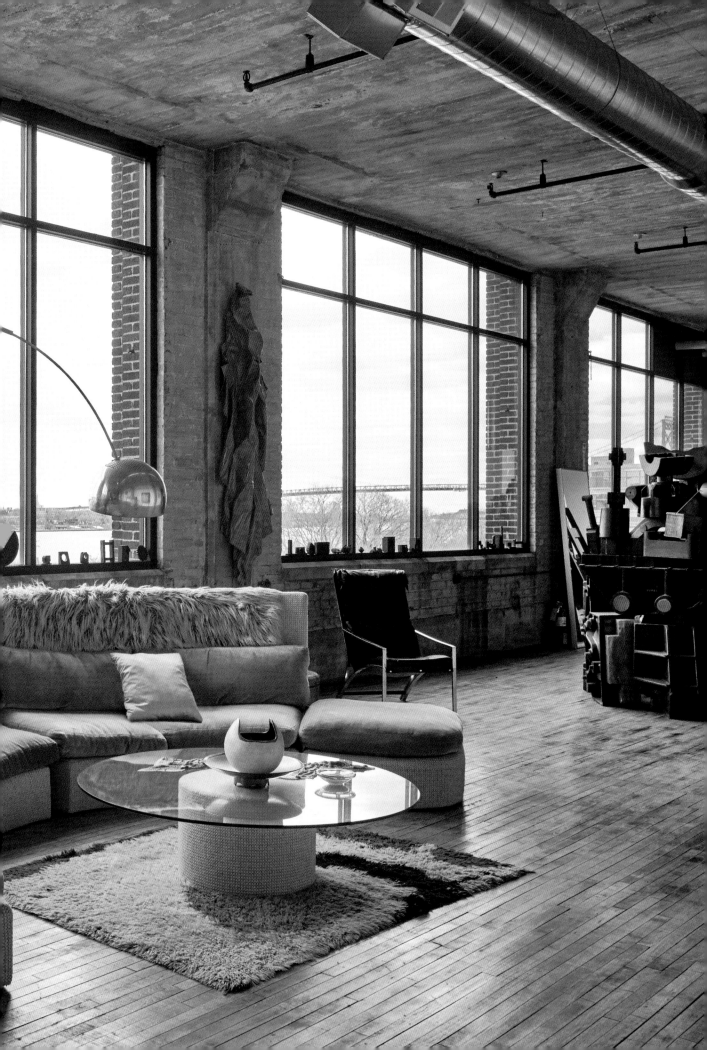

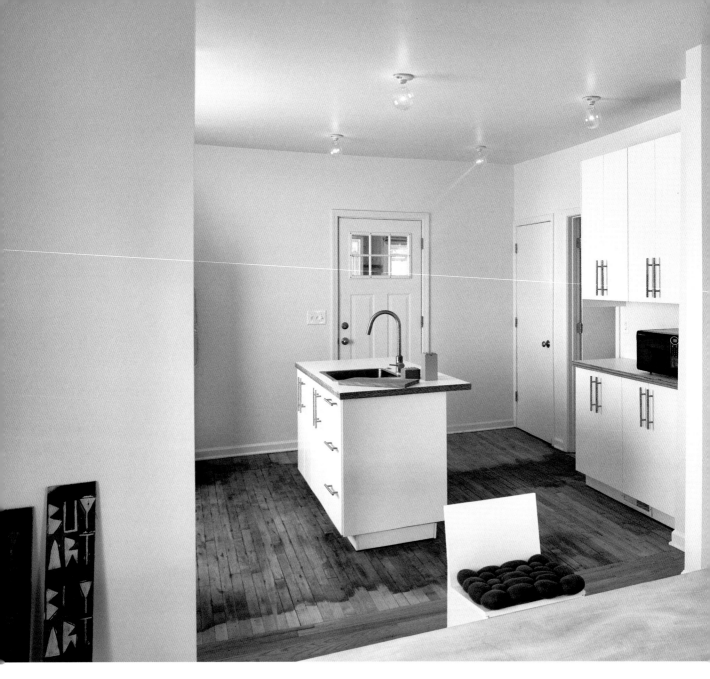

WRITE A HOUSE

Writers Toby Barlow and Sarah F. Cox came up with an idea. What if there was a way to merge the huge inventory of housing in the city with the need to build up the creative community by bringing writers to Detroit? Together, in 2012, they founded the nonprofit Write A House that does just that. Each year, the organization holds a competition that gives a selected writer a house. The writer goes through an intense screening process and must commit to staying in the house for a period of at least two years, then the deed is awarded. Another aspect of the foundation's mission, in partnership with Detroiters Working for Environmental Justice, is to hire unemployed people to do the home renovations. Training in construction is provided and hopefully leads to full-time employment. The project has been a great success—the third house is complete and a fourth is in the works.

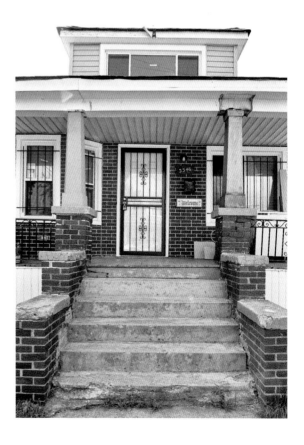

—

ABOVE + OPPOSITE

The renovations allow the contest winner and now new homeowner to move right in. Local furniture companies lend furniture for staging and for the new owner's use, as shown here—a table by Floyd, the modular furniture company, and chairs by subtrakt.

RIGHT

The entrance to one of Write A House's renovated houses. The organization buys the house and makes structural improvements.

SCOTT HOCKING

Scott Hocking works above what appears to be a welding shop in a former garage in the North End. It is actually an artist residency run by two artists, who also have a kiln and woodworking shop on the premises. Hocking has the entire upper floor of the two-story building, in which every square inch is filled with books and materials from some of his assemblages. It is as fascinating to look at as one of his pieces. Hocking is known for creating site-specific installations inside the ruins of buildings in Detroit, but he is expanding his practice to areas beyond the city, such as Michigan's Upper Peninsula and as far away as Lille, France. He often uses the materials on-site to make the work and then documents the pieces with photography.

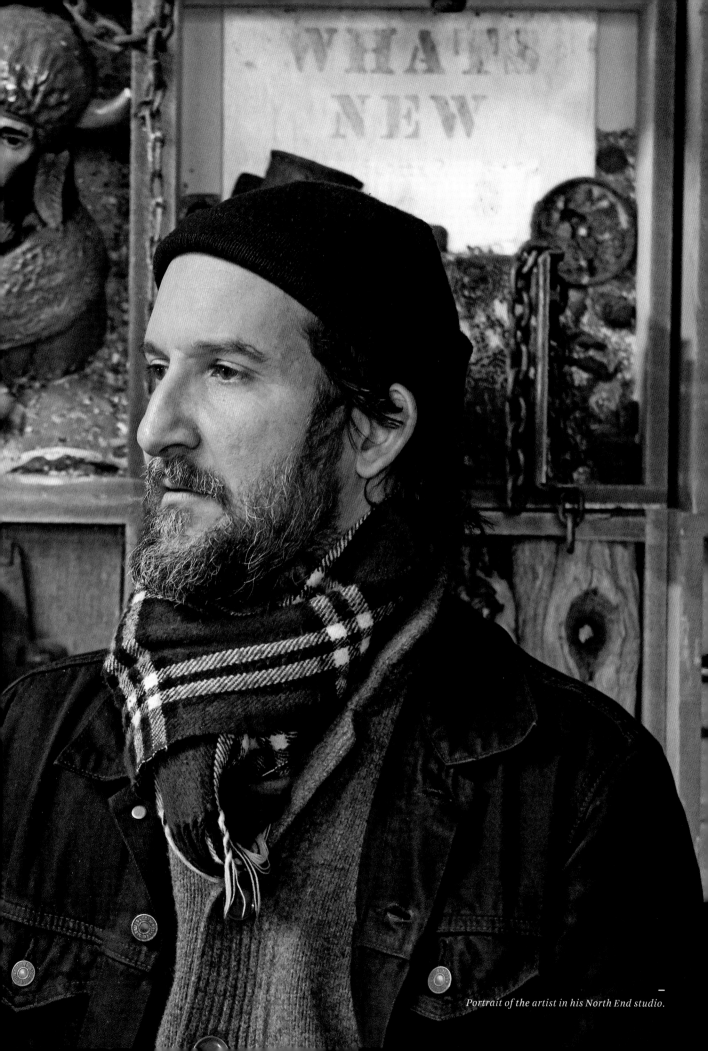

Portrait of the artist in his North End studio.

Interview with

SCOTT HOCKING

MICHEL ARNAUD: *What are you working on?*

SCOTT HOCKING: A lot of my site-specific installations in Detroit are in abandoned buildings, and usually the only people who see them in person are metal scrappers, urban explorers, homeless people, and maybe the people coming to clean out or demo the building. Photographs end up being the work people see in exhibitions. This has been my style of working for about ten years now.

MA: *What do you think about the attention Detroit is getting these days?*

SH: Personally, I see it as a natural cycle. Like all things in nature, there's decline, decay, death, but then there's rebirth. I think the world watches Detroit a little differently because it was such a shining example of the American dream.

I see the city as growing in these concentric rings, radiating out farther and farther. But over time the inner rings started to decay and die, and those rings of death started to spread like ripples. Today the center is starting to be reborn, but there are still death rings around the city, and you can see places where rebirth has not happened and probably won't for a long time. It's a city of islands, of juxtapositions. All the stories about the economic collapse in 2007, about the auto industry leaving and the bankruptcy, were all happening during a time of revitalization. This didn't happen overnight. The city has been depopulating slowly over sixty years, and we've all been watching it change.

MA: *How did it influence your work as an artist? Do you feel a certain anonymity in Detroit?*

SH: I love the solitude that I find in the city. My nostalgia for Detroit is for when it was emptier. I've had to adapt my ideas as the emptiness gets filled. I do like to work in anonymity, and the abandoned spaces of Detroit were and are my solaces. I find beauty in the decay, beauty in the transition. The difference now is that urban exploring has become a worldwide trend. Nothing is really unexplored anymore. So as the city changes, I change the way I work.

MA: *Do you think that's because you grew up in this time of change?*

SH: Well, I like to say that Detroit has always been a city in transition. Maybe that's why creative people like it here. Artists get ideas here, myself included. It's a good home base.

But with all the people coming to Detroit, it doesn't mean they're all good. Some people are opportunists, speculators, profiteers. Some think it's hip to be here. Others come because they can afford it, and there's more space to live and work. But hey, a thriving city has all kinds of people—the good, the bad, and the ugly.

"DETROIT HAS ALWAYS BEEN A CITY IN TRANSITION."

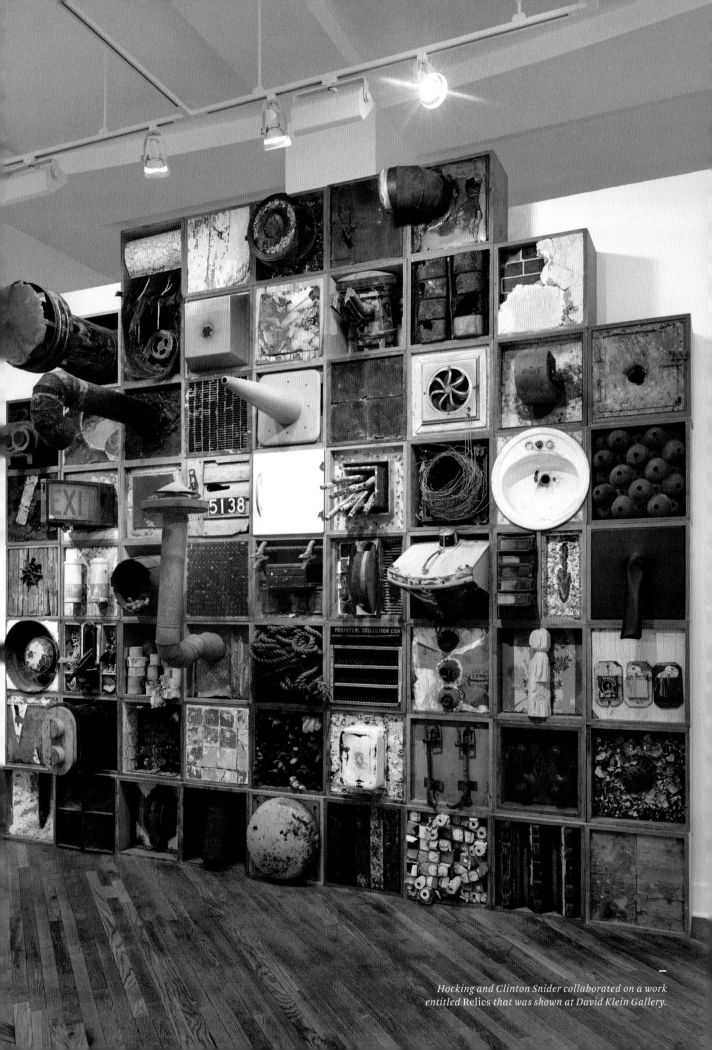

Hocking and Clinton Snider collaborated on a work entitled Relics *that was shown at David Klein Gallery.*

LEON DICKEY
AND GREGORY
BERTERA

After traveling the world and living in other cities, Michiganders Leon Dickey and Greg Bertera bought a nineteenth-century house in Wyandotte, just south of Downtown Detroit. Looking for a place that would be both a studio for their work—Dickey is a sculptor and Bertera a jewelry designer—and a home, they found a house that was well-kept—they are only the third owners. Outside and in, upstairs and down, serve as creative work areas for the two artists. Dickey has converted the dining room table into a workbench, and Bertera has taken over the basement. At any given time, the house can be filled to the brim with art in various stages of progress: Unfinished pieces are being worked on, and finished pieces waiting for transit to various shows in Detroit, Birmingham, and New York are on display in the living room, entrance hall, and even the island in the kitchen. In the garden, works made from natural materials such as rocks, vines, and twigs meld into their surroundings. Dickey says when he starts a piece, he often doesn't know how it will look when finished. The element of surprise also extends to his home; you never know what you will find on any given visit—a tower made of sunflowers, a bowl-shaped work formed from broken glass, or a burned armchair.

—

The late nineteenth-century house has a wide front porch.

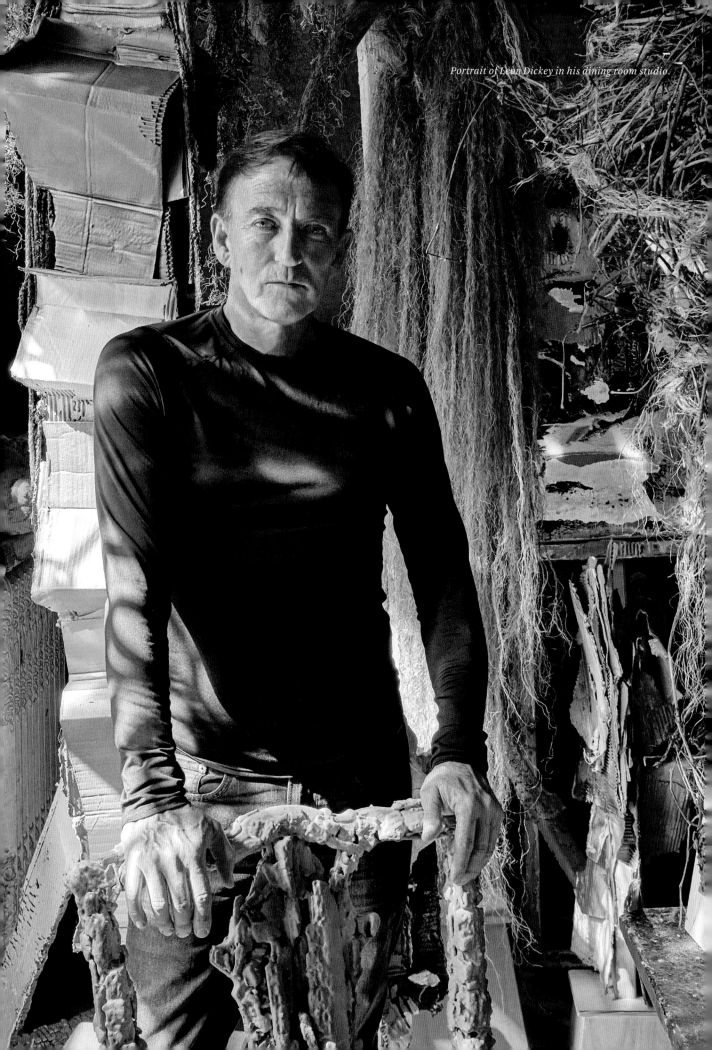

Portrait of Leon Dickey in his dining room studio.

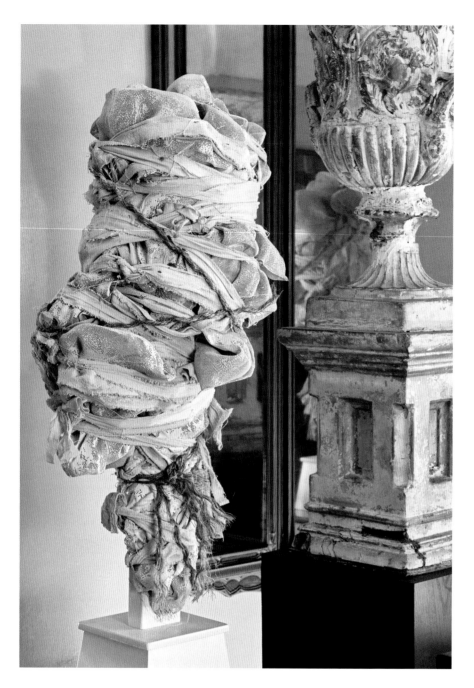

—

ABOVE

The artwork in the front parlor is titled Secrets *and made from painted cotton and burlap. A 1920s antique urn was found in the remains of a condemned building.*

LEFT

In the parlor, an orange sculpture made from broken wood is on display. The furnishings are a mix of antique and contemporary as well as flea market finds.

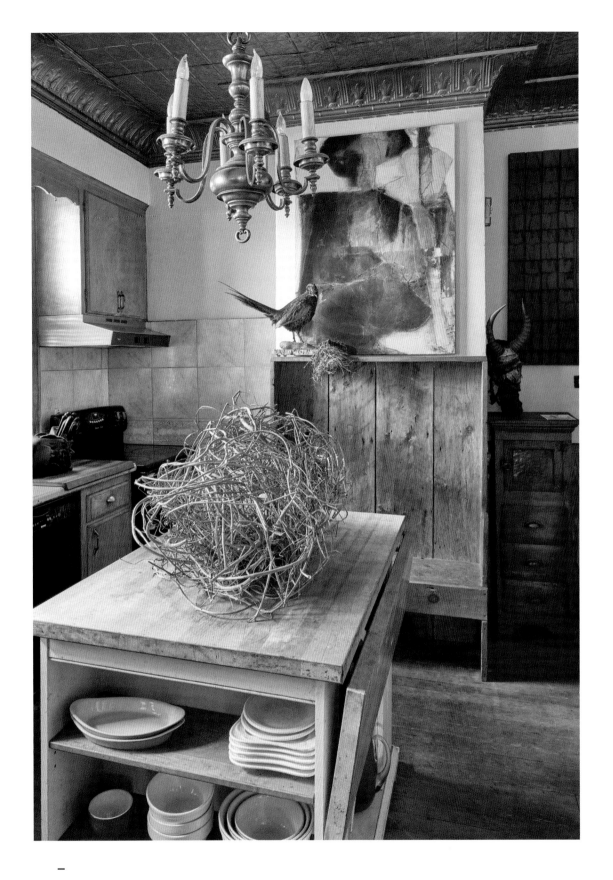

A spun wood nest is displayed on the island in the kitchen.
An oil-on-canvas painting is entitled Night Watchman.

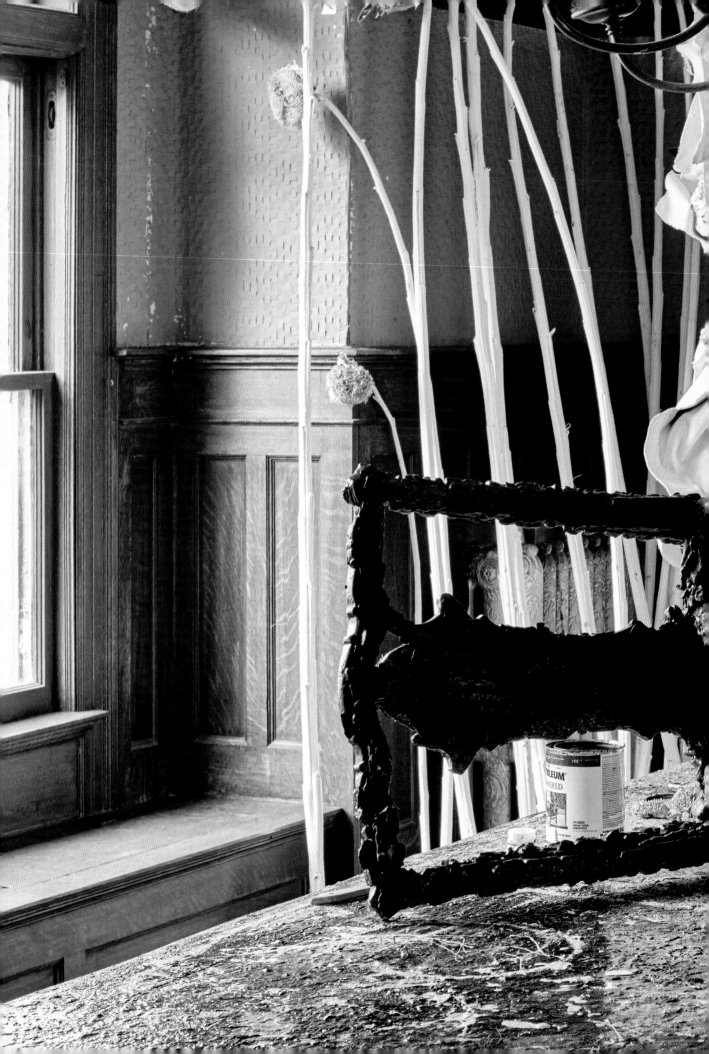

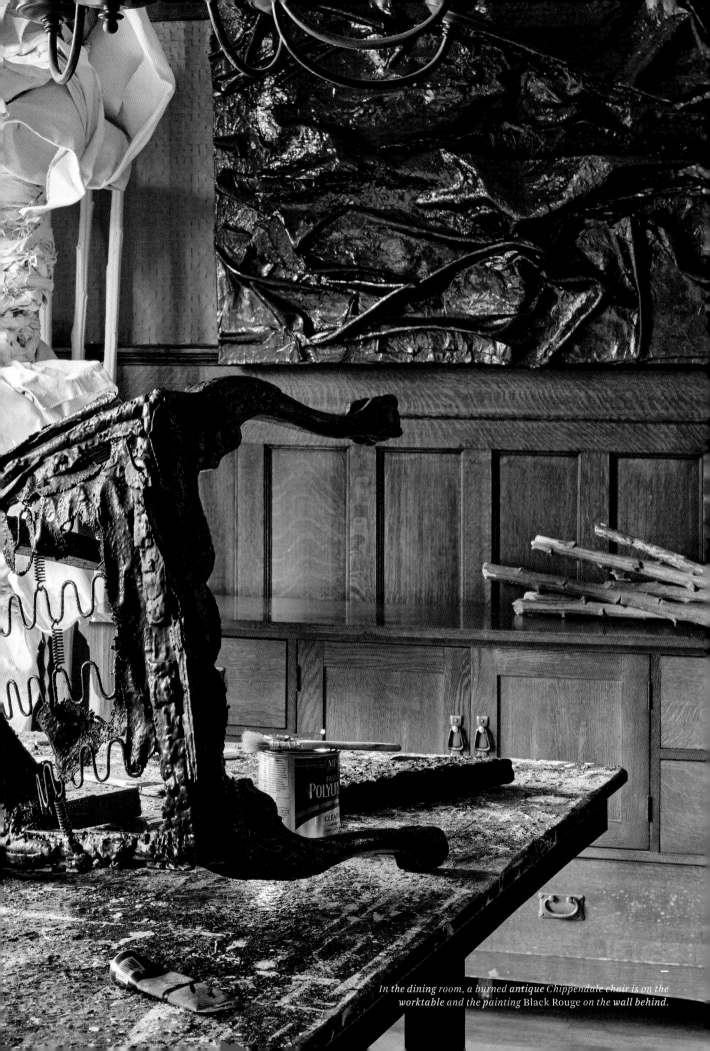

*In the dining room, a burned **antique Chippendale chair** is on the worktable and the painting Black Rouge on the wall behind.*

POLYU...
FAST
CLEAR

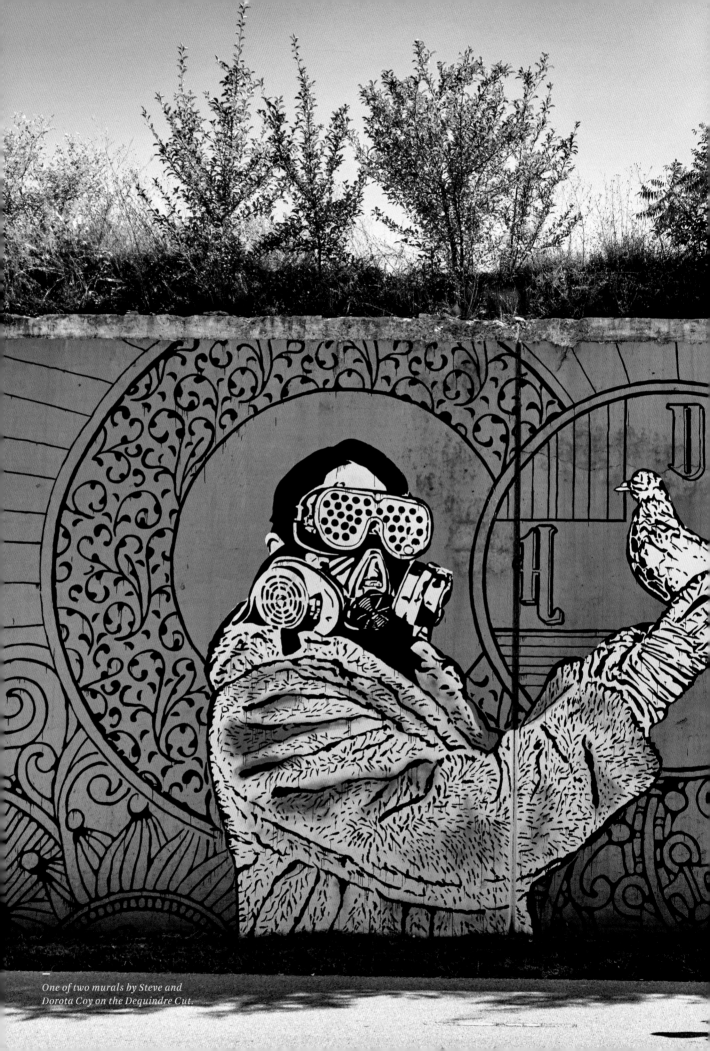

*One of two murals by Steve and
Dorota Coy on the Dequindre Cut.*

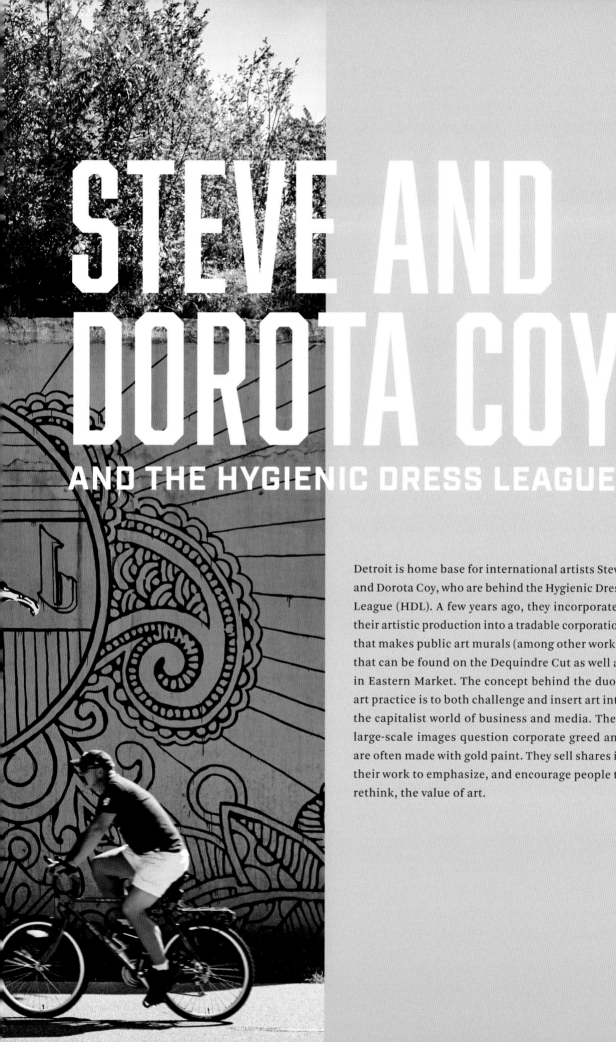

STEVE AND DOROTA COY

AND THE HYGIENIC DRESS LEAGUE

Detroit is home base for international artists Steve and Dorota Coy, who are behind the Hygienic Dress League (HDL). A few years ago, they incorporated their artistic production into a tradable corporation that makes public art murals (among other works) that can be found on the Dequindre Cut as well as in Eastern Market. The concept behind the duo's art practice is to both challenge and insert art into the capitalist world of business and media. Their large-scale images question corporate greed and are often made with gold paint. They sell shares in their work to emphasize, and encourage people to rethink, the value of art.

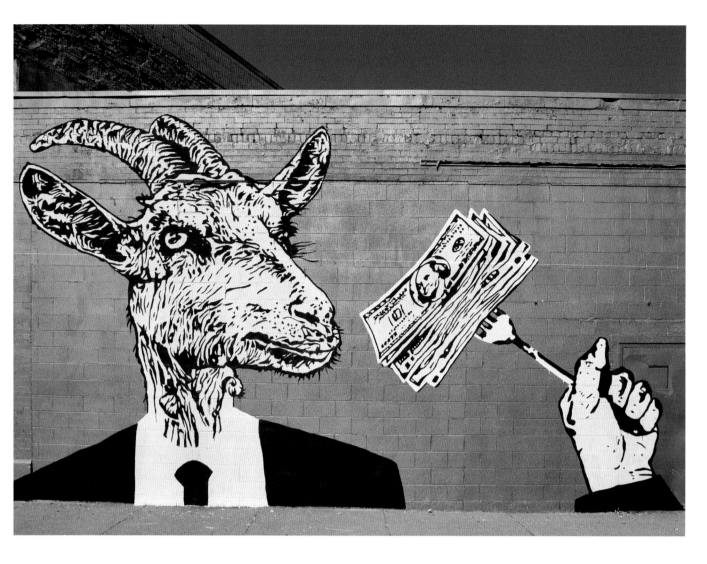

Interview with
STEVE AND DOROTA COY

MICHEL ARNAUD: *Tell us about the first time you came to Detroit.*

DOROTA COY: I had never been to Detroit when we moved here. Steve kept on telling me, you know, "It's pretty bad." I said, "How bad? I mean, it's a major city in United States, right?" I was thinking, people are living there, and I can have a cute little brownstone I've always wanted; I'm sure they're there. We drove around and I cried, "Oh my gosh, I can't believe we moved here. Now what? We have to stay."

STEVE COY: She said this looks like a war has been happening here, like a real war. There were piles of rubble and things were blown out. For me, the shock wasn't there. I grew up in the area so I watched it slowly decline.

DC: I had never been to a city like Detroit. I should preface this: I grew up in Poland. I was there until I was eleven. My parents moved to Upstate New York. That was my first time coming to Detroit, and of course, after being here, I cannot *not* have Detroit in my life. It's like a city that . . .

SC: You fall in love with.

DC: You fall in love with it because it has good but a lot of . . . bad as well.

MA: *What are some of the benefits of living as an artist in Detroit?*

SC: This is a place that people are watching, too. We knew that coming to Detroit as artists doing strange projects, people were going to take notice.

DC: We started working outside and that's our concept—we're not street artists as you might think; we're artists that do stuff outside.

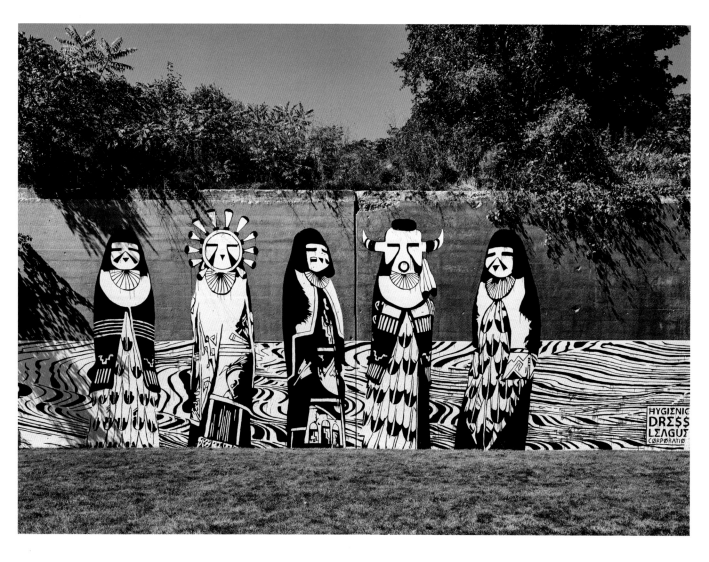

MA: *Can you describe your work in more detail?*

SC: It is art in the public arena. We use the concept of street art but not necessarily the genre. We consider it more of an ongoing conceptual project. We have created a company that's selling stock. Our project takes on the legal form of a corporation.

—

"YOU FALL IN LOVE WITH IT BECAUSE IT HAS GOOD BUT A LOT OF . . . BAD AS WELL."

ADNAN CHARARA AND GALERIE CAMILLE

In 2010, artist Adnan Charara was looking for a new studio when he found an old building on Cass Avenue. The renovation took more time and money than he anticipated. He plunked down all of his savings and sold items from his collections to cover the remodeling. The result is a beautiful, light-saturated art studio with different rooms for painting, sculpture, and jewelry-making, and the nonprofit Galerie Camille at the front. He also leases the storefront spaces to a tapas bar and a used-clothing shop dedicated to helping homeless women find clothing for job interviews. Moving first from Sierra Leone to the East Coast, then to Detroit, Charara makes art that reflects his joie de vivre, his concern for open dialogue, and his own position as an immigrant.

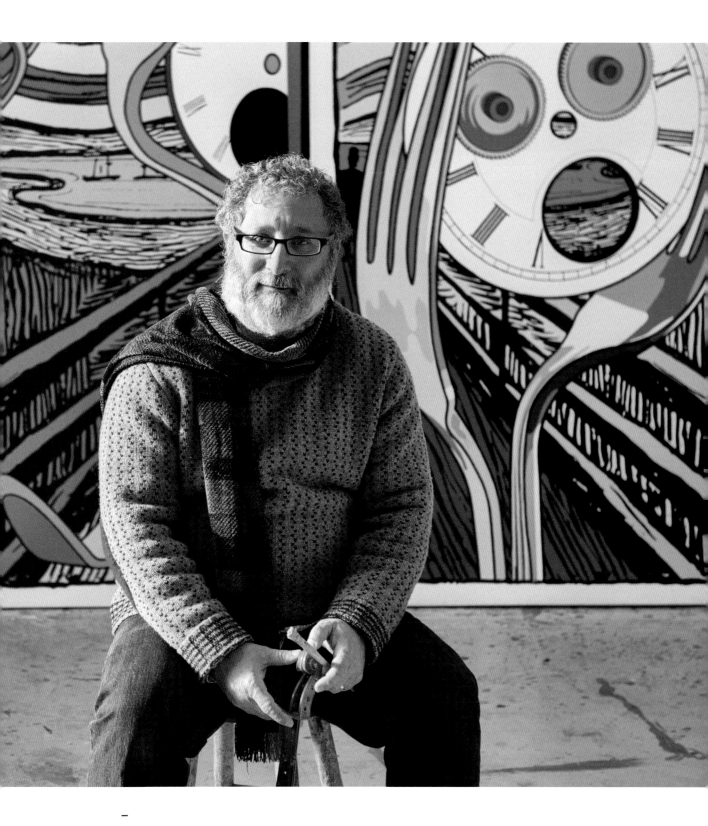

Portrait of the artist in his Midtown studio.

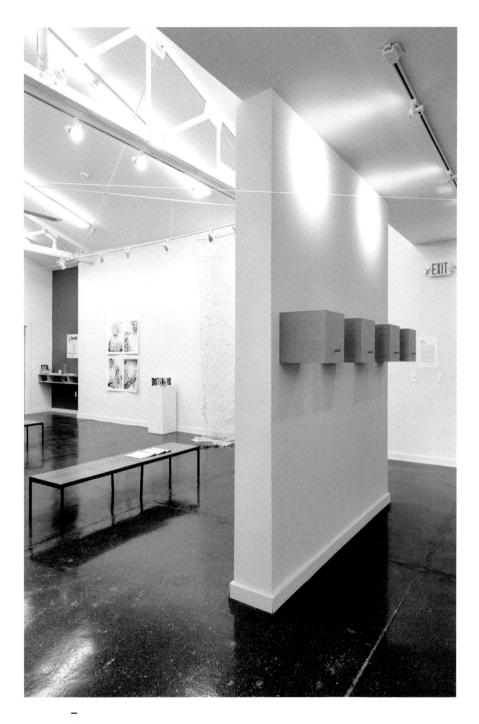

Charara lends the space at Galerie Camille to the local community, schools, and colleges.

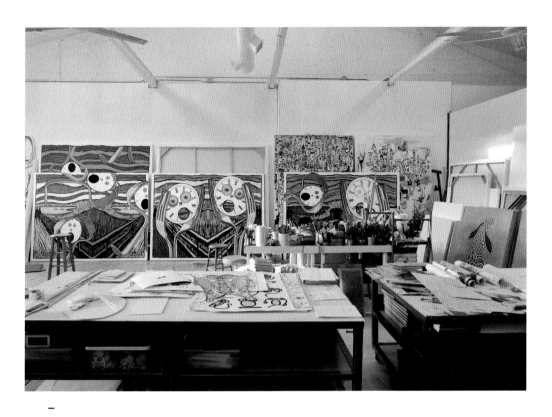

—

The main studio, with large paintings from the After Munch series in the background.

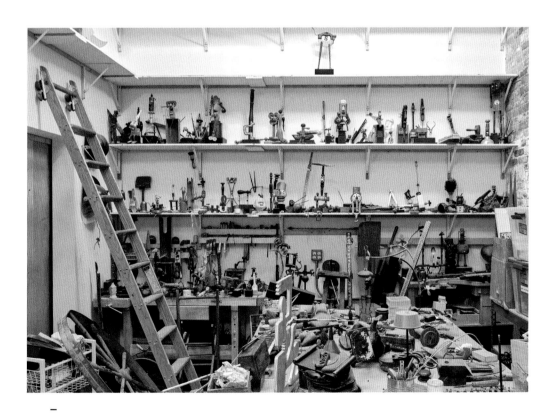

—

In his smaller studio and workroom, Charara stores and collects materials to use in his Found Object Sculpture series.

KOBIE
SOLOMON

Driving along I-75, you can catch a glimpse of a giant Chimera—a winged, lionlike mythological creature—that graces the wall of a building at the Russell Industrial Center. The scale of the mural, titled *Portrait of the City*, is awe-inspiring. Artist Kobie Solomon's painting combines elements of Detroit contemporary iconography with mechanical details, and features that could refer to the city's industrial past.

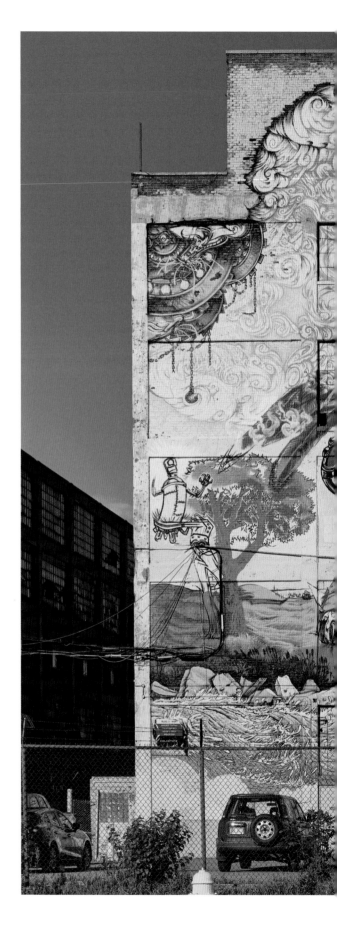

—

Although the mural is loaded with symbolism, Solomon's painterly touch—no small achievement on this scale— created the impression that the winged lion creature floating over the city is its protector or guardian.

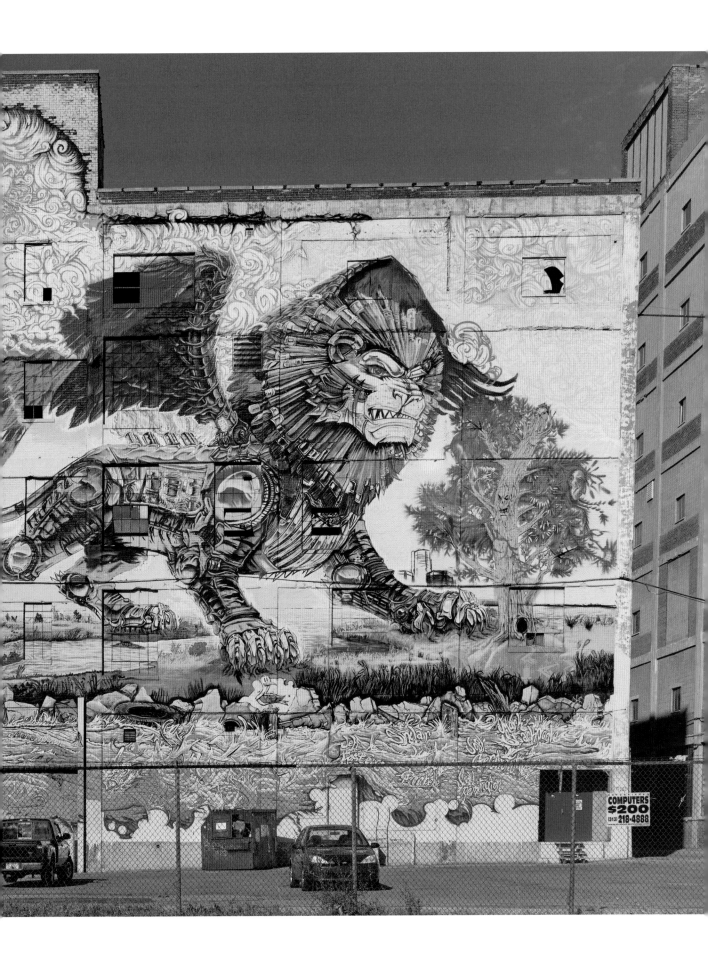

DABLS'S MBAD AFRICAN BEAD MUSEUM

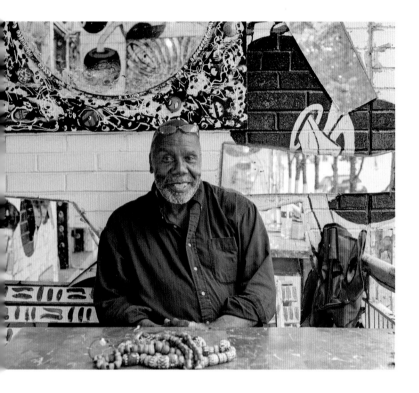

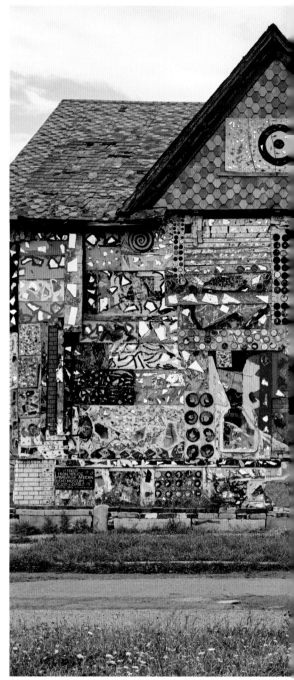

On a side street off Grand River Avenue is Olayami Dabls's MBAD African Bead Museum and gallery. A self-taught artist, Dabls has been collecting beads since the 1970s. His collection includes trade beads from Venice that date to the 1500s. The small shop displays the beads either hanging on the wall or in glass bottles on shelves that wrap around the cash register island. Outside, artworks line the alley that leads past a brightly colored stage to an open field and to one of the houses that Dabls has covered in paint, wood, and mirrors. The abandoned house has a new life as an art object. In 2015, Dabls expanded his work downtown in collaboration with Anya Sirota + Akoaki, a design firm based in Michigan. Commissioned by the Carr Center, the site-specific work, titled *Nice Outfit*, combines his paintings with architectural structural supports. The shard-like sculptures are gathered in Harmonie Park.

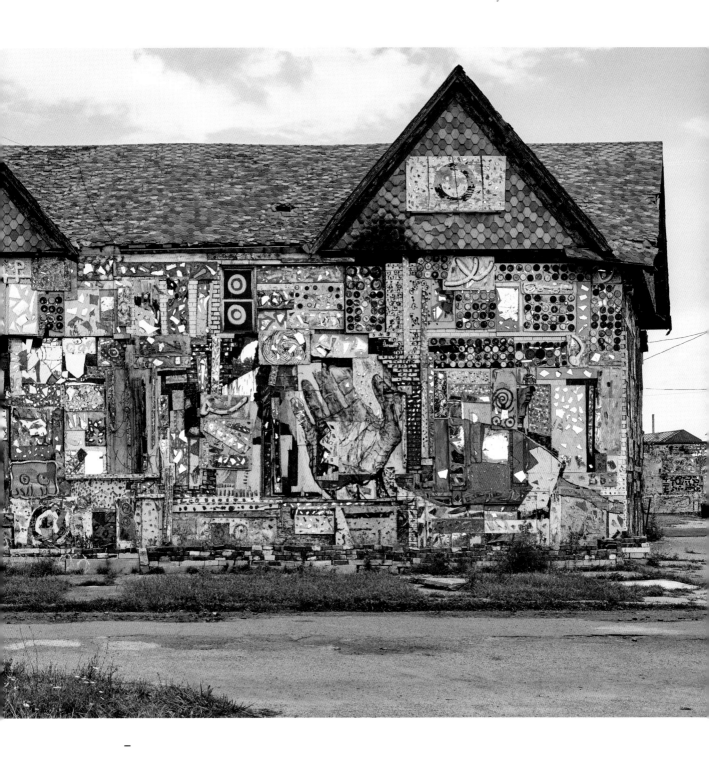

—

ABOVE
Abandoned buildings that have become part of the public installation.

OPPOSITE
Olayami Dabls at the entrance of his African Bead Museum.

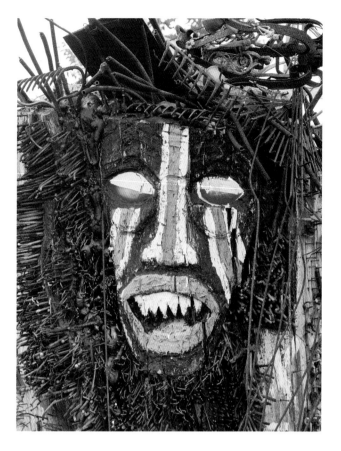

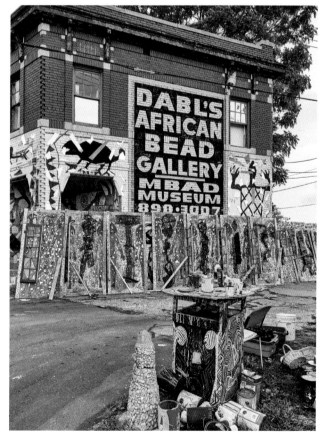

—

ABOVE, LEFT

A mask created by Dabls.

ABOVE, RIGHT

A collaborative, site-specific work commissioned by the Carr Center brought Anya Sirota + Akoaki and artist Olayami Dabls together.

LEFT

At the back of the gallery, a sign that can be seen from the highway advertises the museum.

OPPOSITE

A detail of one of the buildings that Dabls has transformed into an artwork.

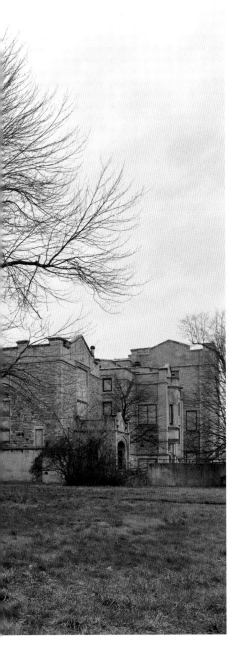

GALAPAGOS ART SPACE

In 2014, director Robert Elmes announced in the *New York Times* that he was moving his well-known and respected art space, Galapagos, from Brooklyn to Detroit. Noting that it was becoming more and more difficult for younger artists to "make it" in the increasingly expensive New York City area, Elmes said Detroit offered the space and affordability that foster creativity. The art world took note. Elmes purchased the campus of Highland Park High School as well as two former printing company warehouses behind Michigan Central Station in Corktown. Renovation and development plans include galleries, artist residences, a school, and restaurants. Galapagos's move was a leading indicator that the Detroit art scene was growing and expanding in many unexpected ways.

—

ABOVE

A side view of the main buildings of Highland Park High School, site of a new exhibition space for the art organization Galapagos.

LEFT

The back elevation showing the various school buildings of the soon-to-be art center.

FAR LEFT

An enormous skylight was part of a previous renovation in 1985. This space will be one of the first sections to be rebuilt in the new development.

MURALS IN
THE MARKET

In September 2015, Eastern Market Corporation, 1xRUN, and Inner State Gallery organized a murals festival in Eastern Market. Artists from Detroit and around the world were invited to make large-scale installations on designated buildings in the neighborhood. The artists were given Genie boom lifts and supplied with paint. More than forty new works were created over the weeklong event that sought to increase visitor traffic to the area. Inner State Gallery showed smaller works by the artists and organized artist talks as well. Detroit is becoming well known for its embrace and support of public art, especially the wall art movement.

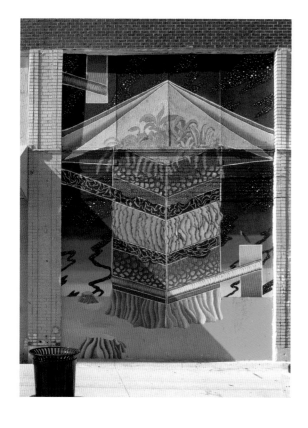

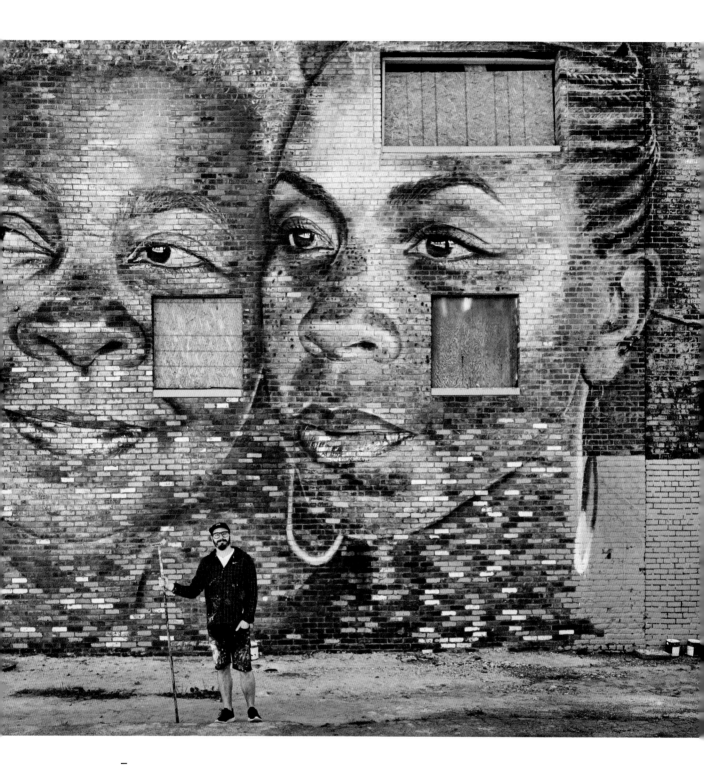

ABOVE

Rone, an artist from Melbourne, Australia, in front of his painting on Gratiot Avenue.

OPPOSITE

Jonny Alexander, an artist who now lives in Detroit, created the mural on Russell Street across from Eastern Market's Shed 2.

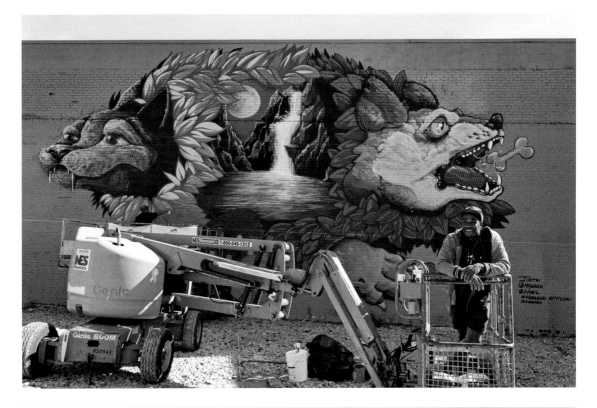

ABOVE

Artist Yis "NoseGo" Goodwin on the Genie lift in front of his wall painting.

BELOW

Kobie Solomon's mural was on the back of the Busy Bee Hardware store on Gratiot Avenue.

Californian artist Jeff Soto and Detroiter Maxx242
created a mural off Gratiot Avenue.

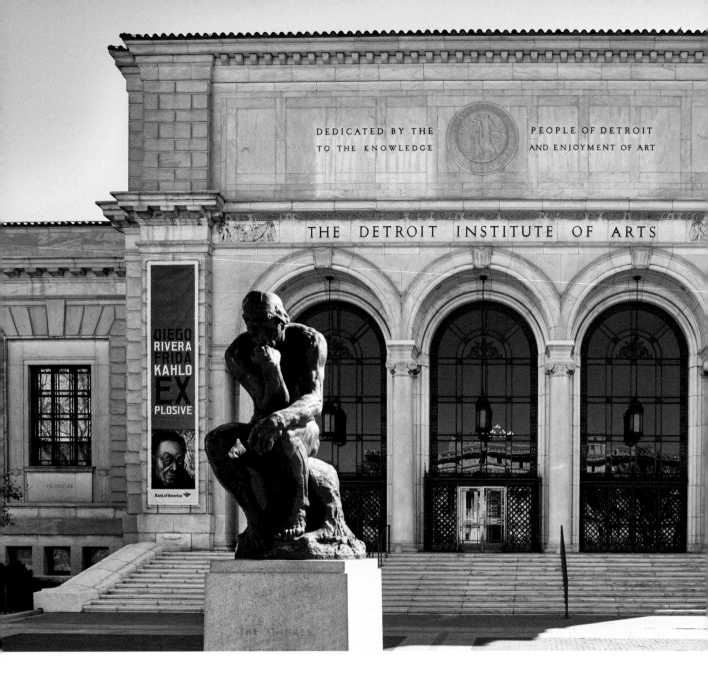

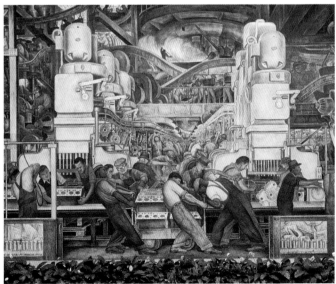

ABOVE

The main entrance of the Detroit Institute of Arts on Woodward Avenue. A cast of Rodin's The Thinker *was donated to the museum in 1922 and sits out front.*

LEFT

A section of Diego Rivera's Detroit Industry frescoes.

OPPOSITE

Alexander Calder's monumental sculpture Young Woman and Her Suitors *is on display at the museum's back entrance.*

THE DETROIT INSTITUTE OF ARTS

This venerable institution was established in 1885. The neoclassical building was designed by Paul Cret and serves as the anchor for the Midtown art district. The DIA has a national reputation for the depth of its holdings and the variety of its departments, including the General Motors Center for African American Art, American Art, and the Arts of Asia and the Islamic World. The museum is home to Diego Rivera's iconic Detroit Industry murals, which the DIA acquired in 1932 and which took Rivera nearly a year on-site to create and install.

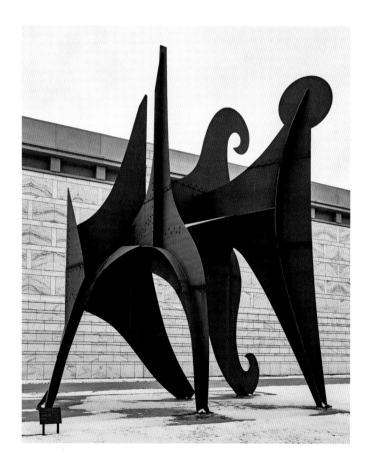

THE N'NAMDI CENTER
FOR CONTEMPORARY ART

George N'Namdi bought his first artwork when he was twenty-five years old. That purchase started a passion that became a thriving, successful business. He set up his initial gallery in Detroit, then moved it to Birmingham, and after a time there he looked back to Midtown Detroit. Primarily focused on African American artists' works, the gallery is housed in a former garage. Within the space, there are three galleries of varying sizes to accommodate shows from different artists at the same time. The nonprofit gallery has an active community-based program. N'Namdi is known as a scout for talent and has a nose for opportunity for young artists and gallery dealers alike.

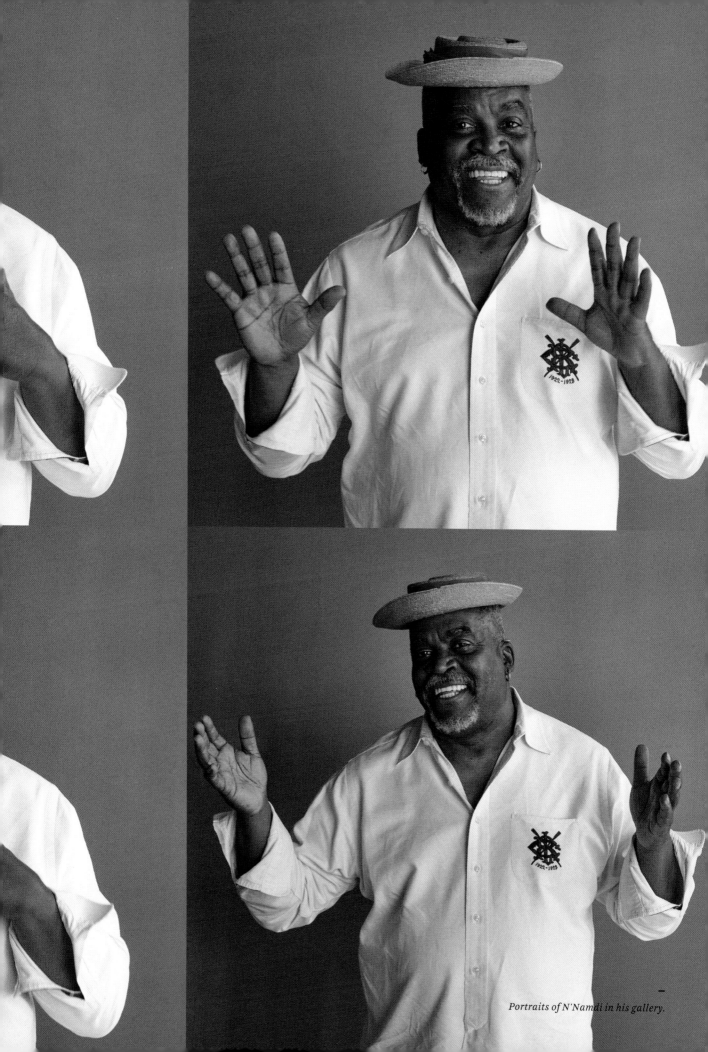

Portraits of N'Namdi in his gallery.

Interview with
GEORGE N'NAMDI

FOUNDER AND OWNER
THE N'NAMDI CENTER FOR CONTEMPORARY ART

MICHEL ARNAUD: *Where did you open your first gallery?*

GEORGE N'NAMDI: I opened my first gallery space in Detroit. I was one of the first African American–owned galleries in the city and even in the nation. I was a bit of a lone ranger; my space was more so a destination for artists and collectors rather than a gallery existing in a larger ecosystem of a group of galleries. I realized I wanted to be at the center of a gallery neighborhood rather than a destination, so in 1988, I moved to Birmingham; at the time it was the art center of the Detroit area. There were about forty galleries there.

In 2001, I decided to come back to Detroit, as I wanted my gallery to have more energy, more funk, and be less like a store. I had the desire not just to show art but to make a contribution to the city. I was not coming back to do better business; I wanted to give a stimulus to the arts in Detroit. MOCAD opened up shortly after. I became a pioneer, in a way, and led this movement of art activation in Midtown Detroit. There were not many small gallery spaces in this area at the time.

MA: *Why choose Midtown to locate the gallery?*

GN: This was a very difficult area to be in fifteen years ago, but I felt it had the vibe. I believe that once I put things in motion, the universe will take care of the details. The building had a sign on it that read "11' x 14' available" with a phone number, so I called. The owner answered and said, "Where did you get this number? The sign has been up there for ten years. No one ever called." He held the space for me for a whole year until I was able to procure the full payment, because he believed in my vision so much. That's how we got here and how we became part of the city's whole rebirth.

MA: *How do you feel about what's happening now?*

GN: I feel that the developers should think in a more purposeful way. If everything begins to look like Birmingham or Royal Oak, you are going to lose that energy and then wonder what happened to this rebirth ten years from now. I'll always emphasize that it is very important that we don't lose our funk—that's what attracts people to Detroit. The cheap real estate is an attraction, sure, but you can find cheap real estate all over the country.

Detroit has been a city where you can come and get local products, even just basic things like locally grown organic food, coffee from independent small businesses, and clothes from clothing stores. The recent developments sort of compromise that in a way. And I think people are drawn to the city because we have historically cultivated and nurtured these homegrown and independent economic efforts. When you come to Detroit, you start feeling this beat, this authenticity. That is one thing that is so important for our whole development now. Detroit has that chance now, but we can't forget that the African-American community has been a very crucial role-player in the city of Detroit and its economy.

MA: *Are you saying in a way that there is resentment from the African American community?*

GN: I don't think it's resentment. There is more of a concern about the lack of inclusion. It is more the feeling of not getting noticed. We did a series of panel discussions under a term I coined called Psychological Gentrification. We invited key past and present influencers to the development of Detroit to speak on how recent changes are affecting the city, and how we can be more inclusive of all residents. Detroit's gentrification should not be the replacement of people, should not be moving people out of their homes. We have so much space. We could have a million people and it would not be a problem. Inclusion has to happen, and the only way it could really happen is to be sure that people begin to think about how space is designed. Is that space welcoming to everyone? How do you program a space? Is that programming welcoming to everyone? As people move out of their psychological comfort zone, the space and the psychology overlap and lead to gentrification.

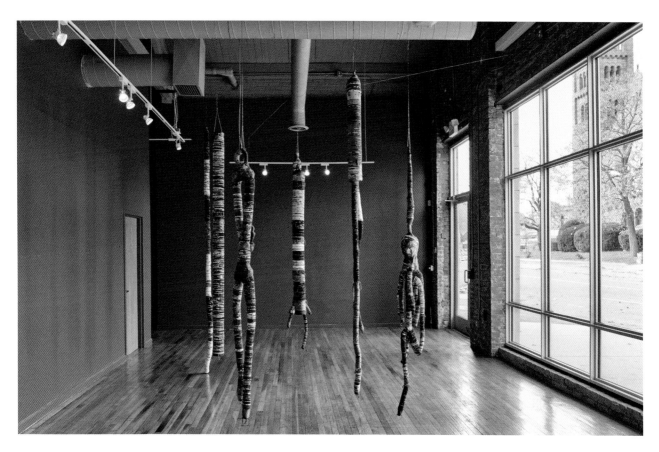

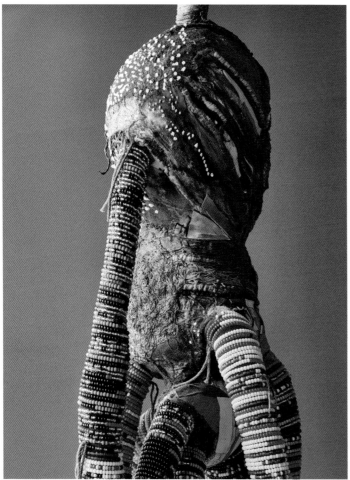

—

ABOVE

The exhibition The Cosmology of Resistance and Transformation, *with work by Leonardo Benzant, was on view in the front gallery space in September 2015.*

LEFT

A detail of one of Benzant's sculptures, made with thousands of beads.

"I HAD THE DESIRE NOT JUST TO SHOW ART BUT TO MAKE A CONTRIBUTION TO THE CITY."

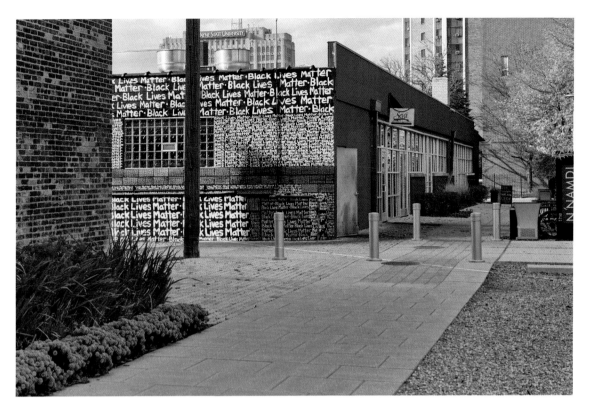

—

Artist Renda Writer made the Black Lives Matter mural on the back of the N'Namdi Center.

LEFT

The entrance of the gallery has paneled glass windows.

OPPOSITE

A view of the exhibition Simbi Dzebasa: Four Contemporary Artists from Zimbabwe, *curated by Chido Johnson and featuring art by Tapfuma Gutsa, Masimba Hwati, Nancy Mteki, and Gareth Nyandoro.*

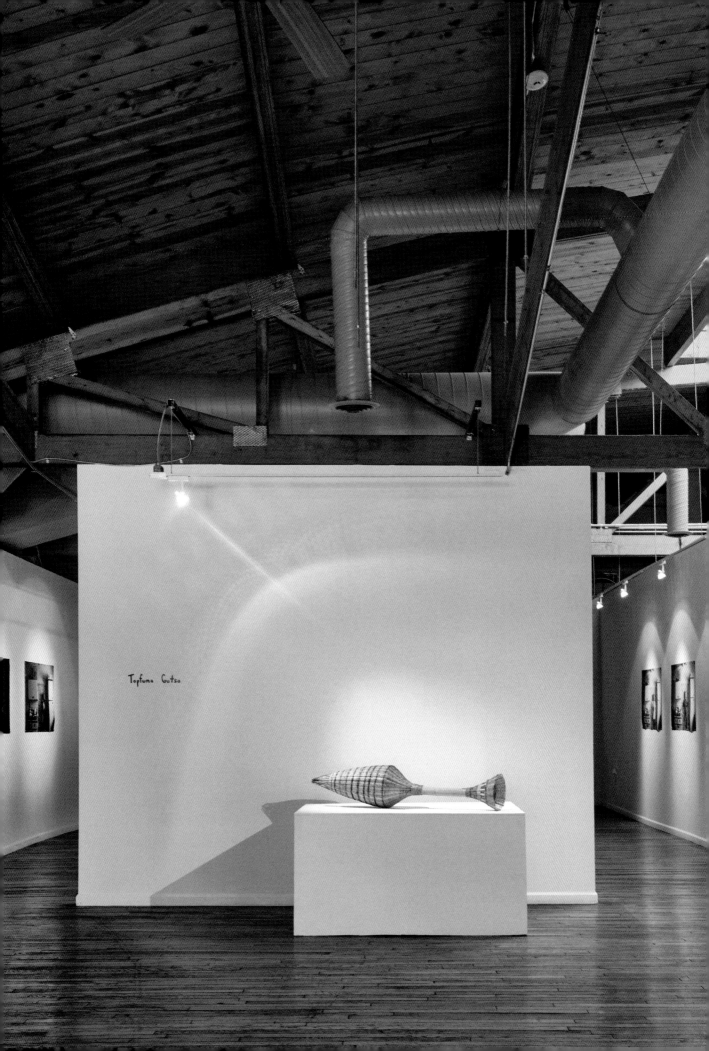

Tapfuma Gutsa

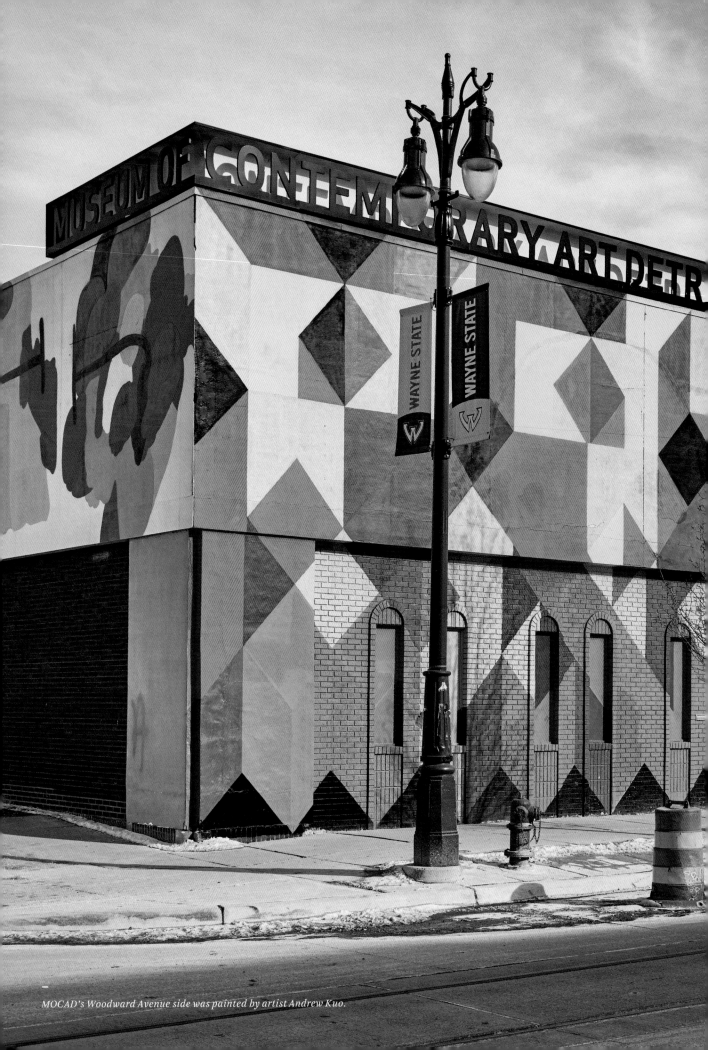

MUSEUM OF CONTEMPORARY ART DETR

WAYNE STATE

WAYNE STATE

MOCAD's Woodward Avenue side was painted by artist Andrew Kuo.

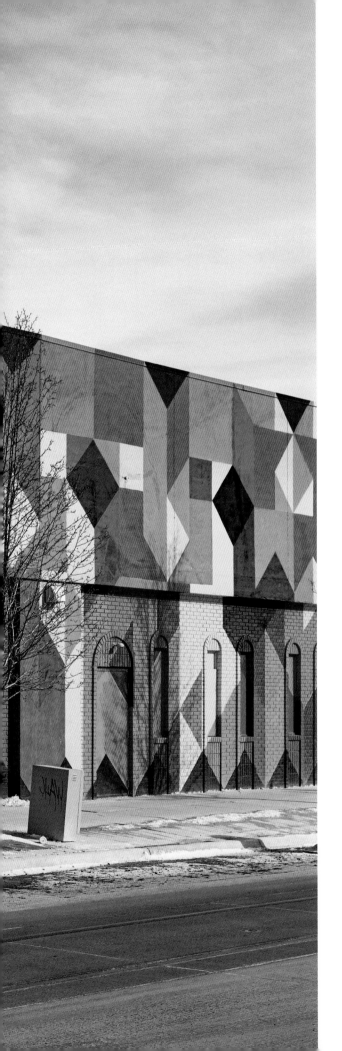

THE MUSEUM OF CONTEMPORARY ART DETROIT

MOCAD was founded in 2006 by Marsha Miro and a group of Michiganders, including Lynn Crawford, who were passionate about contemporary art. The museum is located on Woodward Avenue near the Detroit Institute of Arts. Zago Architecture renovated the over twenty-thousand-square-foot former car dealership. The bare-bones, open-space refit allows for maximum creativity in forming galleries around all types of interdisciplinary exhibitions. Eighty percent of the museum is devoted to galleries. A glass garage door brings natural light to the café in the front of the building, which serves as a gathering place for the community and hosts the annual gala benefit, as well as spoken word, music, and other performance events. The artist Mike Kelley, who grew up in Detroit, conceived a project around the recreation of his childhood home, titled *Mobile Homestead*. The modest, one-story house, painted blindingly white, hovers in a lot next door and acts as another gallery for rotating exhibitions.

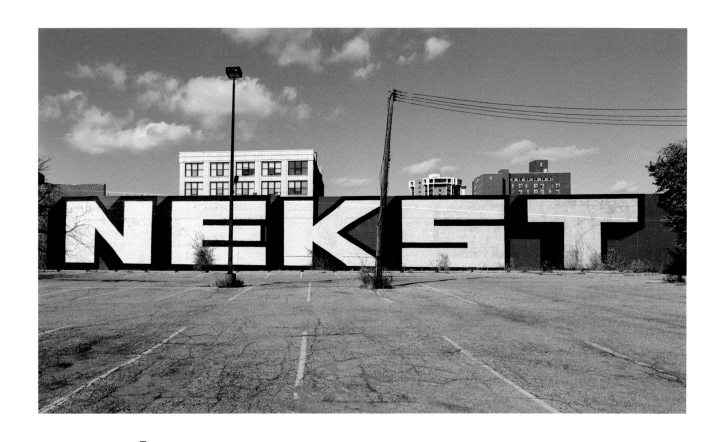

—

ABOVE

In 2013, a group of artists—including DONT, VIZIE, POSE, OMENS, REVOK, and SKREW—gathered at MOCAD to create a mural to honor the graffiti artist Sean Griffin, aka NEKST.

OPPOSITE, ABOVE

Mike Kelley's Mobile Homestead sits next door to the main building.

OPPOSITE, BELOW

The interior of Mobile Homestead acts as room for exhibitions.

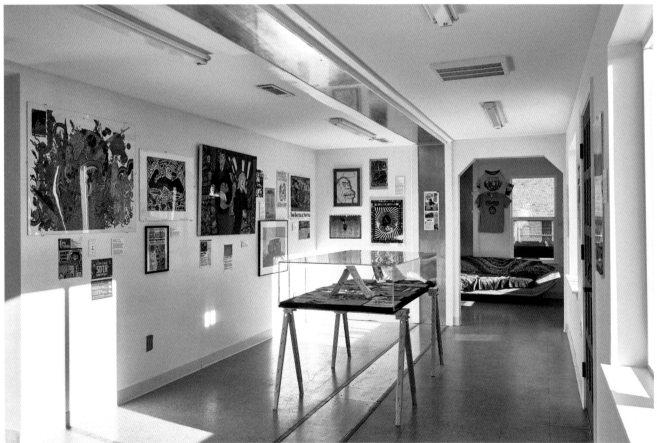

SIMONE DESOUSA GALLERY

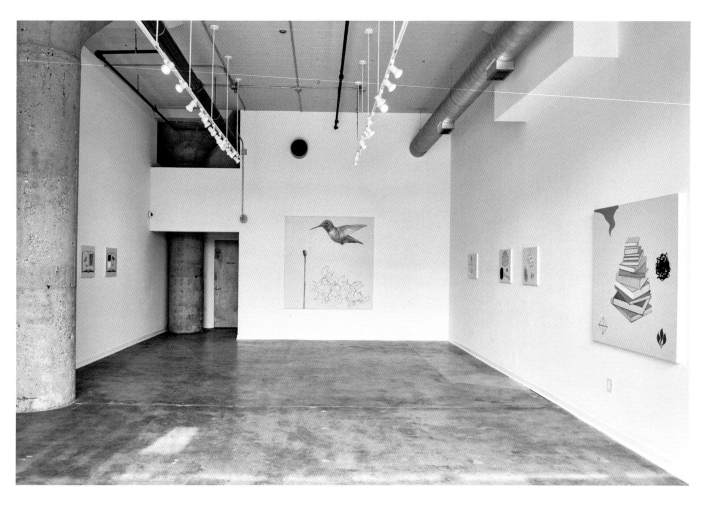

Simone DeSousa's gallery is located on the ground floor of the Willys Overland Lofts building in Midtown. She shows pieces by a combination of up-and-coming and established contemporary artists. DeSousa, who studied architecture and urbanism in Brazil, arrived in Ann Arbor in 1998 and ten years later, in October 2008, started her business when she bought the first of the two ground-floor spaces. In gallery 1, a space formerly used as a service center for a car company, DeSousa left the existing large cement columns exposed, and her design creates a white-box gallery experience. Gallery 2 was designed as a more intimate setting. DeSousa is an artist in her own right and still has studio space for her own practice in the Russell Industrial Center.

In gallery 1, all the works are by Timothy van Laar.

DAVID
KLEIN
GALLERY

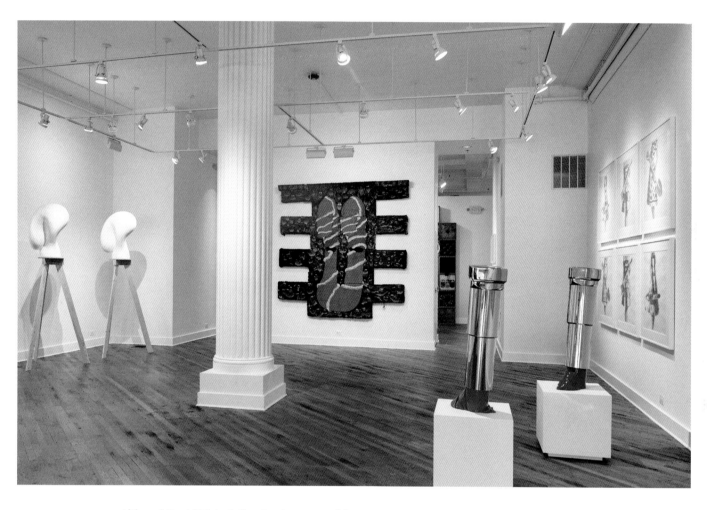

Although David Klein Gallery has been part of the Greater Detroit art scene since the 1990s, opening a gallery downtown in 2015 was a fresh idea. In this location, the pristine gallery is accessible to tourists and gallery goers, who may also visit Library Street Collective as well as the established Carr Center a few blocks away. The new design retained a few interior architectural details, such as the crown molding, Doric columns, polished marble floor, and limestone façade. The artwork being shown is contemporary and includes pieces by emerging artists, many of whom have recently graduated from nearby art colleges such as Cranbrook Academy of Art and the College for Creative Studies.

–

The inaugural exhibition, First Show, *featured works by thirty-one gallery artists. On view were white, standing sculptures by Ebitenyefa Baralaye, a painting by Kari Cholnoky, and lipstick sculptures and prints by Kelly Reemtsen.*

WASSERMAN PROJECTS

Art collector and native Detroiter Gary Wasserman believed in the Detroit art scene but opened a gallery almost by accident. When a former fire department garage in Eastern Market became available, he saw an opportunity. The five-thousand-square-foot space has a *Kunsthalle*-like program that includes long-term exhibitions as well as performances and music. The gallery encourages connections between artists; the opening exhibition in 2015 featured an interdisciplinary installation by architect Nick Gelpi and artist Markus Linnenbrink. The two-part wooden box created by the pair acts as a space within a space and provides a stage. Wasserman Projects is not your typical white-wall gallery. The interior walls have been taken back to their original brick. The pipes that line the ceiling have been painted red—Wasserman's favorite color and a nod to the space's former use.

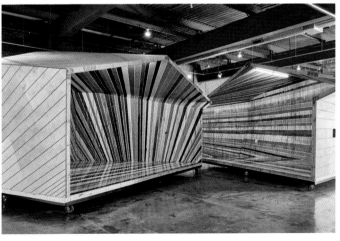

–

ABOVE

*Main entrance to the gallery, with a red steel sculpture by
Canadian Harley Valentine.*

OPPOSITE

*The opening exhibition featured a collaboration between
architect Nick Gelpi and painter Markus Linnenbrink.*

Artist and metalsmith Taru Lahti's buildings in North Corktown.

TARU LAHTI

In 2003, Taru Lahti was renting studio space in three nineteenth-century brick structures that were sitting on two lots in North Corktown when the owner moved away. Over the years, the buildings were used as a store, a bowling alley, and then an aluminum factory. Because the taxes had not been paid, the properties were put up for public auction. Lahti ended up being one of the few bidders that day. Since then he and his brother have been renovating the spaces little by little—and there's a lot to do, including installing plumbing, new windows, insulation, and a roof garden. A sauna and a dunk tank are also in the works (the Lahtis are Finnish). They have plans for two living quarters, a workspace big enough to accommodate large metalworking equipment, and a studio space for Taru's painting practice. Everything is coming together.

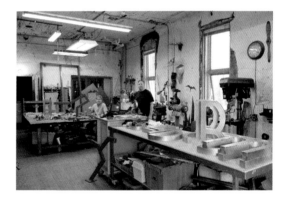

ABOVE
A painting, entitled Boneyard, is made with oil on steel.

BELOW
The Lahti brothers in the metalworking shop.

OPPOSITE
An oil-on-steel painting titled Bedouin.

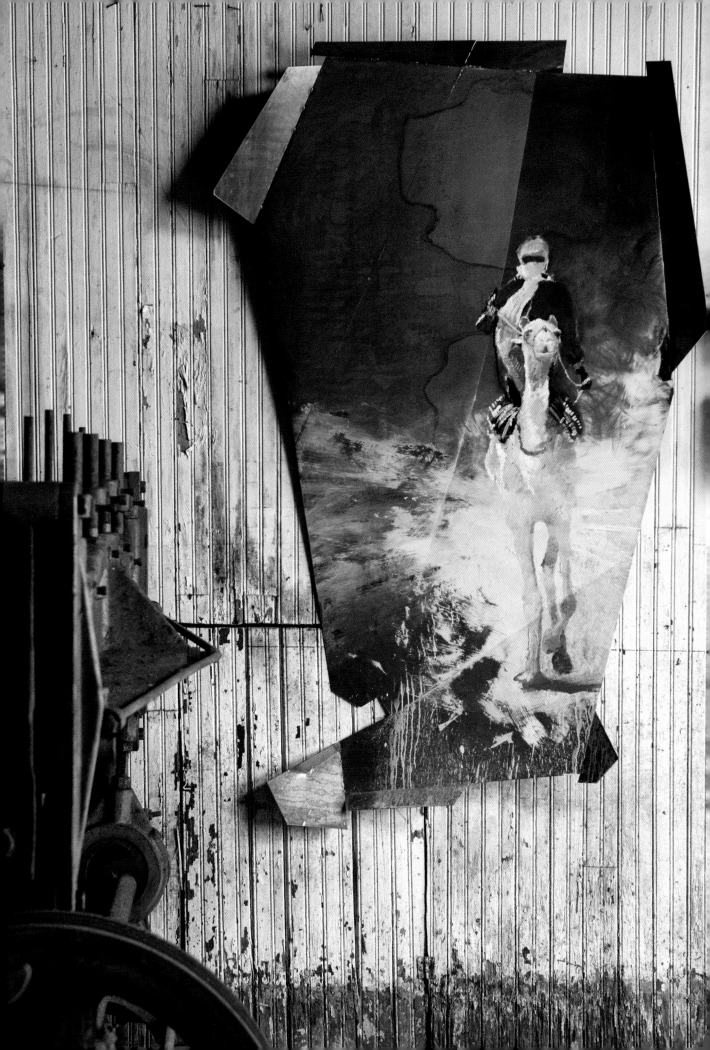

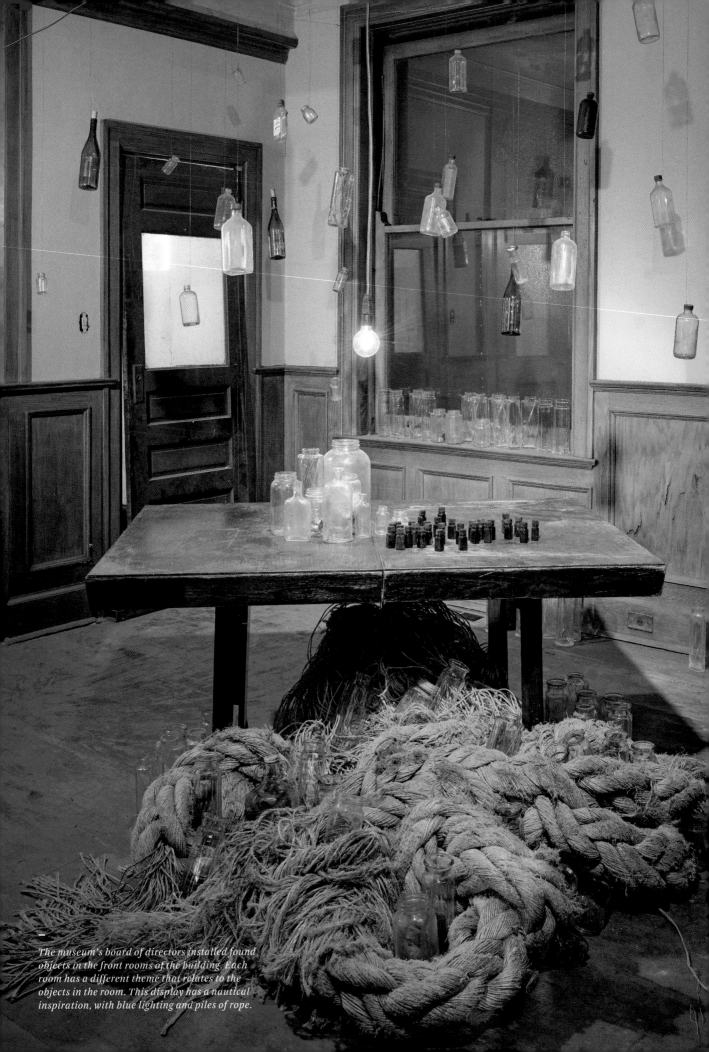

The museum's board of directors installed found objects in the front rooms of the building. Each room has a different theme that relates to the objects in the room. This display has a nautical inspiration, with blue lighting and piles of rope.

THE SEAFOAM PALACE

OF ARTS AND AMUSEMENTS

There is a giant question mark on the front door of an arresting building on Kercheval Avenue. All the windows are boarded up, adding to its mystery. Inside are temporary installations of random displays made from found objects, some discovered on-site. This is an institution, the Seafoam Palace of Arts and Amusements, at the beginning of a journey. The brick-and-limestone building, designed by the architects Baxter, O'Dell & Halprin and constructed in 1925, has been taken over by a group of artists led by Julia Solis, a writer and photographer. Solis plans to restore the building and create a museum devoted to the investigation of curiosity, with a permanent collection as well as rotating exhibitions and other programming, such as film screenings.

—

Interview with

JULIA SOLIS

MICHEL ARNAUD: *What is the Seafoam Palace?*

JULIA SOLIS: We are actually aiming to do a real museum with events, rotating exhibitions, and artist residencies with the mission to explore the idea of curiosity and wonder. We want to use curiosity as a springboard to explore our relationship to things that are unknown, the outlandish and the otherworldly. We want to create a mythology about the building as well.

We want to be like a secret sect that puts its message into the architecture. When you have the clues, you can look around and find hidden messages. We want to design the whole building so it reflects the search for greater meaning, truth, and playfulness. Playfulness is important.

MA: *This is such an interesting building. Do you know its history?*

JS: This was an old lumber company's headquarters. It was constructed with this beautiful, old wood. They were the second-largest lumber company in Detroit. They had a rail line right next door. It's being restored as a bike path [the Beltline, linking to the Dequindre Cut]. Across the street where the parking lot is, that used to be the stop for the trains, where they could load all the wood and transport it down to the Detroit River. But it's kind of mysterious, what happened to the building in the fifties and sixties. We haven't been able to find anything on it, even by going to the library. It's very curious.

To me, the building looked like this great shipwreck that had crashed on the shores of Kercheval. It has a nautical feel—it was creaking and leaking; there was water coming in. I got some friends together; we all decided to go in on it. Everyone contributed some money.

When we bought the building, I had no idea how much actual work it would take to fix it up. Now we have to come up with a whole bunch of money to get it ready. We're pretty optimistic, even though we have so much competition in Detroit for funding.

Before we bought this building, we always wanted to do some kind of arts-related place in Detroit because it seemed so possible. At first, we were thinking of buying an old, vacant house and doing a huge art installation and then leaving it. But this is better.

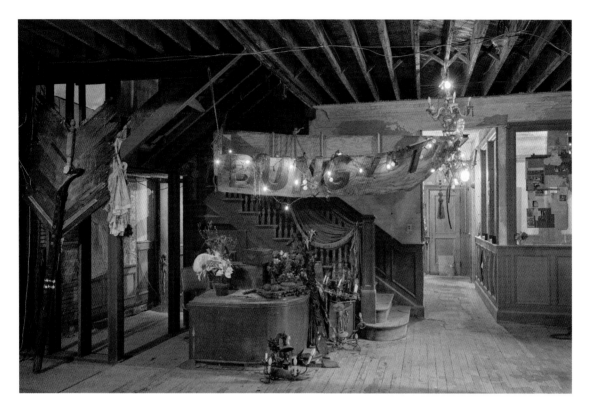

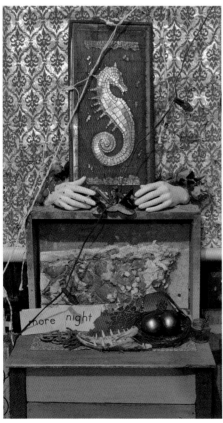

—

ABOVE

At the front staircase, there is a display of frames, carved wood flowers, and makeshift lighting.

LEFT

A detail of one of the installations.

OPPOSITE

A question mark adorns the main entrance of the soon-to-be museum.

CITY
SCULPTURE
PARK

On the corner of Alexandrine, near the service road of the Lodge Freeway, there is a sculpture park. All the works featured belong to one artist, Robert Sestok. It's rare to see a permanent exhibition of twenty-nine sculptures by a single artist for an extended period of time. Sestok took over the care of the empty lots from a friend, then used funds raised from a city grant to buy the property and create the park in 2015. Each vertical work is made of rusted steel—mostly recycled pieces that are welded together. The choice of material seems both practical, as it handles all types of weather, and symbolic, as it refers to the millions of cars that pass by on the nearby highway. The exhibit can be viewed passing by in a car or on foot.

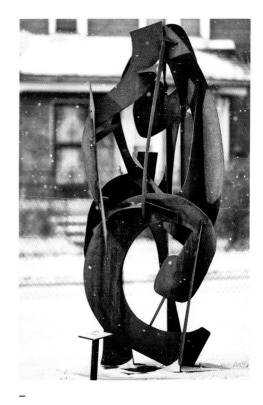

—

In the foreground, an artwork entitled Sister Mary *is shown in the context of the neighborhood.*

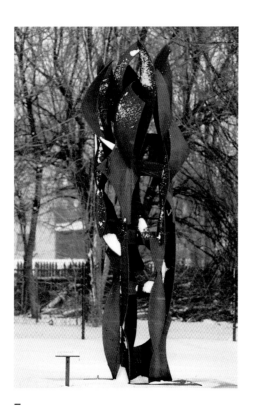

—

A piece titled I275.

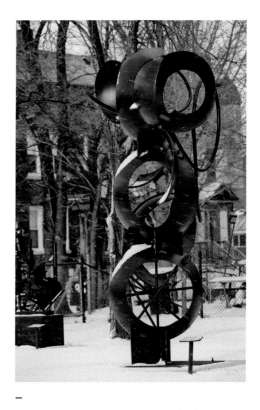

—

Triosphere *is made from a five-hundred-gallon propane tank.*

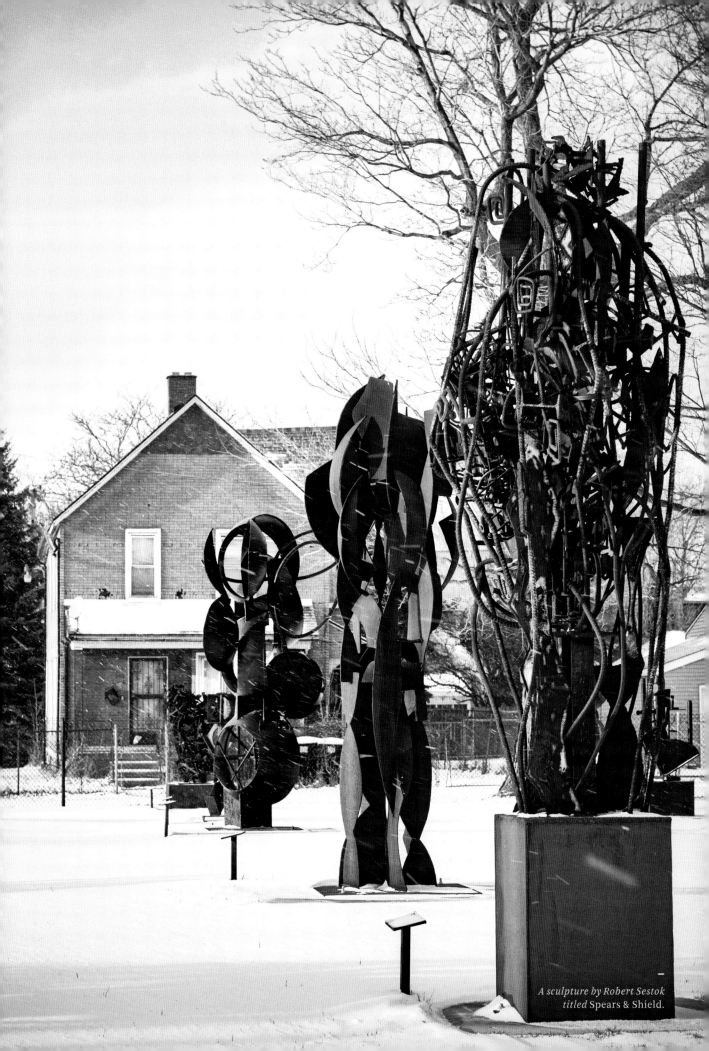

A sculpture by Robert Sestok
titled Spears & Shield.

YOUNG WORLD
INTERNATIONAL

Artists Ben Hall and Andrew Mehall were collaborating on installations when a large one-story garage across the street from Ben's east side studio became empty. They decided to investigate. The building included an oversize room with skylights and white cinder-block walls—it was a perfect exhibition space for their first gallery. They saw the opportunity to give local artists the chance to exhibit work on a large-museum-size scale, which they felt the Detroit art scene lacked. They knew this type of space would attract international artists to the city as well. Maintaining the unfinished features of the place and deciding to use only natural light kept renovation costs low and allowed the work to be seen in an experiential way. Another advantage is that lightless rooms are well suited to display video pieces. Their program included performances along with monthly exhibitions. Recently, Young World International left this first location in search of a new space.

—

A street view of the Young World International building.

In the main gallery, a sculpture by Claire Ashley.

AVERY WILLIAMS

Avery Williams, an attorney, and his wife have lived in Detroit for twenty years. Today they live in the North Rosedale Park neighborhood on Detroit's west side. Williams has been collecting paintings since 1988, and he is the main collector in the family. Williams is attracted to statement pieces and works that strike a personal chord. He mainly buys from galleries and dealers, such as George N'Namdi. The moment you walk into Williams's home, you are greeted by a large, vibrant painting from the Buffalo Soldier series by artist Bernard Williams, and yet there are quieter, smaller pieces, such as Vicente Pimentel's *L'Affluence*, in the collection as well.

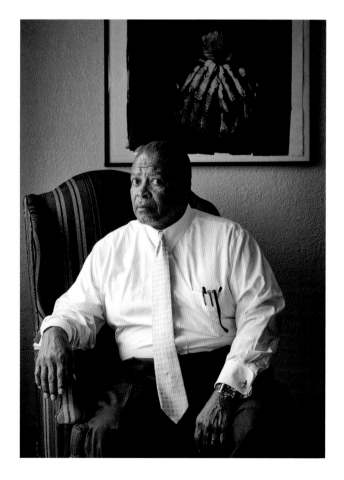

—
A portrait of art collector Avery Williams with a photograph in his collection, Hands *by Rashid Johnson.*

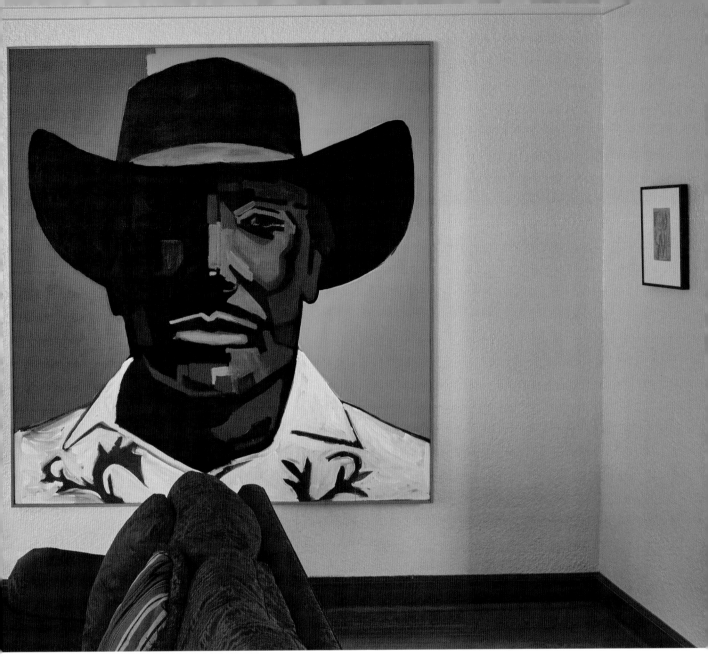

ABOVE

In the front sitting room, a bold painting from Bernard Williams's Buffalo Soldier series.

LEFT

An abstract painting by Vicente Pimentel, L'Affluence, has a muted palette.

FAR LEFT

A painting, Moon Indigo, *by Detroit artist Allie McGhee hangs above a work by Frank Bowling entitled* Plum Dusk at Dawn.

TYLONN SAWYER

The 4731 Grand River Avenue building houses over thirty-one art studios and a gallery on the first floor. Artist Tylonn Sawyer has a modest studio there with one window at the end of the room, two chairs, a rolling painting table with brushes and paint, some sketches on the floor, and some very powerful paintings leaning against the walls. Sawyer, who was born and raised in Highland Park, completed his degree in drawing and painting at Eastern Michigan University and his masters at the New York Academy of Art. Today, when he is not working in his studio, he teaches art at Center for Creative Studies. Nearly everything in his life revolves around art in some way.

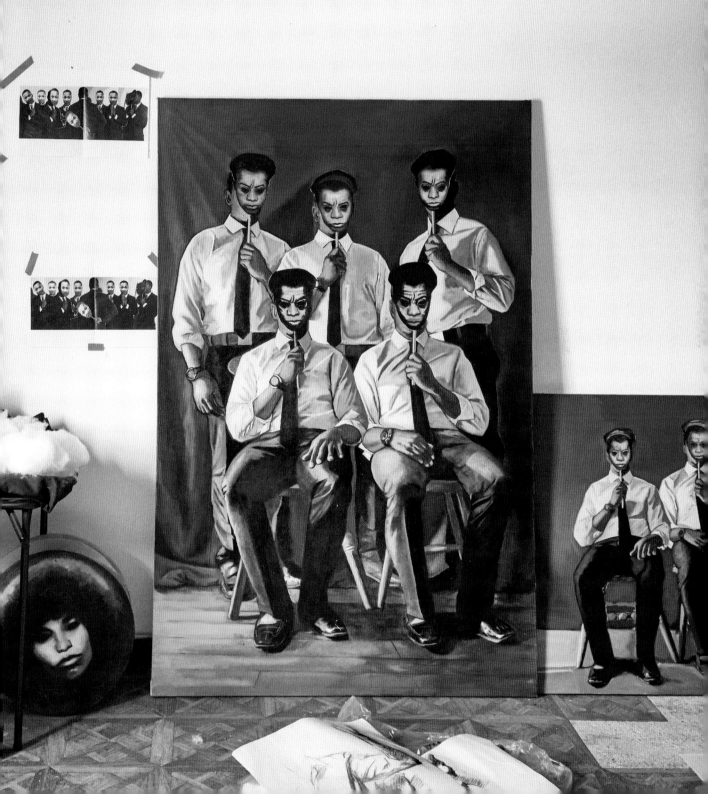

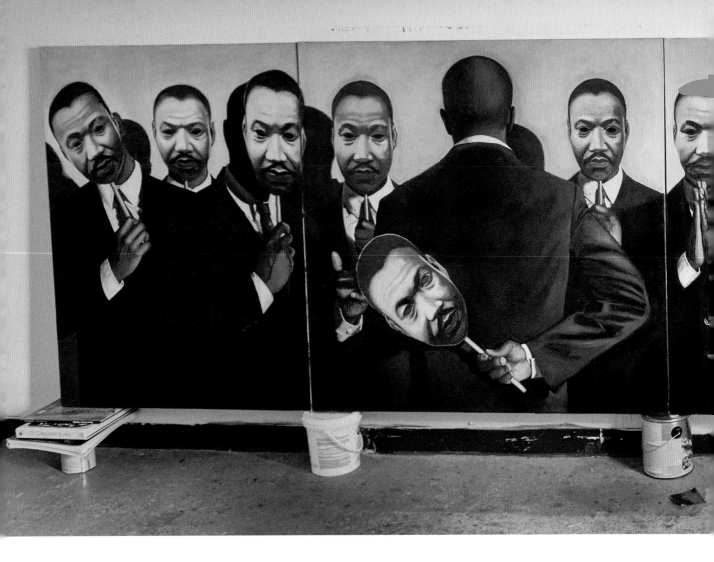

Interview with
TYLONN SAWYER

MICHEL ARNAUD: *How do you feel about what's happening in Detroit now?*

TYLONN SAWYER: Overall it's a positive thing. Nice businesses and large-scale businesses invested in the city. It's much better than having squalor or buildings staying abandoned for years; in that respect it's very positive. At the same time, I can see the effects of gentrification. Witnessing it firsthand, it's a cause for concern because people are getting pushed out, or priced out.

The negative effects of this type of development happen to people of color for a multitude of reasons that I don't want to go into. It's my hope that we can still maintain our identity in terms of business, commerce, and the social scene. When a city becomes commercialized and consumer-driven, it can become stale and kill the character of the place.

Being an artist, I'm an entrepreneur. Most of my views are within the art scene. In that respect, when you talk about the possibility of putting people on a global scale, I see gentrification happening at a very stark and disturbing rate. We use the term "black erasure," where blacks aren't even acknowledged or the type of work that we do is not put up on that stage. It can be frustrating.

I'm not saying that I have an answer, but we live in a world where people say everything is messed up and don't realize that we all need one another. Systemic racism and gentrification are absurd. But the sad fact is we live in a world where they exist and so you have to confront them. You can't ignore them.

MA: *Tell me about your work.*

TS: This is the new series I have been working on over the last year. I was a portrait painter. I did work

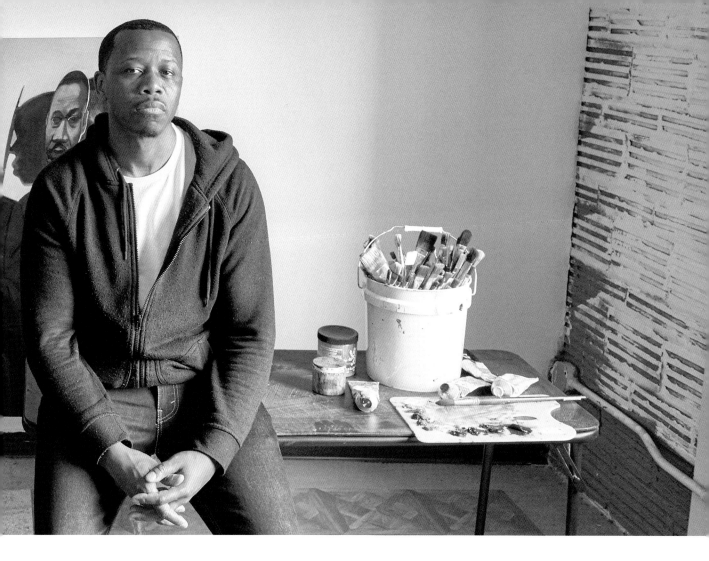

to make black people look big and beautiful. Oversize portraits—I wanted to dispel the negative images of blacks. But in these particular times, I didn't think that was powerful. My work has always been about race and identity, but now it is not as overt as it used to be. I'm raising questions and I'm trying to figure out my place in today's society.

M A: *Who is the man behind the mask?*

T S: Well, in reality they're all me, but they're not of me. Some people might want to debate the idea that everything you paint is a self-portrait, but I don't adopt it. When I paint self-portraits, I'm clear that they are self-portraits. In this work, I'm a model—I'm an actor for the purposes of this painting.

The painting *Congregation: MLK* is inspired by the event last year when two police officers were killed in New York. The mayor gave a speech, and the entire police department turned their backs on him. I wanted to capture that kind of protest composition and use it for my purposes.

Another thing I considered while working on this painting was Martin Luther King's position as a reverend and the congregation relating to that spiritual aspect. I don't know if you've ever seen those church fans made of thin cardboard and these little wooden sticks. That's why I made the mask—because it reminded me of church fans, particularly those found in black churches.

This current body of work involves people adopting the identities of archetypes from the past. It's my hope that this work raises questions. Why do you cover up your face with a James Baldwin mask? Why a Nina Simone mask, why Martin Luther King? Are these people saying that they are these particular archetypes, or are they against them wearing masks to hide their identity?

3 THE DESIGN
SCENE

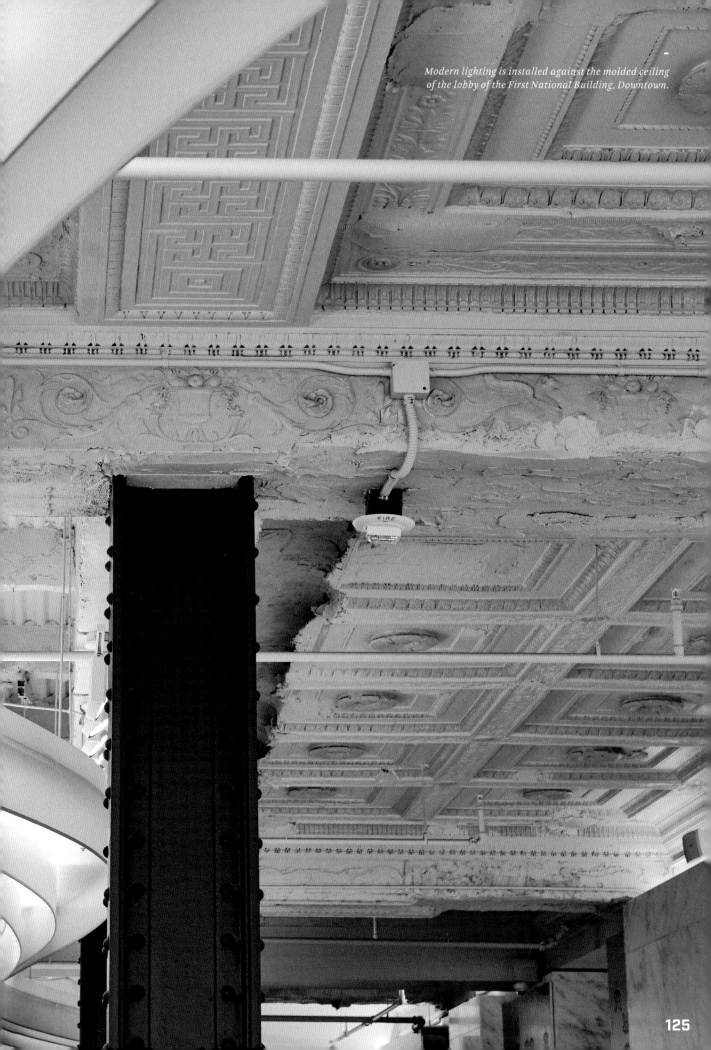

Modern lighting is installed against the molded ceiling of the lobby of the First National Building, Downtown.

MODERN DETROIT DESIGN:
SEEKING THE INDIVIDUAL

-

Essay by

SARAH F. COX

A NIGHTMARE IS A SORT OF DREAM, and the foreclosure crisis of the early aughts set the backdrop for the turnaround in real estate, which has led to the current burgeoning design scene. Called "a hurricane without water," this crisis of the banks left derelict many parts of Detroit, which don't need to be depicted here.

The turnaround has come with its complications. Wide-eyed coastal transplants fleeing high rents fell in love with the cheap building stock, to the horror and shock of some long-term residents, who called the transplants carpetbaggers. Meanwhile, billionaire Dan Gilbert scooped up heaps of the Downtown building stock without much competition, owing to the difficulty everyone else had securing a loan for a commercial building (a problem that persists).

But it's starting to feel as though Detroit is leveling a real estate playing field that has operated, for the most part, in cash deals. The stifled mortgage market has limited would-be buyers' ability to participate in the resurgence, but the mayor's office has announced a new program supported by banks and nonprofits to open up more lending for homes, which is a very hopeful sign.

And while there may be a narrow number of players in Detroit's design scene, there is still no star. In terms of design, Detroit lacks an iconic personality, project, or aesthetic. Many of the best projects are renovations of much older buildings, which allow designers to put an imprint on someone else's work, but not to define the type. To many, the city's defining architect is Albert Kahn, whose legacy has taken a hit from demolition in recent years, but is seen thriving at the wonderfully preserved art deco Fisher Building. Other major projects to restore his work at the Packard Plant and the Free Press Building were announced to much fanfare but have seemed to struggle getting off the ground. At least it seems as if the tidal wave of demo is subsiding.

The current renovation scene has swerved through phases of neon, reclaimed wood, a love affair with industrial lofts, DIY, more DIY, and the great rediscovery of Mies van der Rohe. One area where property values rebounded, doubled even, is the bucolic co-op community designed by the German-born architect and built in 1956 known as Lafayette Park. Over a period of a few years, the attention lavished by design magazines and real estate blogs has created a midcentury feeding frenzy. It also helps that the neighborhood is surrounded by one of the best-maintained landscape designs in the city.

Detroit design is at its best when it incorporates preservation. If you weren't in Detroit on October 24, 1998, you missed a wild demo party when the Hudson's department store was imploded. As of 2017, that site is still a derelict girder-farm in the midst of Downtown. Detroit has a bad habit of throwing its architectural legacy in the trash, or at least failing to stop private developers from doing so. Fortunately, other Downtown structures were luckier post-nineties. The formerly boarded-and-vacant David Whitney Building, developed by the Roxbury Group, became a hotel whose stunning ceiling restoration is the best part of the design. Downtown in general is shifting from an atmosphere once dominated by bland corporate interiors to something with a more boutique, or boutique-inspired vibe (if still largely supported by corporate money, much of that from Gilbert). As for the billionaire, it's been nice to see the taste of his organization evolve. What began with much too many attention-grabbing details and colors has finally refined itself befitting an organization of massive profits.

Detroit was built as a city of single-family homes, and the city's personality is most evident in décor determined by individuals. Homes not originally built

Sarah F. Cox's renovated Victorian
house is in Midtown.

to be homes (former firehouses, bank buildings, industrial manufacturing plants) are becoming the poster children for the city's most impressive renovations. While a dearth of new construction means a constricted rental market, seeing old buildings renovated in place of new, cheaply built condos and apartments has been rewarding over the last few years. Though much has been made of Detroit "coming back," thus far the census numbers point to a slower loss of population, not an actual gain. But that is still a turn in the tide. (An article from 2015 put the average population loss at about 1 percent per year, less than the 2.5 percent loss per year in the decade before.)

Many of the properties on these pages experienced periods where they were boarded up and possibly stripped. Disinvestment meant many that stayed occupied were not properly maintained; current property owners trade war stories about replacing roofs, doors, windows, and weather strip, and the exhausting hand labor of doorknob polishing, paint scraping, and tuck-pointing. There are labors of love, then there are labors of love/hate, which might better describe the process of bringing a property back from distress. I asked a homeowner mid-renovation if he knew the previous owners and was told no, but if he did he'd like to strangle them for painting all the dark wood over with white paint. It's a delicate act of stripping the past to get to a deeper past.

My own home, an 1890s Victorian mansion, had already lost most of the historical character from the interior by the time it was purchased in 2012 to be converted into three apartments and a storefront. When the rebuild was finally completed, I invited a longtime Detroiter who worked in development to tour the third floor, an attic-y apartment of swooping rooflines. While she gushed compliments, she also noted that putting a modern interior into an old building was "so East Coast." I'd never thought of it this way before, but as an East Coaster I'd taken what I was used to for granted as something that happens everywhere. And that's the danger and the beauty of encroaching on Detroit. Old and new, coastal and midwestern, can inform each other and miss each other at the same time; it's important that we all keep talking.

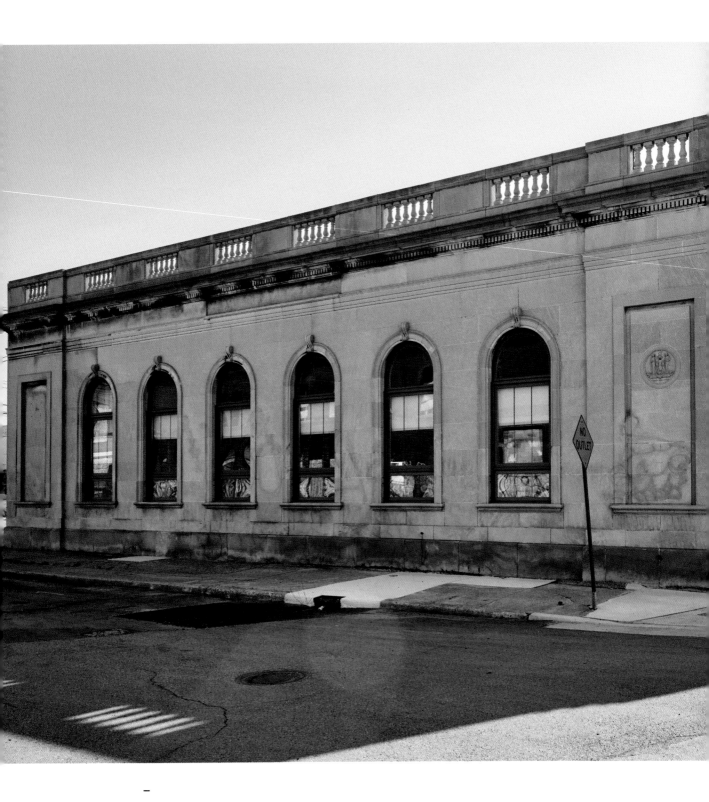

The Savinos purchased the bank in October 2013.
The price was $65,000.

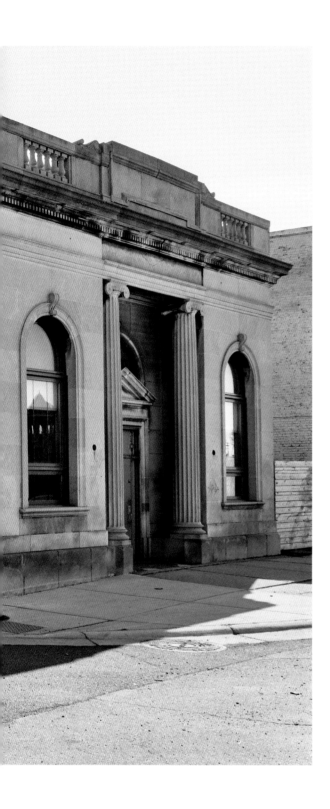

MIKE AND LYNNE SAVINO

With a surplus of freestanding buildings in Detroit, it is not surprising to find a lot of adaptive reuse projects. However, the Savino project takes the cake for turning one type of very commercial space into a residential space. About five years ago, Mike, a builder who owns a concrete company, and his wife, Lynne, a sales director for an urban microdistillery, decided to buy a place to live in Detroit. They were searching for an unconventional property, and they found it—an abandoned bank branch with an empty lot and bar next door. The rich interior architectural details included the copper metalwork around the entryway, terrazzo marble flooring, and the original, intact vault. The property also had a complete limestone exterior with classic columns on the façade. The Savinos decided to create an open living plan with modern furniture such as Mies van der Rohe and Lilly Reich's Barcelona chairs and a sofa by TrueModern. They built a second level in the back of the building to accommodate the bedrooms, bathrooms, and office. The overall effect is more loft-like than bank-like and looks like a million bucks.

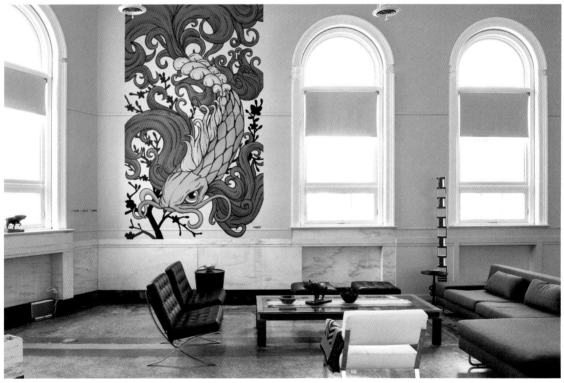

—

ABOVE

A long counter with concrete tops and an island are featured in the kitchen of the loft.

—

BELOW

The Savinos asked a local artist, Ken Dushane III, to paint a mural in the main living area.

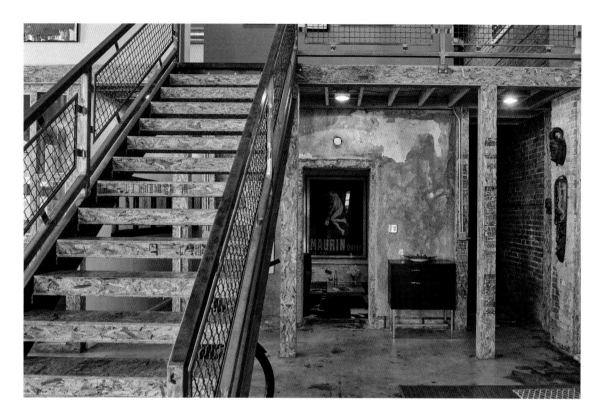

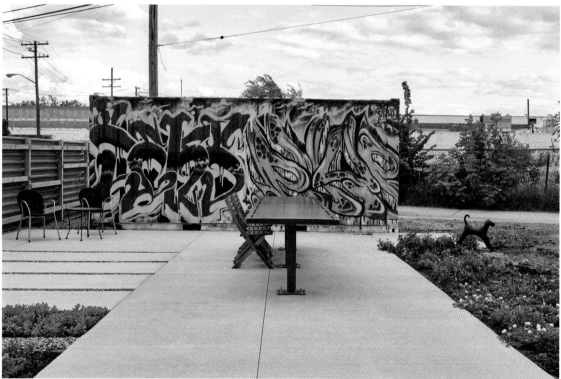

ABOVE

Oriented strand board (which is also known as OSB) is used throughout the home: around the wall treatment in the kitchen, as a support to the wall of the office, and in the staircase leading upstairs. The material was chosen for its raw look.

BELOW

The garden behind the bank has a container with a mural by artist Ken Dushane III and a few of his friends, as well as a steel table that's bolted to the patio.

DONNA TEREK AND PAUL RYDER

Paul Ryder was a top real estate agent in Detroit—he has since retired to run PJ's Lager House, a music club and restaurant in Corktown. He had long admired Indian Village, a neighborhood of about 350 homes built between 1895 and 1929 that was once home to car executives and important Detroit families who lived in beautifully proportioned houses on wide, tree-lined streets. Most of the homes were built by some of Detroit's most well-known architects, including Albert Kahn and William Stratton. When Paul heard of a property coming on the market, he took his wife, Donna Terek, now the multimedia columnist for the *Detroit News*, for a look. The house was designed by architect James Meier and built in 1916. The Meier family owned the house until about 1960. The minute she walked into the house, Donna immediately knew this was "it," despite its state of disrepair. Paul and Donna decided they would take on the restoration themselves.

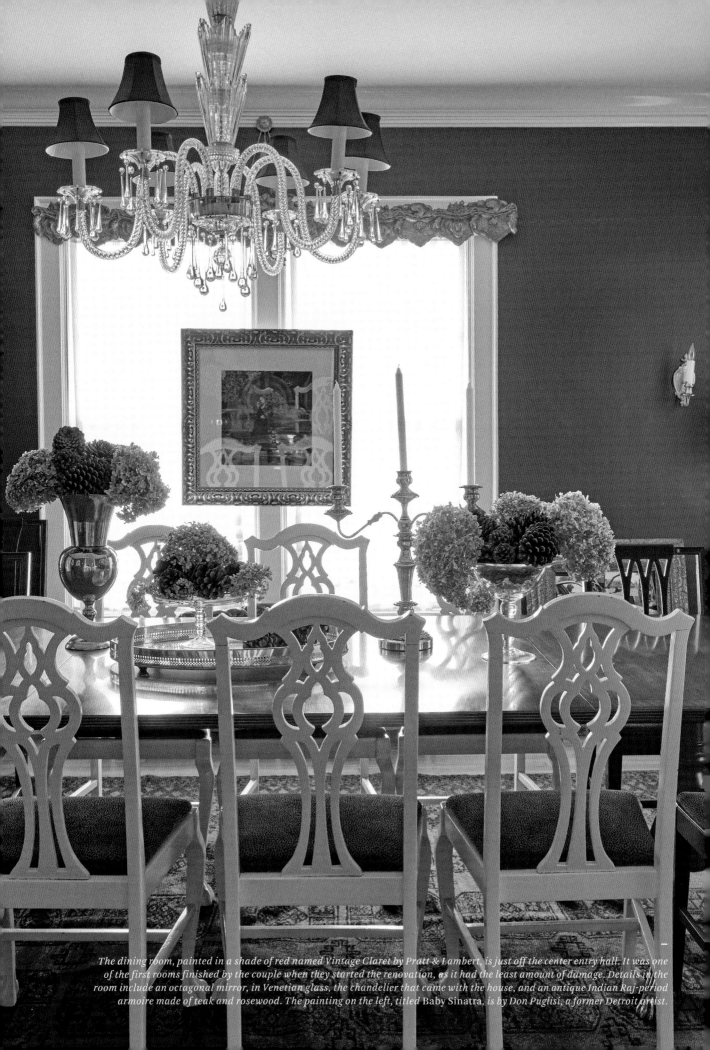

The dining room, painted in a shade of red named Vintage Claret by Pratt & Lambert, is just off the center entry hall. It was one of the first rooms finished by the couple when they started the renovation, as it had the least amount of damage. Details in the room include an octagonal mirror, in Venetian glass, the chandelier that came with the house, and an antique Indian Raj-period armoire made of teak and rosewood. The painting on the left, titled Baby Sinatra, is by Don Puglisi, a former Detroit artist.

Interview with

DONNA TEREK
AND PAUL RYDER

MICHEL ARNAUD: *When did you buy the house and why did you choose the Indian Village neighborhood?*

DONNA TEREK: I'd been hoping to find a home that hadn't been "remuddled." So many houses had lost their butler's pantries to kitchen enlargements; original bathroom fixtures were replaced with stuff from big box stores. This house had only two previous owners, and almost all of the original features were still intact, including the glass-fronted cabinets, and the plate-warming radiator in the pantry, and his and hers Italian porcelain pedestal sinks in the master bath.

There's a common saying in the Village: "You come for the house, but you stay for the neighbors." This is the kind of neighborhood many of us grew up in, where we all know one another, swap home restoration advice, and socialize together. It's a hard place to leave.

PAUL RYDER: As many people who come to town have told me, "This is one of the friendliest places I have ever come to."

DT: We wanted to respect the history of the house, so we approached the project as restoring its architecture while updating its function. But even so, we saved as much as possible, the push-button light switches and nickel-plated faucets. We feel a responsibility to be good custodians of our home's history. For example, when we found original wallpaper behind a radiator, we left it intact for future owners to discover.

MA: *How do you feel about all the attention Detroit is getting right now?*

PR: The changes that have happened in the city in the last five years I didn't think I would ever see in my lifetime.

As far as how the world looks at Detroit, the biggest single factor is the barrier to entry here is relatively low. Detroit has become a city of crazy ass ideas—CAI as I call them.

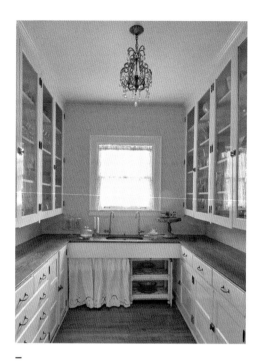

—

The butler's pantry, with its plate warmers under the sink and wooden countertops, was a holdover from the house's past.

I remember meeting the head chef of Slows Bar-B-Q, Brian Perrone. He said, "We're getting ready to open a barbecue place," and I said, "Where?" He said, "Fourteenth Street at Michigan Avenue," and I said, "At the train station?" He said, "No, across the street." I said, "Across the street? Those buildings are empty, the roofs are gone—it's probably falling down." He said, "Yeah, in the basement, you can see the sky."

I thought, "That's the craziest ass idea," and said, "Who's going to come to your place?" Two years later, in 2005, they opened, and this week they had their tenth anniversary. Now if someone comes to me and says, "I want to do 'whatever,'" I say, "That's kind of cool." If they ask, "Well, what do you think? Do you think it's a good idea?" I say, "What do I know? The crazy ideas always seem to work in this city."

MA: *What do you think about the new people coming to the city?*

PR: Personally I am delighted. They are bringing ideas, energy, and money. There's going to be a whole generation of people in Detroit that have their own houses and no mortgages. Just imagine!

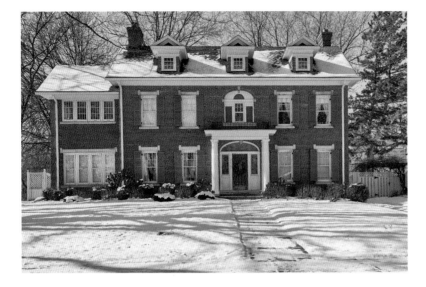

The Federal Revival house was designed by architect James Meier and built in 1916.

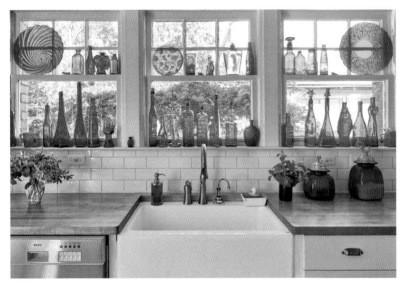

Terek's collection of blue glass is on the kitchen windowsill.

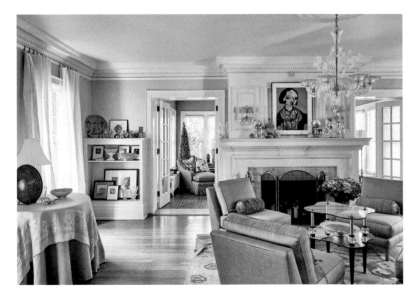

The focal point of the living room is the hand-blown Murano glass chandelier that hangs in the center of the room. A painting by Bertha Cohen is above the mantel.

CAMPBELL
EWALD

In January 2014, international marketing and advertising agency Campbell Ewald moved its Detroit office to the old Hudson's department store warehouse located in the Ford Field complex in the heart of Downtown. The company, working with architects at Neumann/Smith, decided to respect and honor the original structure of their five-story space and its essential building element—concrete. They created an environment that appears to be totally transparent and raw, with exposed ductwork and structural elements as well as glass-enclosed conference rooms and work spaces. The concept was to promote creative collaboration within the firm and with its clients. Yet the design team also inserted more intimate spaces into the overall plan, creating "pods" and "treehouses" that perch above the spectacular open atrium. With its forty-two-foot LED screen, the atrium serves as an office-wide gathering area, and more importantly, it reflects the original building's grand style while making a modern, jaw-dropping experience for those who work and visit there.

—

The atrium of Campbell Ewald's office is over five stories high. The design team decided to leave the space unfinished so that layers of activity could be viewed from all directions.

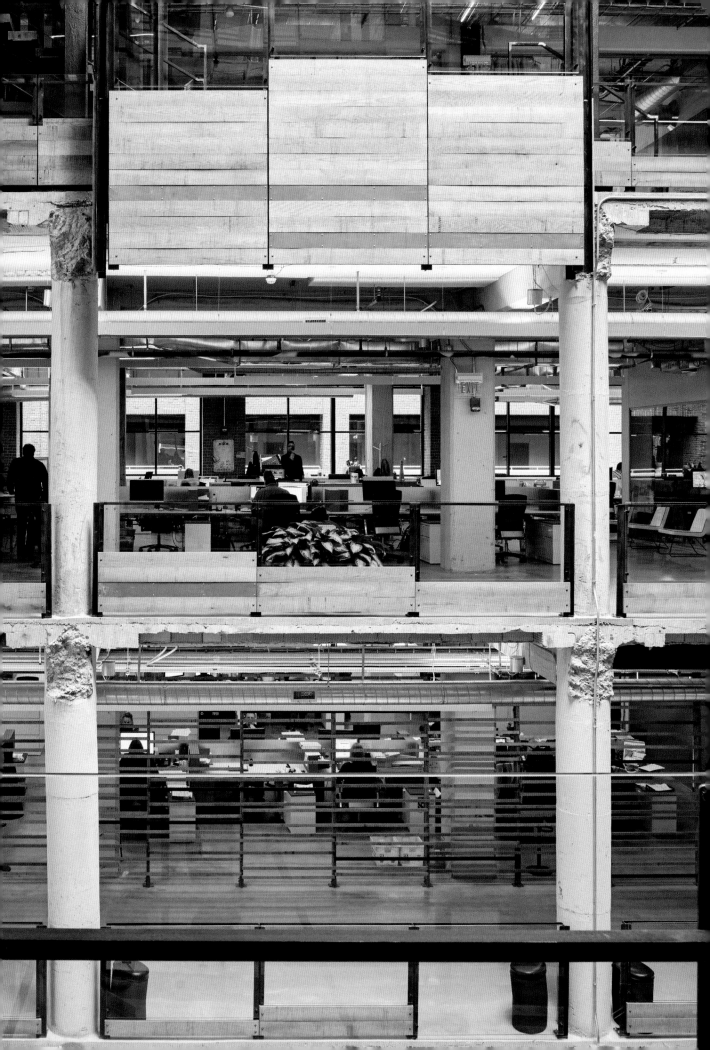

At the entrance of the office, the materials reflect the company's over one-hundred-year history as well as its future. The ceiling is covered in printing plates from the 1950s to the 1980s, and iPads showing digital work are installed on two walls.

The project was all about the details; everything was exposed, from structural elements to nuts and bolts and electrical conduit.

Views of the "treehouses" on the mezzanine level. These small, intimate conference rooms and meeting places afford colleagues more privacy.

—

Repurposed wood is used throughout the building, from furniture made from shipping pallets to pods made from recycled doors.

CHRISTIAN
AND MICHELE
UNVERZAGT

In 2008, architect Christian Unverzagt and his wife, Michele, moved into one of the townhouses in Lafayette Park designed by Mies van der Rohe. The low-rise units and three apartment towers were part of a development that was completed in the 1960s and aimed to provide housing for Detroit's middle class. The green enclave, centrally located near Downtown, Midtown, and Eastern Market, replaced a neighborhood called Black Bottom. Christian and Michele were former residents of the Lafayette Towers and waited years before a townhouse became available. As design enthusiasts, they have outfitted their home with midcentury furniture, including pieces designed by Charles and Ray Eames for Herman Miller. The townhouse has floor-to-ceiling windows in the back and front, making the amazing landscape, designed by Alfred Caldwell, fully accessible and enjoyable.

—

The townhouses were part of a planned development that included three residential towers, a shopping mall, and a school. A committee of residents meets regularly to organize the maintenance and preservation of the landscaping.

—

Upstairs in the office, a collection of skateboards by various artists including
Michael Leon and Chad Kouri hang above the Eames Sofa Compact.

—

The guest room has a view of the courtyard townhouses.

The eat-in kitchen is in the front of the house. Its yellow wall in a shade
named Citron by Benjamin Moore continues upstairs. The Real Good
chairs in blue and white are a contemporary design by Blu Dot.

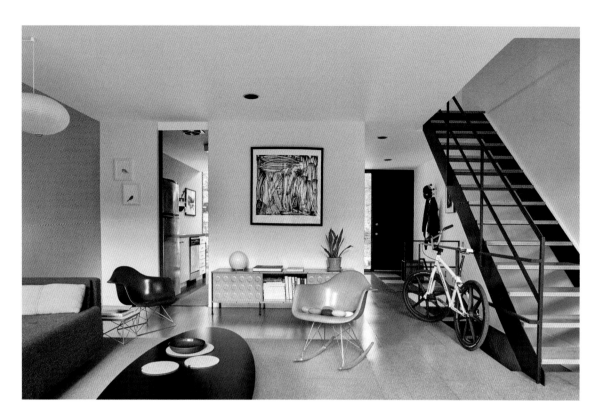

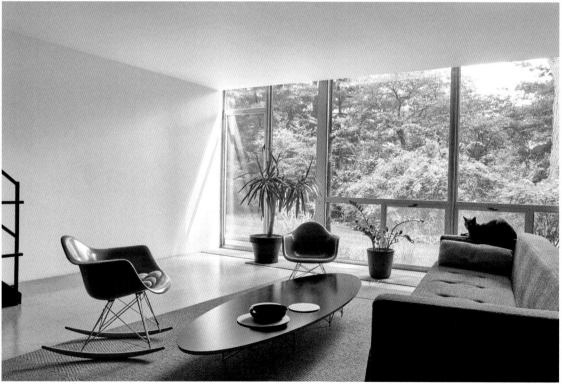

The Unverzagts have kept the furnishing minimal and modern.

CHRISTOPHER
BURCHAM

—

*A former hardware store is transformed into a residential
loft building by Studio Detroit architects.*

In 2014, Detroiter Christopher Burcham bought the building that had been the Bullock Green Hardware Company from 1905 through the 1960s and began to transform it into a residential loft designed by Studio Detroit architects Kevin Crosby and Shane Burley. Burcham needed a loft for himself and decided also to include two other rental units in the building. Inside, Burcham wanted to preserve many of the original features and materials—the wood floors, which were refinished; the brick, which was cleaned; and a hundred-year-old mechanical elevator, which was repaired. The city has an active anti-blight program that fines property owners for graffiti that is not removed. As a preventive measure, Burcham commissioned muralist Louise Chen, aka Ouizi, and MC Bevan to paint a floral mural, which is adjacent to a lot that will be a courtyard for the residents as well as a parking lot. The architects also developed the curved façade, which sought to activate the building's exterior and turn it slightly toward Downtown. They investigated several possibilities for cladding and settled on wood. The building does seem to wave as you drive past, as if to say, "Stop. Look."

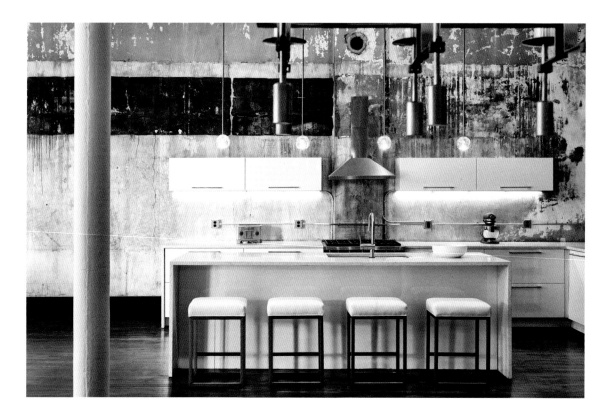

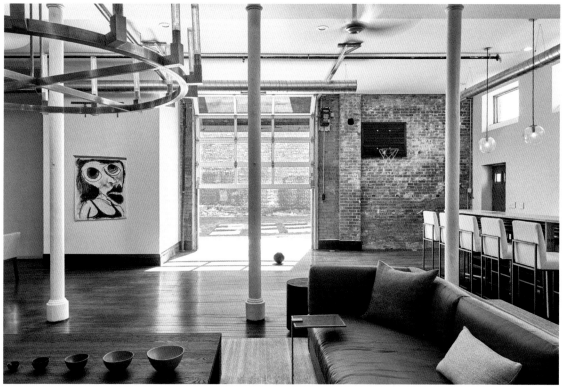

—

ABOVE

*A streamlined aesthetic is maintained in the kitchen.
The wall's original patina was left intact.*

—

BELOW

*Burcham installed a basketball hoop next to the rolling
glass garage door in the first-floor living area.*

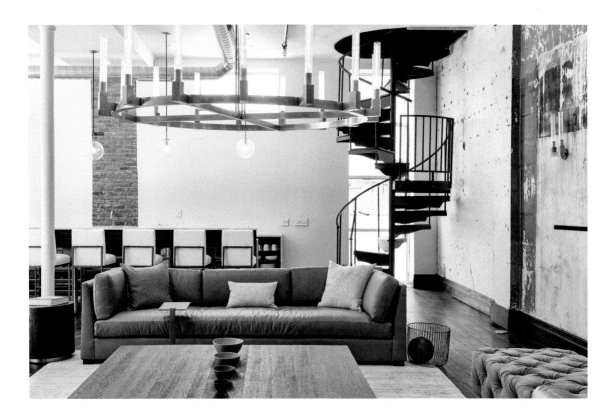

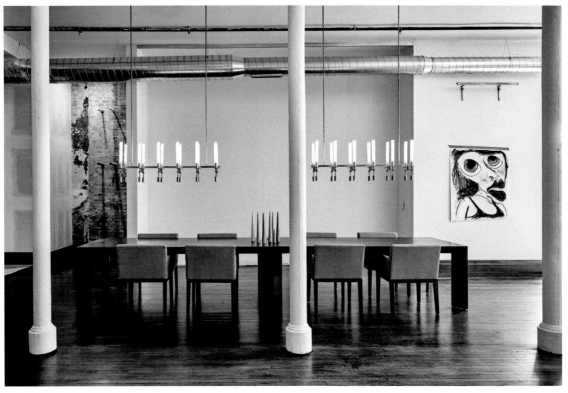

ABOVE

The spiral staircase leads to the master suite upstairs.

BELOW

Burcham, who studied design and business, decided to work on the interiors himself. He sourced many of the furnishings from Restoration Hardware's RH Modern line, including the Morgan Track chairs around the dining room table.

ERIN WETZEL AND JT MCCLUSKEY

When Erin Wetzel and JT McCluskey moved into a former motorcycle shop in Eastern Market seven years ago, the industrial workspace didn't seem friendly to the family homelife they envisioned. Because it was a rental unit, their build-out and changes had to be minimal. Along one of the existing brick walls, they constructed three rooms: one master bedroom, a play-room, and a bedroom for Wetzel's son, Wilder, who is eleven. McCluskey found salvaged doors and installed them on barn door hardware. Two rooms with interior glass block windows in the back serve as McCluskey's office and music studio. The couple display their architectural remnant finds in the open living room, dining room, and kitchen. It's their way of saving history. In fact, one attraction to Detroit for the couple was the city's commitment to renovating and reclaiming some of its architectural treasures. Indeed, their landlord has tried to keep the aesthetics of the building's first past life as a brewery. Through the original iron windows, which recall the building's 1880 inception, Wetzel and McCluskey have views of a modern Detroit skyline in the distance.

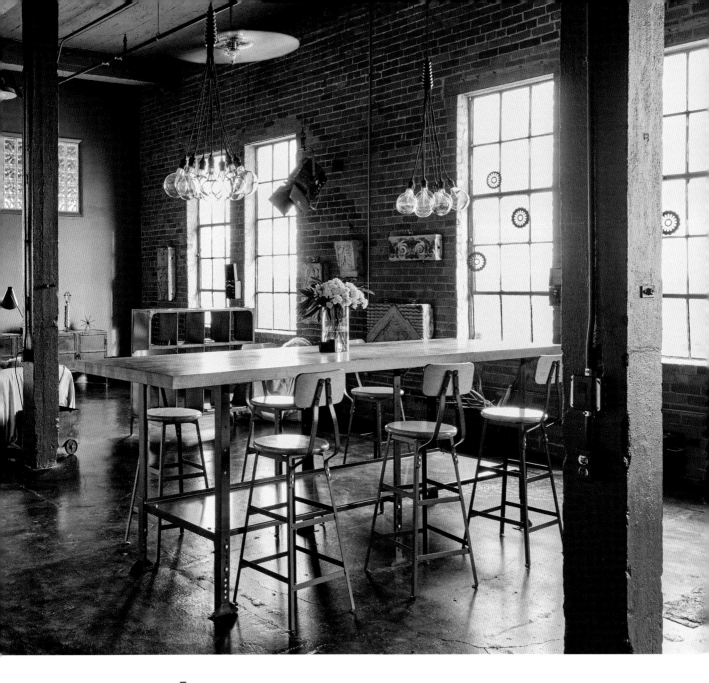

—

ABOVE

The open loft's living room and dining room. Lights from Z Gallerie hang above the dining table.

OPPOSITE

The building was built as a brewery.

–

The galley kitchen has exposed brick walls.

–

Each of the bedrooms has a salvaged door installed on barn door hardware.

–

In the bathroom, two metal lockers serve as cabinets.

The original metal windows look out toward St. Joseph's Catholic Church and on to Downtown Detroit.

ORLEANS + WINDER

Perched above bustling Eastern Market is the fashion store Orleans + Winder. The shop owners, Erin Wetzel and JT McCluskey, decided to leave the space as they found it, with the cinder-block wall and the building's structural concrete exposed. The choice of cutting-edge European and American designer fashion, with unexpected tailoring and beautiful fabrics, is equally surprising. The juxtaposition of the two elements—one raw and unfinished, the other finely tailored—is quintessential Detroit.

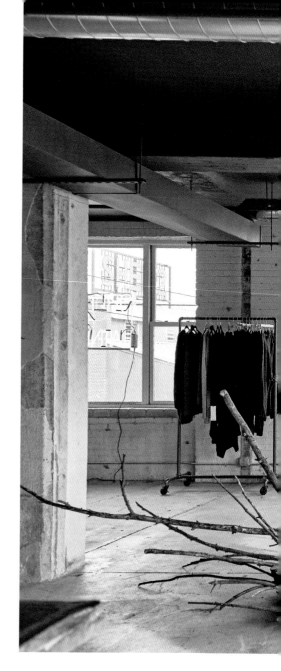

—
The building that is home to Orleans + Winder sits on the corner of Eastern Market.

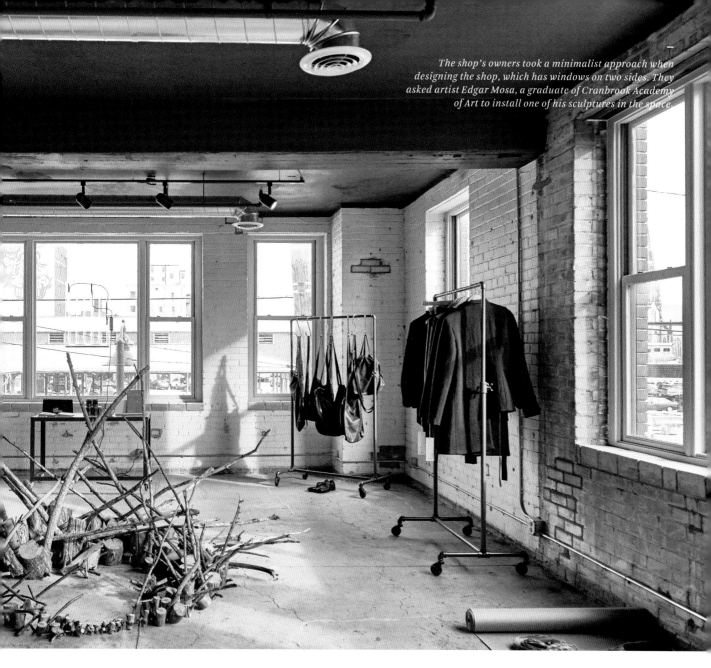

—

The contrast of the elegant gilt mirror against the cinder-block wall speaks to the store's style.

—

A view of the dressing room with canvas curtains.

153

THE QUICKEN LOANS TECHNOLOGY CENTER

Quicken Loans worked with Troy, Michigan, architectural firm Integrated Design Solutions to build a new data center from the ground up in Corktown. Under the design direction of dPOP!, the public areas and conference rooms feature bright colors and surprising materials to make the spaces extremely people-friendly. One important consideration was sleeping space for the employees who are responsible for maintaining the system twenty-four hours a day, seven days a week. The design team incorporated sleeping pods that can be pulled out when in use and stored away during the day. Elements of humor provide relief from the cold, bland aesthetic that is often associated with office technology.

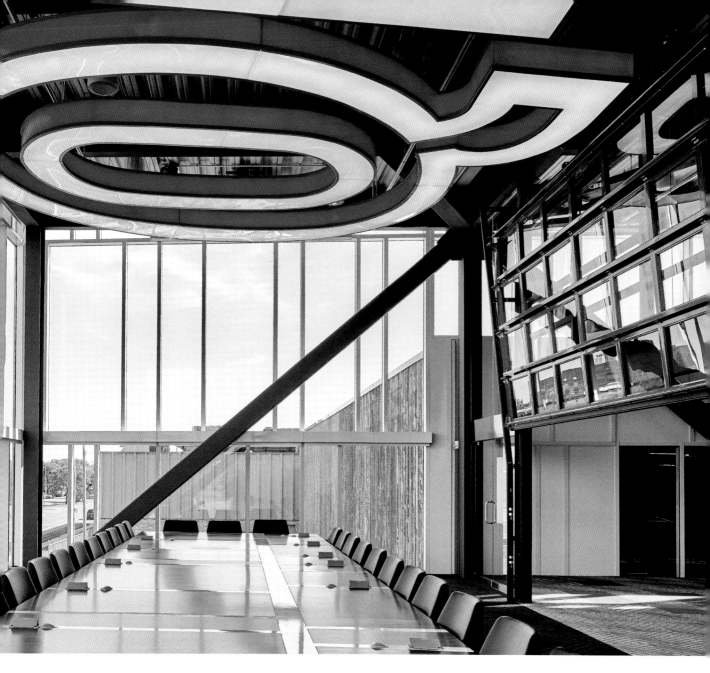

—

ABOVE

Upstairs on the main level, a large open room accommodates a thirty-two-foot-long conference table.

LEFT

A staircase with color-changing lighting welcomes visitors to the data center.

FAR LEFT

The building's café doubles as sleeping quarters for the overnight employees who monitor the systems. Sleeping pods are hidden behind the blue doors along the window wall.

DAI AND JESS HUGHES

Astro Coffee's owners, Dai and Jess Hughes, met working in a coffee shop in London. After traveling around the world, they moved to Detroit to pursue their dream of opening their own shop. Dai grew up in Ann Arbor, so it was also a sort of homecoming. Looking for a place to live, they bounced around the city before settling into a house in Corktown, near their café. They decided to work on the renovations themselves. Objects, including artwork and textiles from their travels, have greatly influenced the interior of the house. They believe that bold colors emit positive vibes, and these rooms reflect that belief. In typical DIY style, their home reveals their personalities and personal vision and truly stands out on the block.

Interview with
DAI HUGHES

CO-OWNER, ASTRO COFFEE
HOMEOWNER, CORKTOWN

MICHEL ARNAUD: *Why Detroit?*

DAI HUGHES: I am from Ann Arbor, which is about forty miles west of Detroit. We definitely don't consider ourselves the suburbs of Detroit. There's a lot of history, biases, all sorts of feuding, conflicts, and racial turmoil that polarized some of the communities in Detroit. The fifty years of decline that this city experienced doesn't just disappear— it just gets absorbed by those who stayed and endured. New residents to the city may not understand or live with those memories. The pain does not go away because a few new restaurants open, we must remain thoughtful at every level of growth to be considerate to the past.

Jess and I, we worked in all kinds of different places all over the world. Detroit was a big question mark with no certainty whatsoever. Having my own shop had been a thought, a dream, and an obsession for all the time I was traveling.

The challenge of Detroit, as well as its opportunity, is that all this brilliant architecture can be lost any day. If somebody doesn't save one of those buildings or stores or homes, it's over; it will never come back.

MA: *How do you see things changing?*

DH: We just got a huge network of streetlights working; for anybody living here, it was such a big deal. Then we received recycling barrels eleven months ago; I almost cried when they showed up.

I'm grateful that collectively we all share the ability to change and adapt, and it's really a beautiful lesson. You can't run from yourself in Detroit. It can be the reason this place is very hard for people who can't honestly face themselves. But if you can take that opportunity to clean house, so to speak, this town is really rewarding and a wonderful place to live.

—

The exterior trim of Dai and Jess Hughes's 1893 house in Corktown is brightly painted in shades of blue, green, and red.

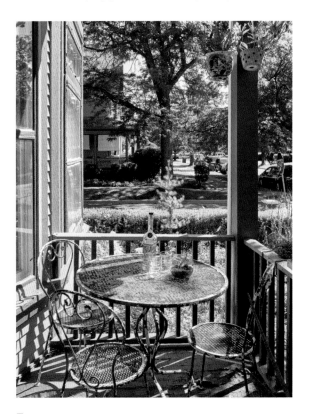

—

A small café table on the front porch.

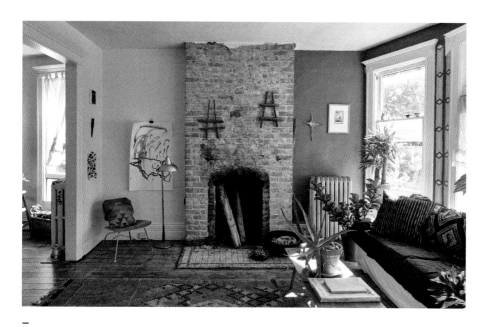

The central fireplace in the parlor was restored.

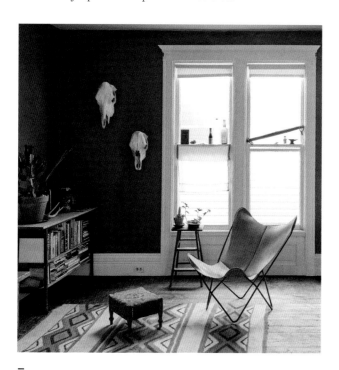

A leather-covered butterfly chair sits in the couple's music room which is painted in Sherwin-Williams's Frank Blue.

In the entry hall, the staircase is painted a shocking green named Tantalizing Teal.

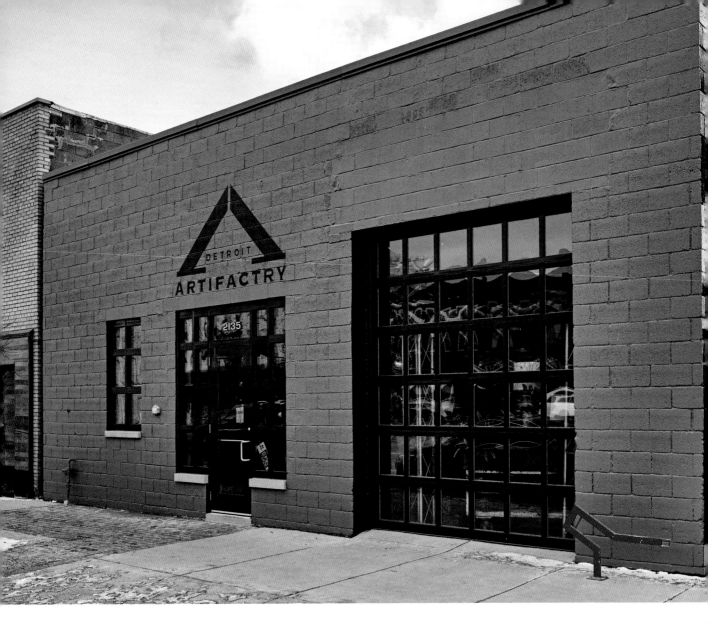

DETROIT ARTIFACTRY

Gail Kwiatkowski and her husband, John, were familiar with the garage across the street from their son Dave's successful cocktail bar, Sugar House, in Corktown. It had been a speedometer shop for many years. In 2011, they took the plunge and decided to buy out the owner and remodel the space into a retail store. John oversaw the details of the build-out. They retained the cinderblock walls, paneled another wall and the ceiling in recycled wood, replaced the old concrete floor with a new polished version, and added chic industrial lighting. The old garage doors were replaced with new doors both on the storefront and facing the parking lot in back. During the summer, the doors are open. Gail carefully stocks the shop with products that are antique, vintage, or Detroit-based, even creating some products herself, such as soy candles and custom pillows. Detroit Artifactry is one of the first design shops in that section of Michigan Avenue.

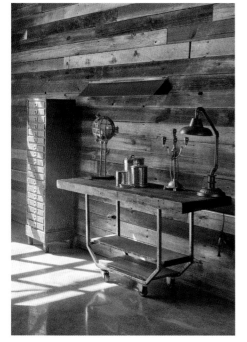

—

ABOVE

The exterior of Detroit Artifactry, a former speedometer shop, was painted a dark gray.

OPPOSITE + LEFT

Other renovations included the walls and ceiling, which were covered in wood boards of varying colors. The store specializes in furniture transformed from industrial pieces.

LINDA DRESNER

Fashion entrepreneur Linda Dresner is a lifelong Michigander and an art collector extraordinaire who was looking to start over with a new house in her old neighborhood in Birmingham, part of Metro Detroit. Her previous home was a modern structure, but she decided to work with architect Steven Sivak from Ann Arbor to create a new house for this different phase of her life, after her children left home. Linda and her husband, Ed Levy, have gathered a world-class collection of museum-quality art, furniture, and objects, including works by Alexander Calder, Phillip Guston, and Emil Nolde. The interior, with its mix of antique and modern furnishings, is closer to an urban loft than a tony traditional house, like the ones next door.

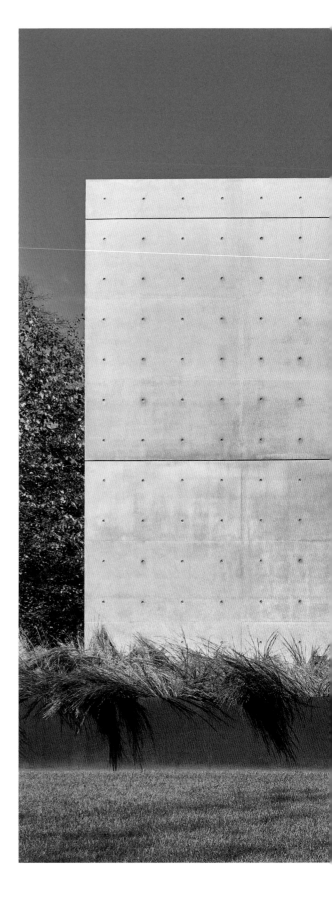

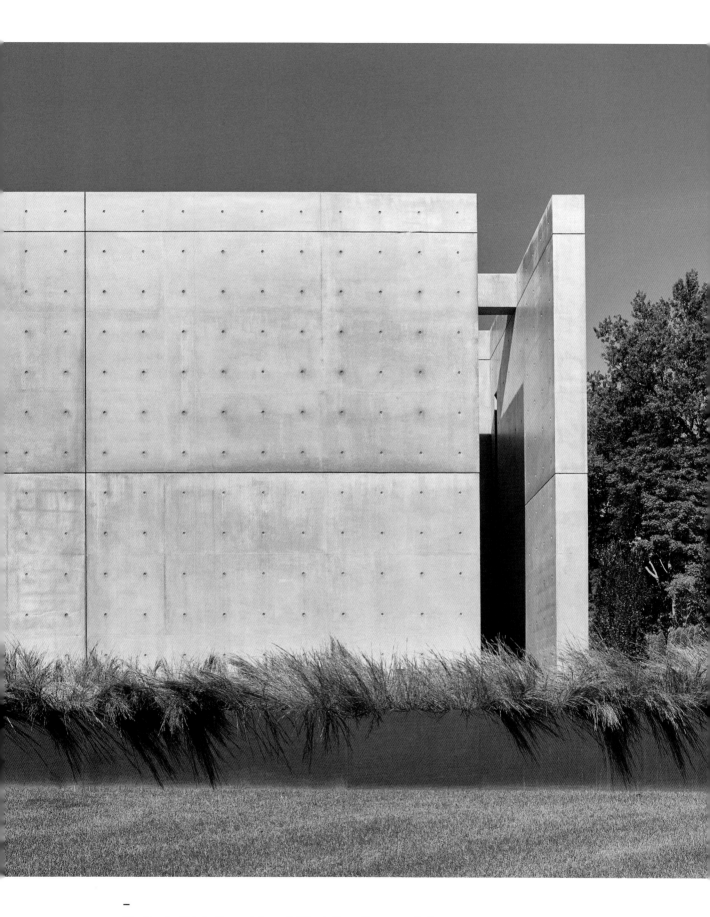

—
The façade of Linda Dresner's home in Birmingham. Dresner worked with landscape designer Andrea Cochran on the plantings.

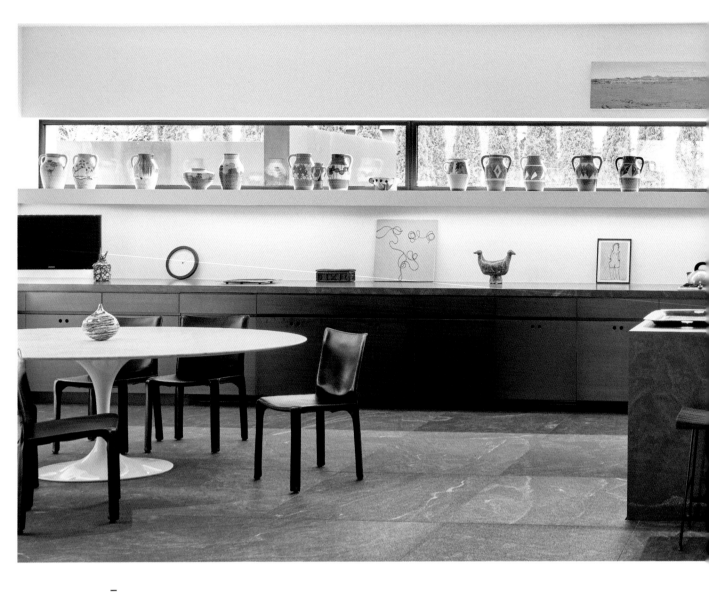

—

ABOVE

A painting by Rackstraw Downes hangs above the long narrow window and black counter in the kitchen.

OPPOSITE

The kitchen table is set for lunch. The antique sideboard has a copper finish.

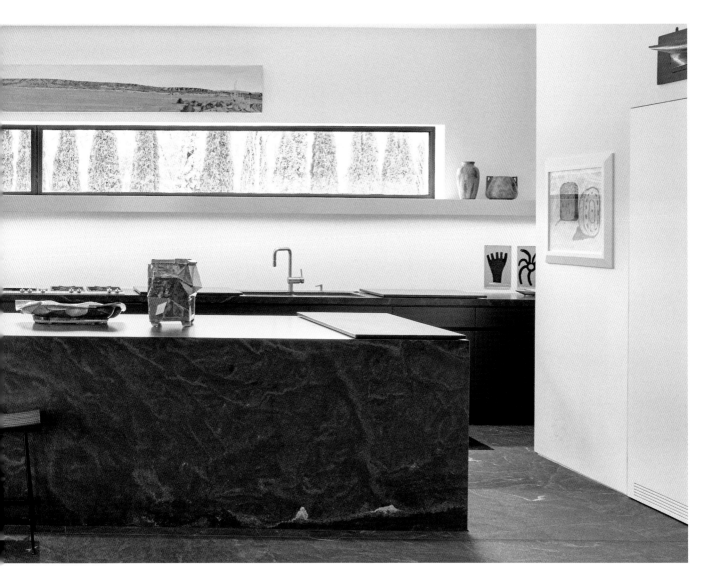

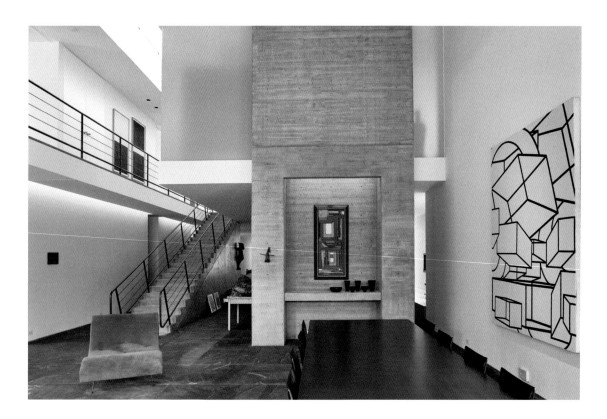

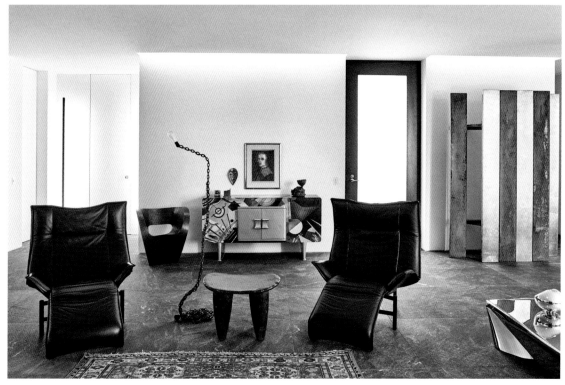

ABOVE

The view from the back entrance beyond the dining room, featuring a painting by Al Held, reveals the translucent walls of Linda's second floor bedroom. Up past the concrete staircase are drawings by sculptor Richard Serra on the landing wall.

BELOW

The large downstairs room is divided into two sitting areas. The second area has two leather chairs as well as a dresser with an Emil Nolde painting and an upside-down picnic table by artist Forrest Myers.

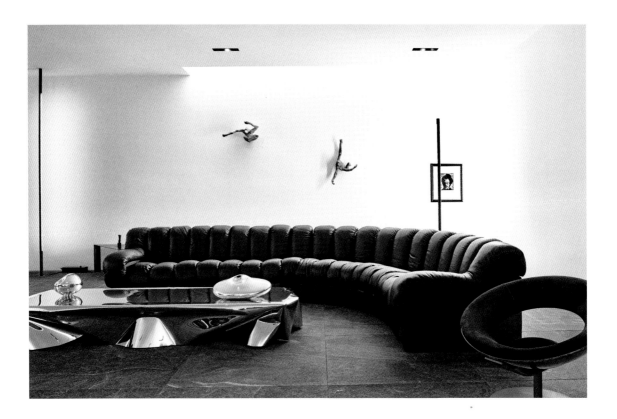

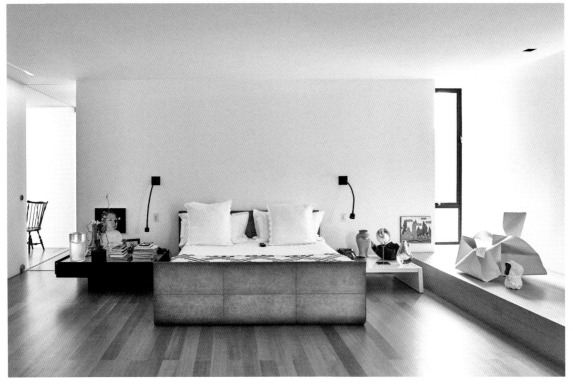

ABOVE

A black leather De Sede "Snake" sofa from the 1970s fills a corner of the second seating area.

BELOW

The master bedroom with a sculpture by Scott Reeder.

DÉTROIT
IS THE NEW
BLACK

Located just behind George N'Namdi's gallery on a charming alley was a fashion shop with a spirited name, Détroit Is the New Black. The owner, Roslyn Karamoko, studied fashion merchandising and worked in luxury retail for many years before trying a pop-up that led to the store. She created a line that boasts the shop's logo and name in both French and English. Karamoko also has brought in fashion from Linda Dresner's shop in Birmingham by designers such as Rebecca Taylor and Comme des Garçons, which are not usually found in Midtown. The clothes, jewelry, and accessories were artfully displayed alongside sculptures and paintings by artist Leon Dickey. In 2016, Karamoko moved her business to a new retail location on Woodward Avenue.

—

Designer clothing along with the company's own line were displayed on inventive fixtures made of metal pipes. An interesting combination of artworks was shown in relation to the fashion.

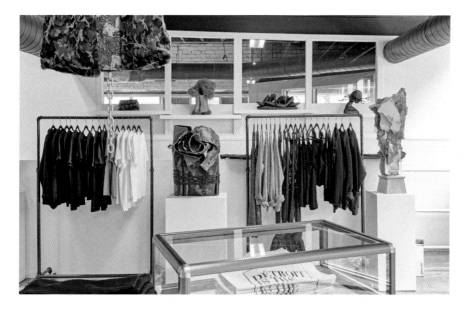

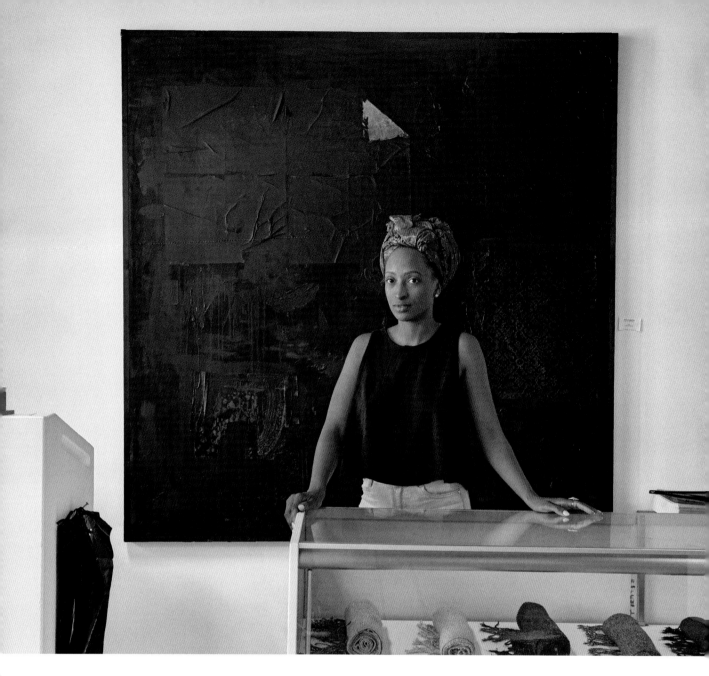

—
A portrait of owner Roslyn Karamoko in front of a Leon Dickey painting.

JEFF ANTAYA
AND PETER
ROSENFELD

The former warehouse and service center for the Willys Overland car company was built in 1912. Today it houses five floors of residential lofts with art galleries on the ground level. Jeff Antaya and Peter Rosenfeld left their lives in the suburbs for an urban lifestyle, purchasing one raw space in 2011 and another a year later. With the help of designer Bob Endres, they combined the two units to create one spectacular home. They are avid art collectors, and the two-story loft serves as an exhibition space for their growing collection—a mix of pieces by local and international artists. Upstairs on the mezzanine level and on the terrace, there are expansive southern and western views of Downtown and the River Rouge Plant, respectively. In some ways, returning to the neighborhood is familiar; Jeff's grandparents lived down the street when he was growing up. "We are an immigrant family from Lebanon. My great-grandfather had a house, a grocery store, and a boardinghouse. He raised five kids. So my grandmother grew up in this neighborhood."

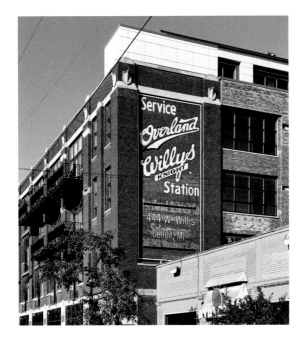

The exterior still shows the painted billboard of the car company Willys Overland that used the building as a service center.

Antaya and Rosenfeld display their art collection throughout the apartment. Works by artists such as Jane Hammond, Brenda Goodman, Mel Bochner, and Peter Stephens are shown alongside modern furniture. The metal staircase was designed to keep an industrial look to the former warehouse.

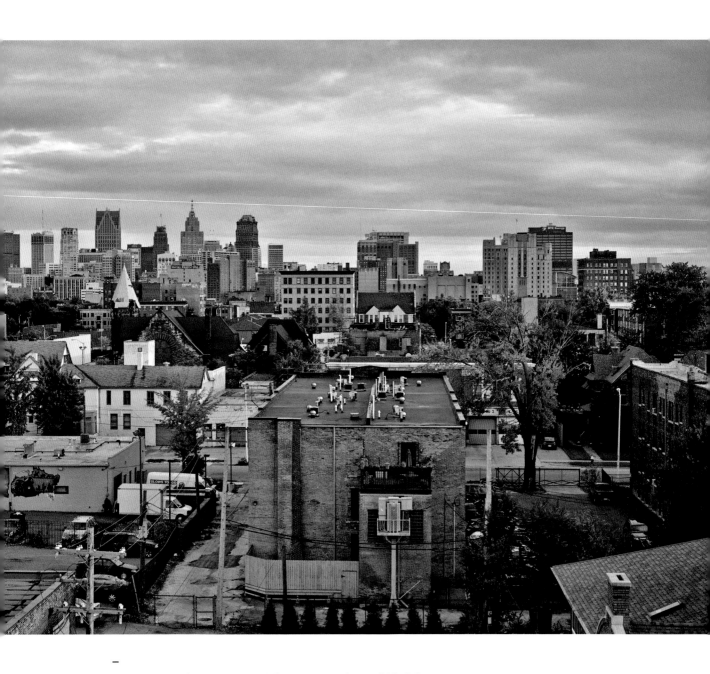

Southern view of Downtown Detroit from Antaya and Rosenfeld's loft.

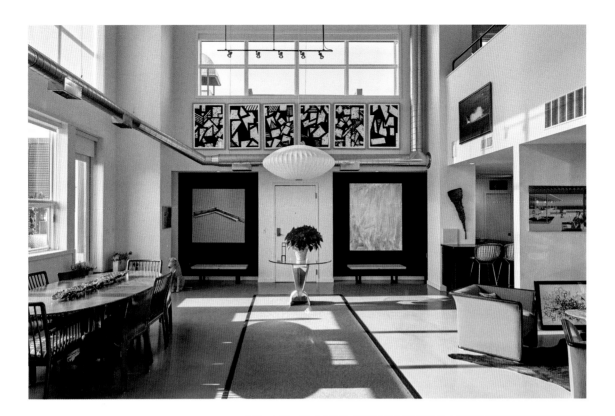

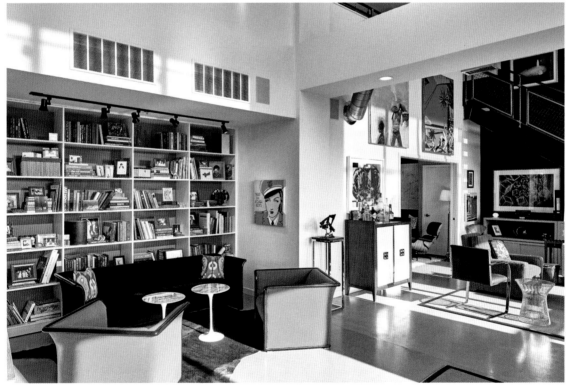

ABOVE

The downstairs has an open plan; the dining room, living room, and a seating area all share the space. Paintings by Gordon Newton, Adam Lee Miller, and Greg Fadell surround the entrance.

BELOW

Antaya and Rosenfeld have created vignettes of furniture and art all over the loft. A sculpture by Mark di Suvero sits on a pedestal near the colorful library nook.

ABIR ALI
AND ANDRE
SANDIFER

Designers Abir Ali and Andre Sandifer met in architecture school at the University of Michigan. They decided to form a creative partnership, Ali Sandifer Studio, to design a line of elegant modern furniture. In 2013, they made another life/design decision to move into a 1914 house in Boston Edison. They fell in love with this Detroit neighborhood, which is quiet and full of retirees and only seven minutes away from their studio at the Russell Industrial Center. The house had already been rehabbed so they had to make very few changes but for painting and decorations, and adding their own designed and built furniture. The six-bedroom, three-floor house easily accommodates their family—three boys as well as an extended family who come for the holidays.

—

RIGHT

The dining room of the house retains its original molding. An Ali Sandifer custom table was made for the room. The table is eight feet by two feet and has a long bench made from walnut, sap wood, and a mature wood with blond variations. The walnut stools were made for a public art project called Last Supper.

BELOW

The exterior of the house.

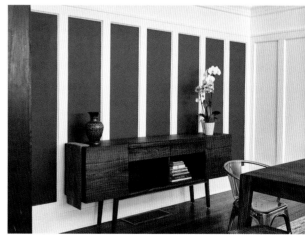

LEFT

Ali's father replaced the living room fireplace's ceramic tile work. The leaded glass windows are authentic. The coffee table is an Ali Sandifer prototype. As Ali explains, "We live with our experiments for a while."

MIDDLE

As modernists, the architects were concerned about living in an old house. Instead they found they could relate to the perfect proportions of the rooms and details such as the 1½ inch floorboards. Their walnut Edith credenza is placed against the dining room wall.

JOSHUA RONNEBAUM AND BOYD RICHARDS

Along the tree-lined streets of Palmer Park is the Tudor Revival home of Joshua Ronnebaum and Boyd Richards. The couple bought the house, which was built in 1923, in January 2013. They moved in almost two years later after an extensive rehab. All of the major utilities within the house (electricity, plumbing, heating) had to be either replaced or updated. After the demolition started, they could see the first floor from the attic. However, there were existing details that made the update go smoothly, including the narrow plank floorboards and ornate plasterwork. In addition, the slate roof was in great shape, as was the brick façade. Working with designers Art|Harrison Interiors, they thoughtfully brought the house into the twenty-first century.

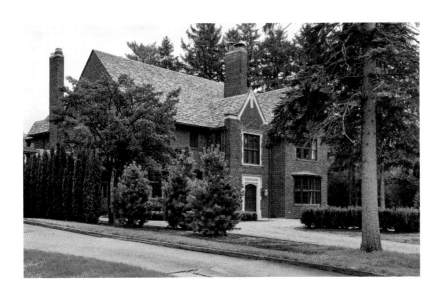

Many of the homes in Palmer Park were built in a Tudor Revival style.

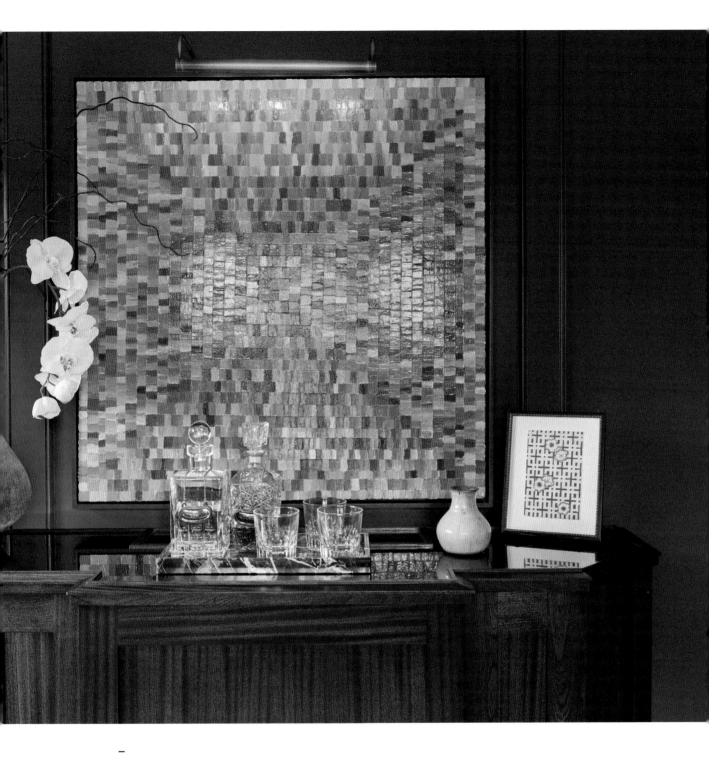

A painting by Peter Arvidson hangs above a custom sideboard.

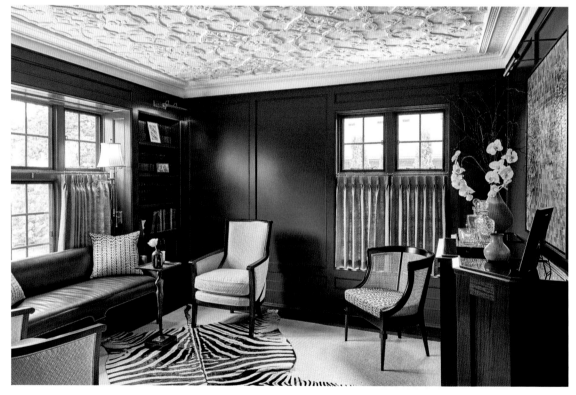

ABOVE

*Ronnebaum and Richards decided to install
Pewabic tile as flooring in the sunroom because
of the company's long Detroit history.*

BELOW

*The plasterwork ceiling in the library is original.
The walls are painted in Benjamin Moore's
Gentleman's Gray.*

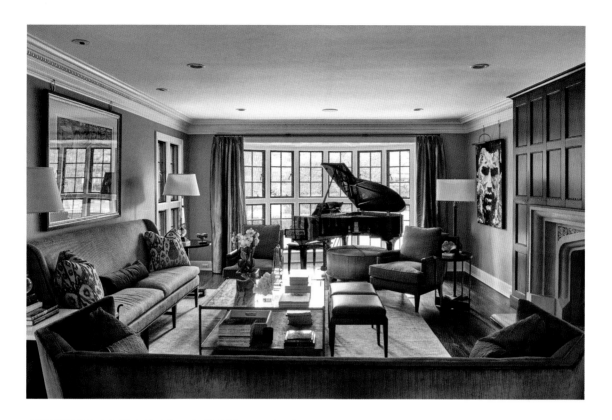

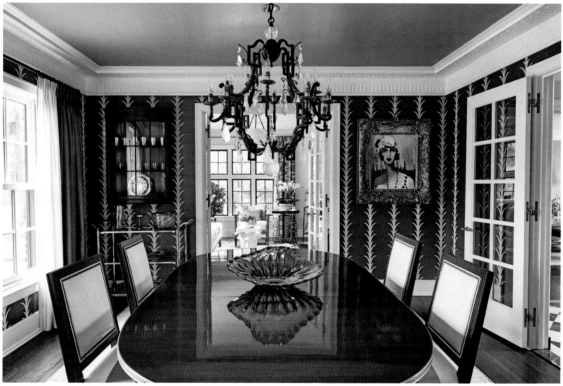

ABOVE

In the living room, they replicated the limestone fireplace and installed a beautiful mahogany panel surround. The two living room sofas are both by Hickory. The Martine sofa is covered in a Schumacher fabric and the Malbec sofa in a fabric by Pollack.

BELOW

The dining room wallpaper, Acanthus Stripe, is by Schumacher. A rock crystal and black stained aluminum chandelier, made by Art|Harrison Interiors, hangs over the antique mahogany dining table.

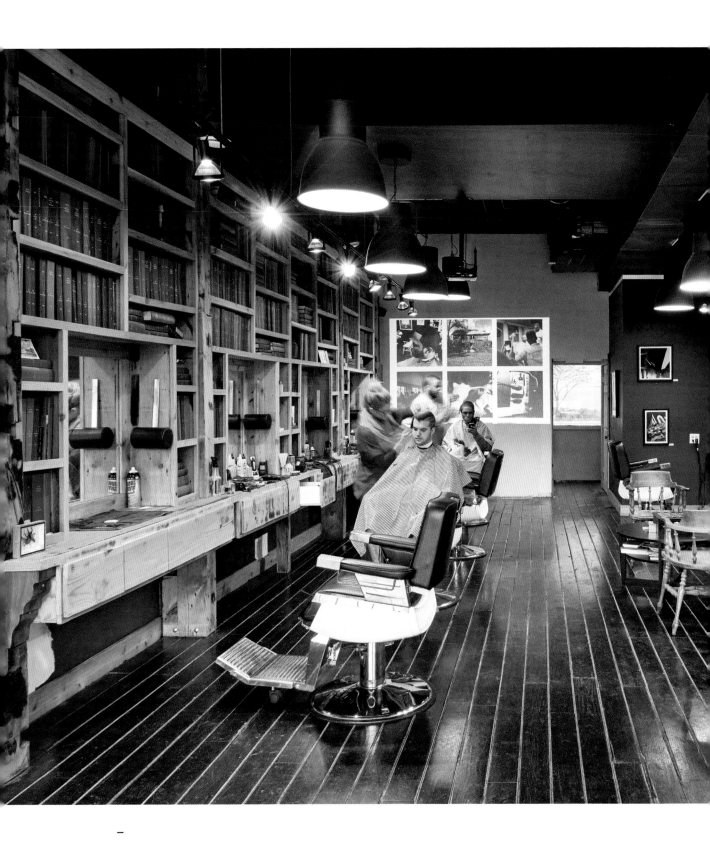

Five stations with classic barber chairs fit in with the unconventional, book-filled décor.

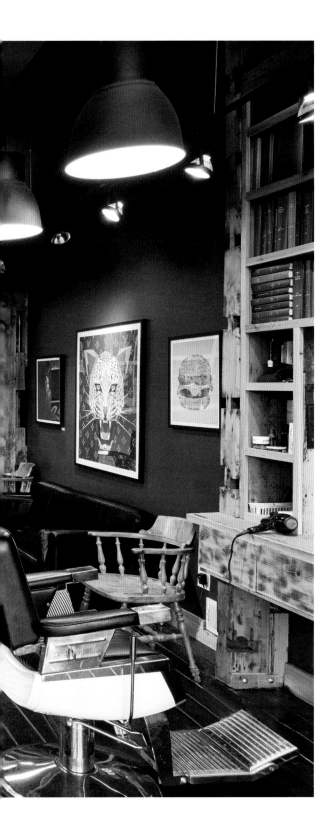

THE SOCIAL GROOMING CLUB COMPANY

Located on Wayne State University's campus is an unusual barbershop with an unusual name: the Social Grooming Club Company. The owners, Sebastian and Gabrielle Jackson, have created a different type of salon. They are open to all types of customers with all styles of hair, and they have an active social program with special events such as talks and films. The dark blue walls of the shop are covered in books; shelves made from recycled wood create a warm, inviting feeling. The Jacksons worked with several incentive programs, including MBAs Across America, to create the interior.

JOHN VARVATOS

Fashion designer John Varvatos is a Detroit native, so it seems only fitting that his brand is one of the first high-end retail shops to call Downtown home. The shop is on the first floor of an 1890s building that has been carefully restored and renovated to provide room for a restaurant above the shop as well as offices on the upper floors. The dark and polished interiors have a rock 'n' roll vibe, which Varvatos's boutiques across the country are known for. There is even a stage for musical events where musician Alice Cooper performed for the grand opening. Clothing is displayed on equipment cases and amplifiers throughout. Above, the mezzanine-level balcony, which is used for photography exhibitions, looks onto the main floor and the elaborate chandelier. Detroit's musical history is reflected in the store's cool look and celebratory feel.

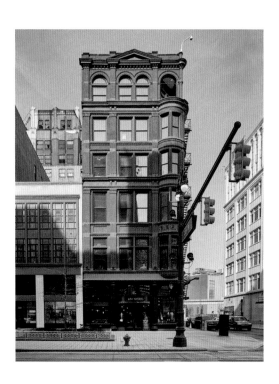

—
The exterior of the John Varvatos store on Woodward Avenue in Downtown. The Wright-Kay Building was built in the 1890s.

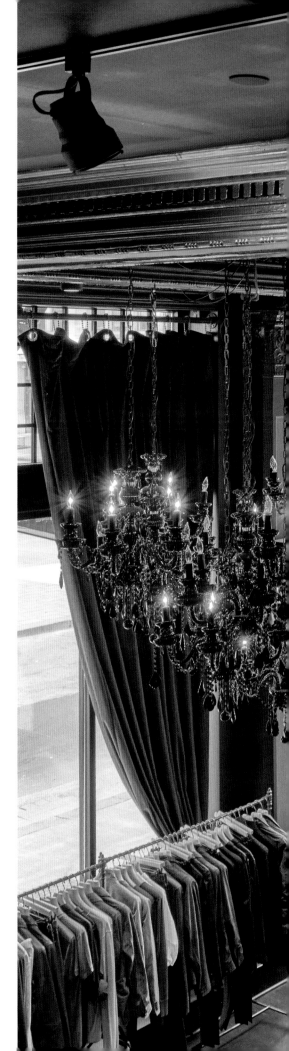

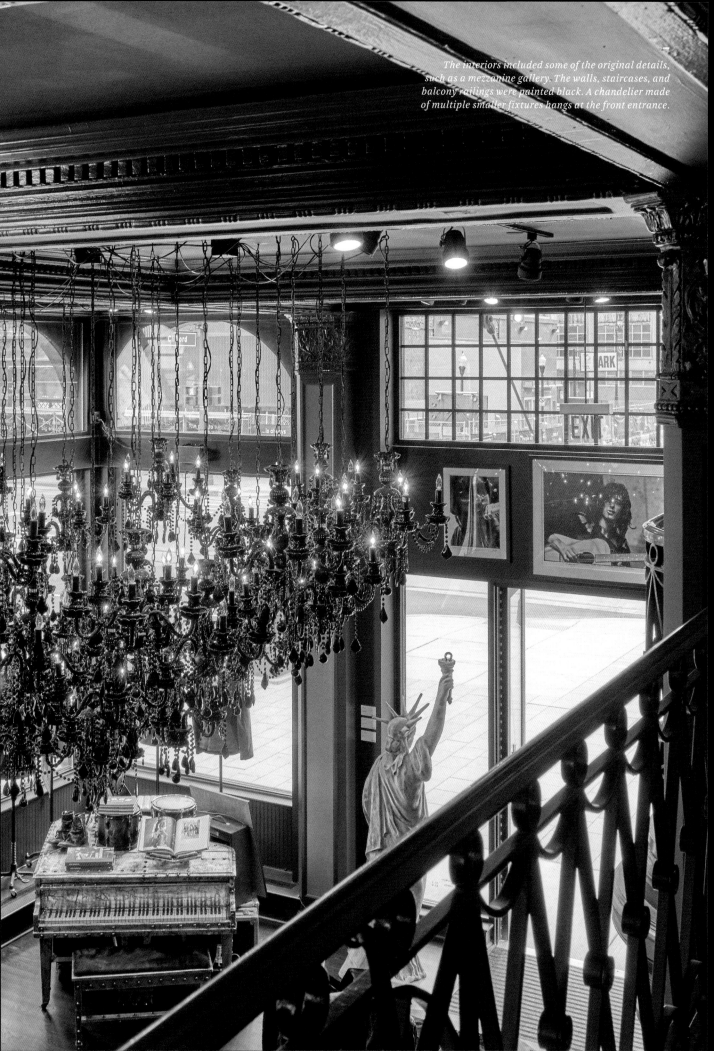

The interiors included some of the original details, such as a mezzanine gallery. The walls, staircases, and balcony railings were painted black. A chandelier made of multiple smaller fixtures hangs at the front entrance.

DPOP!

dPOP! began as the facilities team for Quicken Loans, but the business has developed into a full-service interior design company with projects all over the country. At first, the team, which is led by Melissa Price, was responsible for the design and build-out of all the offices for the mortgage loan company, and later they helped outfit spaces for tenants of Bedrock Real Estate Services, Dan Gilbert's real estate company, and other companies, such as Roasting Plant. They tapped into the way office environments are being reconsidered—think workstations, not cubicles. Their own corporate offices are housed in the basement of the former Dime Savings Bank Building, now known as Chrysler House, built in 1912. They moved there in 2013 after an extensive renovation. With architectural elements such as two intact vaults, the space was ripe for dPOP!'s imaginative, pop culture–influenced style. Mixing colors, materials, and themes, the space works with a creative flow and defies all old concepts of the workplace. As Price explains, "There's a lot of conversation about work-life balance. Everyone is asking how the two worlds can blend. We are looking for a common language as it relates to the mental and physical work that is happening. The creature comforts of home have to be accessible in the office as well. In both environments, you just want to feel like a whole person regardless."

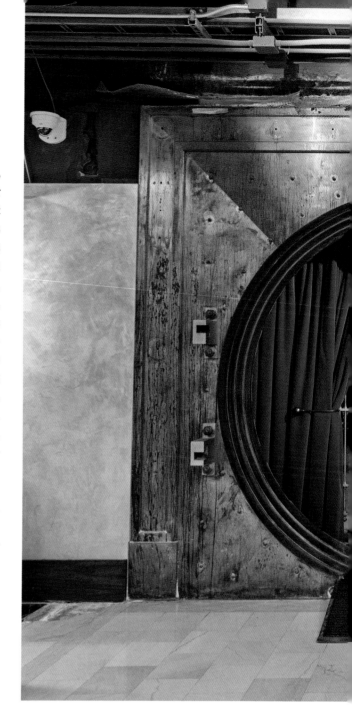

—
dPOP!'s designers left the safe-deposit boxes in place when they installed a conference room, called the Eleanor Twitty Parlour, in the second vault. They added a leather Chesterfield sofa, a crystal chandelier, and red velvet curtains at the entrance.

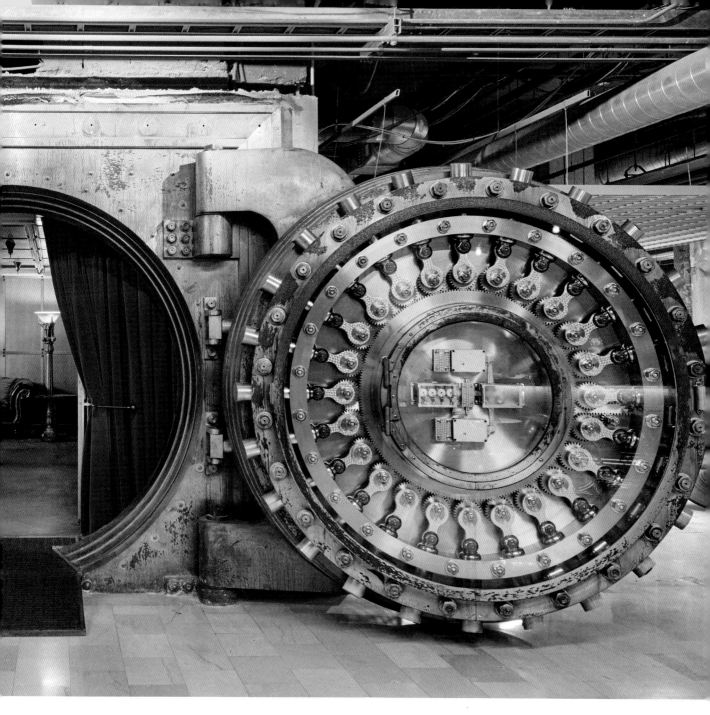

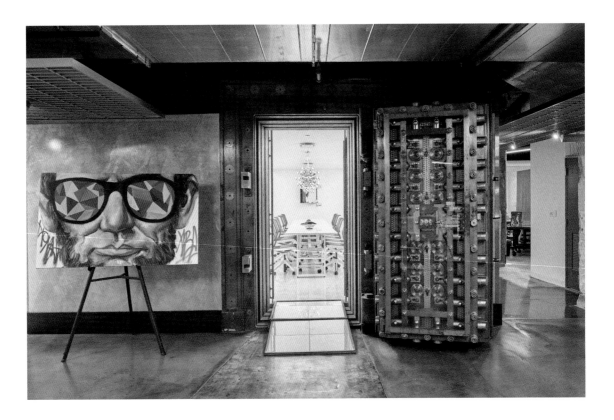

ABOVE

A painting by Désirée Kelly, Abe in Shades, *is on display in the main office.*

BELOW

It was important to the designers that the concrete columns, walls, and ceiling, with all their imperfections, were left unfinished and exposed. In some areas, such as this meeting room known as Weaver Hall, new floors and tiered seating were added. Office-wide meetings happen around the Ping-Pong table.

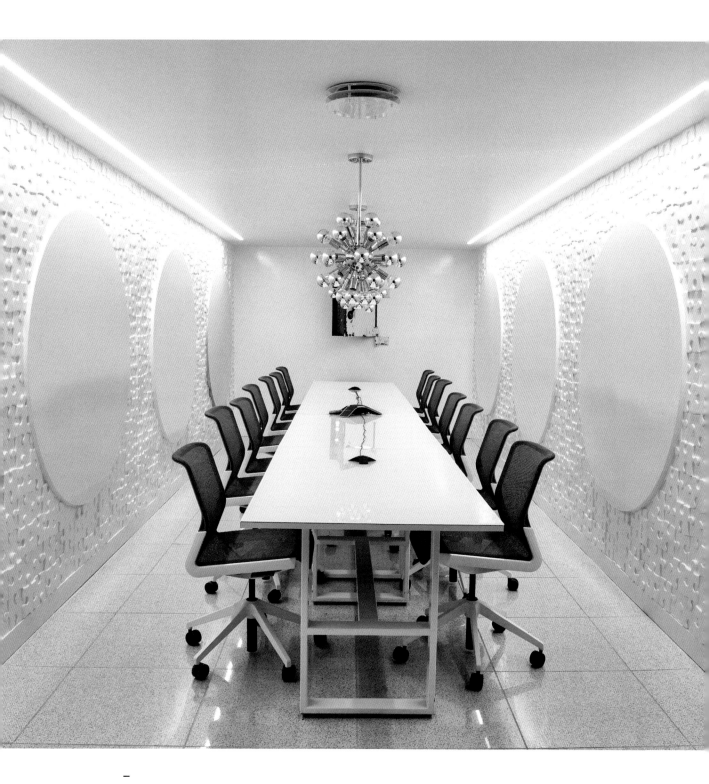

The film 2001: A Space Odyssey *was the inspiration behind the décor of the mostly white*
conference room known as HAL 9000, with its long table and sputnik chandelier. The walls
of the former vault are made of Interlocking Rock Panels by Modular Arts.

PHILLIP COOLEY AND KATE BORDINE

It seems that entrepreneur Phillip Cooley has always been on the move and always looking for a place to call home. Through all the projects that he has worked on, there has been a place for Phillip and, recently, his wife, Kate Bordine, to set up camp, only to be displaced by the growth of the places they are working on, for example, a room at Ponyride, the start-up incubator, or an apartment above the Slows Bar-B-Q restaurant. Finally, there is a permanent place in the works—this is the first home Phillip has owned in Detroit. In 2013, Phillip and Kate acquired a decommissioned firehouse in the West Side Industrial area near the Detroit River and started to convert it into a loft upstairs and space for their business partners in the project, Michael Chetcuti and Kyle Evans, on the ground floor. Phillip took advantage of the grand proportions of the building while keeping and showcasing original features such as the timber beams. Phillip, who along with his crew did the construction, also added details to give a sense of modern luxury, including an oversize bathtub in the master suite and custom-built walk-in closets. They even added a sauna and steam room, made from the slabs of the old shower in the firehouse, and there are plans for a glass-enclosed greenhouse on the balcony off the kitchen.

ABOVE

Exposing the existing wood beams emphasized the double-height ceilings. Steel beams reinforce the structure. Cooley converted the exhaust vents for the fire trucks into skylights. A collection of vintage chairs surround an industrial cart that was transformed into the dining room table. Polished concrete floors with brass inlays are found throughout the loft.

RIGHT

The façade of the firehouse.

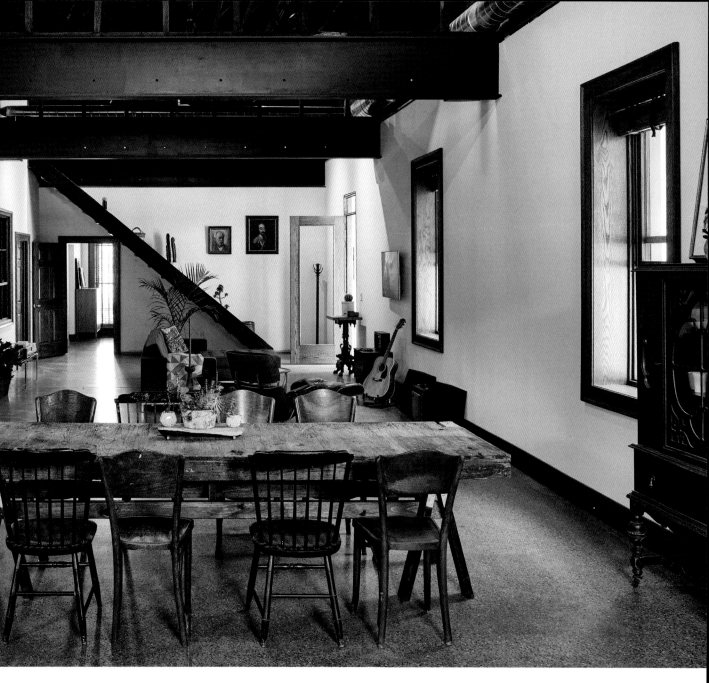

—

LEFT

The master bathroom includes elegant fixtures such as a crystal chandelier and a bathtub by Victoria and Albert. Two sconces by Cedar and Moss and two round antique mirrors sit over the double sink.

MIDDLE

Two long low cabinets with cement countertops define the kitchen: One creates an island for seating and the other gives room for appliances and a work area.

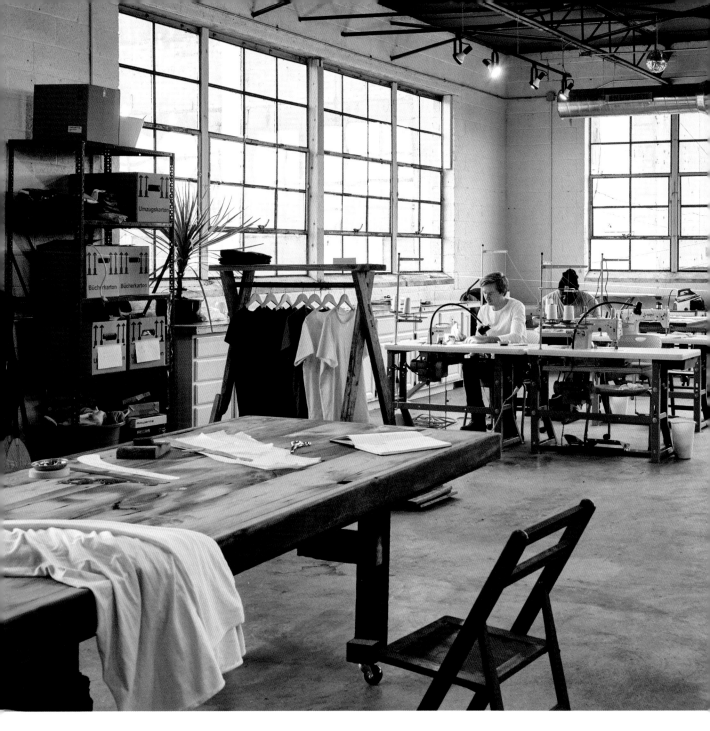

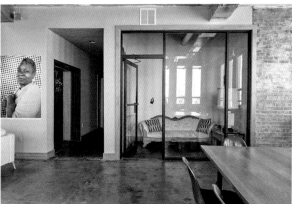

ABOVE

Lazlo, a luxury clothing company started by Christian Birky, has a space that includes sewing machines for manufacturing their T-shirt line.

LEFT + RIGHT

On the second floor, there are public areas that are open for all the businesses to use. These facilities consist of conference and meeting rooms, individual workstations, and a reference library that doubles as a phone booth, couch included.

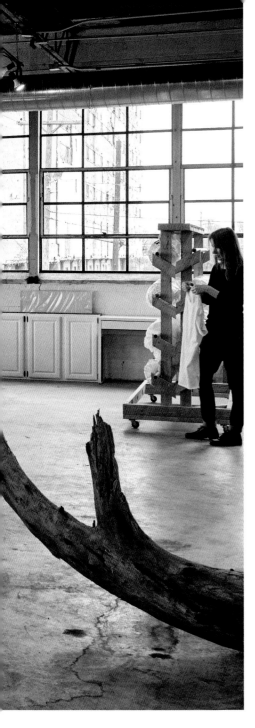

PONYRIDE

A nondescript former factory building has been turned into a beehive of entrepreneurship in Detroit. It's the energy from the new tenants that has set a new tone. The building is home to Ponyride, a start-up incubator that was founded by Phillip Cooley and his wife, Kate Bordine, both entrepreneurs. With a full board of directors and funding from organizations such as the Ford Foundation and Bloomberg, Ponyride has helped many of the small businesses launch. The reasonable rental rate, as well as the ability to mentor to or exchange services with each other, extends to start-ups such as Lazlo, a luxury apparel brand; Floyd, a furniture design company; Detroit Denim, a clothing company; and The Empowerment Plan, a business that makes coats that double as sleeping bags for homeless people. While Ponyride is not the only incubator in Detroit, the building and its interiors have a fresh vibe that's contagious.

—

A band of murals by Wen One wraps around the outside of the building. There is a café tucked into a corner on the ground floor, and red bicycle racks made by artist and metalsmith Taru Lahti.

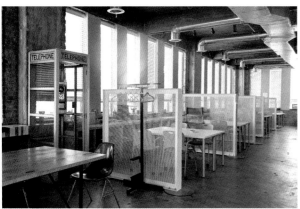

SHINOLA

What is a luxury watch and bicycle company—named after a shoe polish—doing in Detroit? When the founders of the company started looking for a place that would accommodate the type of workforce and production manufacturing that the new business needed, Detroit easily made the top of the list. The executive team also wanted to set up shop in a city where the company could make an impact. Known for its comprehensive employee training, Shinola employs over four hundred Detroiters, who work in the A. Alfred Taubman Center for Design Education building making watches or in the West Canfield shop in Midtown working on custom bicycles. The renovated and expanded flagship store offers the company's leather goods line, a bicycle shop, and a vibrant café that opens early for neighborhood residents and shoppers alike.

—

RIGHT

The redesign of the store opened up the ceiling, with its metal trusses and skylight. The company's bicycles are assembled on-site.

BELOW

Shinola's factory floor.

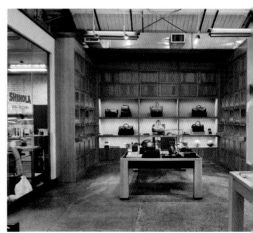

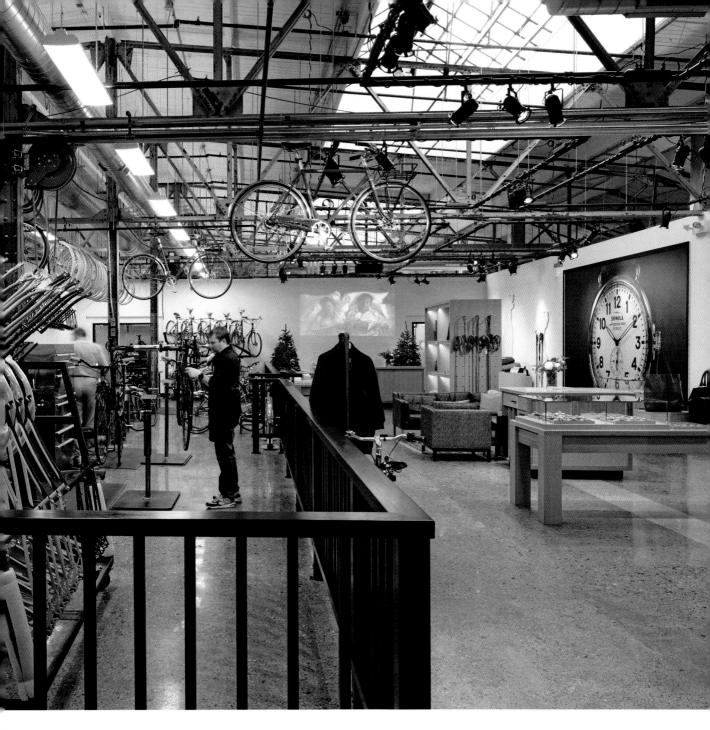

—

The company that is now associated with Detroit's renaissance moved into the brick flagship store, a former warehouse for the Willys Overland car company, in 2013.

MIDDLE

The shop's cases are made with a blond wood and inserted against the outer walls. Tables placed throughout the store make products easily accessible.

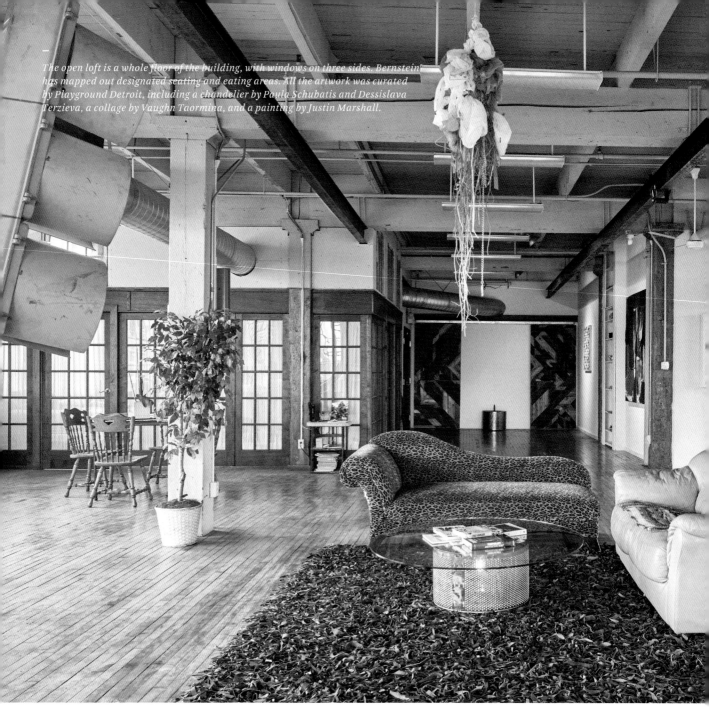

The open loft is a whole floor of the building, with windows on three sides. Bernstein has mapped out designated seating and eating areas. All the artwork was curated by Playground Detroit, including a chandelier by Paula Schubatis and Dessislava Terzieva, a collage by Vaughn Taormina, and a painting by Justin Marshall.

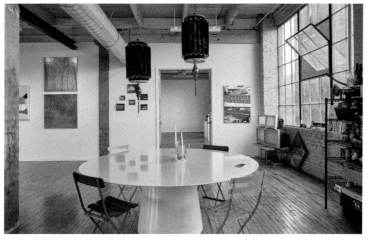

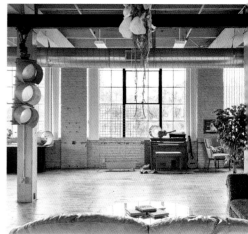

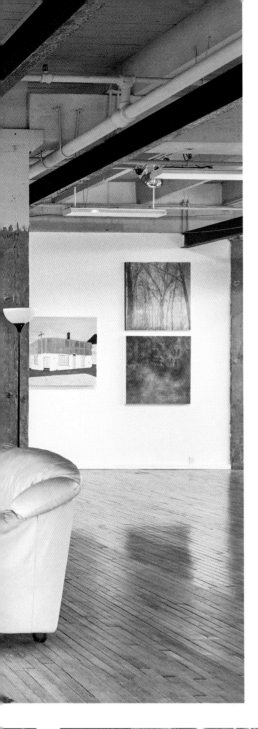

ERIC BERNSTEIN AND PLAYGROUND DETROIT

Serial entrepreneur Eric Bernstein, who has moved from Brooklyn to Detroit by way of New Orleans and a few other cities, built out this loft on the edge of Corktown. Bernstein hosts music events on-site and leased half of the space to Playground Detroit, an upstart art gallery run by Samantha Schefman and Paulina Petkoski. At one time, both Bernstein and Schefman also called the loft home. Her bedroom is discreetly tucked behind a gallery wall. His bedroom suite, complete with private bathroom, disappears behind two custom-made sliding doors. Shows in the gallery changed on a monthly basis and featured up-and-coming artists from Detroit. In 2016, Playground Detroit moved to a retail gallery space.

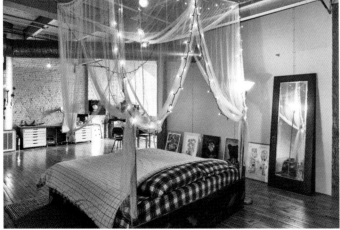

—

LEFT

Bernstein's bedroom has a canopy bed that floats in the center of the room.

MIDDLE

The space has plenty of room for the musical events that Bernstein hosts.

FAR LEFT

Artwork by artists such as Justin Marshall, Kristin Adamczyk, and Rachel Roze is displayed in the loft's kitchen.

LESLIE
ANN
PILLING

Leslie Ann Pilling was born in Detroit. Her parents were professors at Wayne State University. After living in the suburbs for most of her married life, she decided to make a change and move back to her hometown's east side in 2009. When she walked into the condominium complex known as Garden Court, designed by architect Albert Kahn in 1915, she felt a connection. The original graceful layout of the apartment, with its views on both west and east sides, shines through despite some of the later unfortunate modernizations, such as dropped air ducts and holes in the flooring where radiators were removed. The apartment has room for both her fashion business and her collection of antiques, *objets*, and artifacts. Small features of Kahn's design sing out—the elegant proportions of a French door and its hardware, for example, still survive.

An antique mirror reflects one of Pilling's clothing designs on a mannequin.

The center hall entryway welcomes visitors into the apartment.

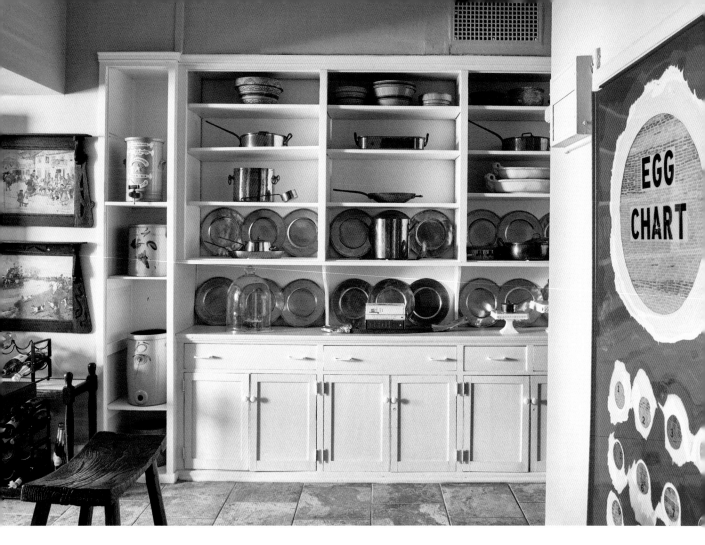

—

ABOVE

The kitchen cabinets are original Kahn designs.

LEFT

The dining room displays Pilling's varied collection of furniture and antiques.

OPPOSITE, ABOVE

The living room of the apartment, with its baby grand piano and a wing chair.

OPPOSITE, LEFT

One of Kahn's French doors.

OPPOSITE, RIGHT

Two black masks hang above an antique dresser.

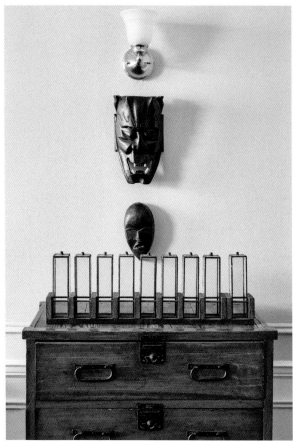

Once a Grand Trunk Railroad line that brought cargo from the Detroit River to Eastern Market, the Dequindre Cut is a public park that links these two locations and beyond. Runners, walkers, and bikers take full advantage of the traffic-free roadway. The park is part of the federal government–funded Rails-to-Trails program that includes the High Line in New York City. Artists were invited to paint murals on the concrete slab walls of the remaining underpasses. Plans to extend the line were completed in 2016.

—
In 2016, the Dequindre Cut was extended to Mack Avenue.

–

The below street level greenway extends two and half miles.

–

Fragments of bridges and overpasses remain as part of the park.

Onassis CONEY ISLAN

OPEN

4 THE FOOD
SCENE

CAR ACCIDENT
1.800.411.PAIN
nt Attorneys

OUTFRONT

CORKTOWN

EATON
DETROIT SPRING INC
313.963.3839
www.eatonsprings.com

OPEN

REIMAGINING A FLAVORFUL CULINARY PAST

–

Essay by

JENNIFER A. CONLIN

THE NATIONAL MYTH about the Detroit food scene is that it has erupted out of nowhere. That the revitalization efforts have spurred a flurry of new eateries where there were previously nearly none, and that fast food chains were until recently the accepted norm.

Discovering the truth, however, like everything in Detroit, requires talking to long-term residents. They will quickly tell you the Motor City has, in fact, a much-celebrated gastronomic heritage, which has endured every hardship—economic, political, and racial—yet continuously fed its people more than adequately. It dates back to the early 1900s, when the migration of Greeks, Jews, Poles, and Hungarians, followed soon after by African Americans and Mexicans, made the city not only one of the most diverse in the country but a culinary midwestern mixing pot.

Barbecued ribs with collard greens could be found as easily as kielbasa with pierogis, stuffed grape leaves with moussaka, or pork tacos with salsa. One could also find a Coney dog (which many say got its start in Michigan, not New York), Great Lakes fish, deeply layered pizza, and fried frog legs (in 1910, Detroit produced, shipped, and consumed twelve tons of frog legs). The city's cuisine was not just hearty but happy, lovingly prepared for both the autoworker and the executive and served in both hotel dining rooms and street-side shacks.

That is still the case.

What is nationally notable, however, is the spate of restaurateurs and chefs opening new cafés, bistros, bars, bakeries, and diners throughout the city. Many are returning home, having worked for years in other places, knowing that Detroit's affordable rents and hungry clientele equal opportunity in the highly competitive restaurant industry. They are also coming back infused with respect for the past but wanting to help develop the city's future. To that end, they are reimagining the spaces, ingredients, and themes in their establishments, ever mindful of those who cooked, worked, and lived in them previously, offering a nod to history imbued with a modern twist. They are also partnering with food producers, from farmers and gardeners to pickle and cupcake makers, to support as many local businesses as possible.

The owners of Wright & Company decided to renovate the second floor of a historic Downtown building, turning a turret into a dining nook and the ceiling into a tin canopy. Kuzzo's Chicken & Waffles serves blackened catfish with creamy grits under the watchful eye of a colorful portrait of Barack Obama. Everyone is gaining inspiration from the city's cultural legacies. Antietam, located in two restored art deco buildings, is named after a street in a once-thriving black neighborhood that was demolished in the sixties. A new generation has emerged at Sweet Potato Sensations, bringing foot traffic to one of the most blighted neighborhoods in Detroit by expanding the family's nearly thirty-year-old business to include savory items along with sweets.

Another difference is the quality of food that is increasingly available. Due to a dearth of grocery stores in the city—a problem that is slowly being rectified—urban farms have been cropping up in Detroit's empty landscapes for decades. Earthworks and D-Town Farm have been gardening the longest, helping to address Detroit's food security issues by hosting weekly markets, distributing seeds, and training gardeners. Now the city is filled with urban gardens, like Lafayette Greens, a Downtown space outfitted with reclaimed and repurposed pallets and doors, growing more than two hundred types of organic vegetables, flowers,

herbs, and plants, with donations going to area food banks. Then there is RecoveryPark, which operates a pair of smaller urban farms, growing vegetables like radishes, greens, and edible flowers, while simultaneously helping people with substance abuse problems maintain their sobriety.

Anchoring the food world of this large city of 140 square miles is Eastern Market—one of the oldest open-air markets in the nation—where some 250 vendors sell everything from fruits and vegetables to local cheeses, jams, honey, sausages, and artisanal breads. It is a food lover's haven on a Saturday morning, when one can dine just on samples while meandering through the outdoor and covered sheds year-round, and receive an education on a variety of tasty nonprofits. Sip a free cup of Detroit Bold and learn about a company whose goal is to open coffee shops in the most economically deprived neighborhoods. Or buy a box of cranberry-date "Mitten Bites" prepared by the Detroit Food Academy's high school students.

But it is in the city's newest, top-end restaurants (nearly all of which have kept their prices below twenty dollars with filling, small-plate dishes) where one sees both the space and the food transformed in a way that truly feels authentic to Detroit.

In the historic, triangular-shaped Grand Army of the Republic (GAR) building in Downtown Detroit, one finds Republic Tavern. The 1897 five-story structure with arches, towers, and columns was originally used as a meeting place for Union Army veterans of the Civil War. Now, with its blue décor (the same hue as Union soldiers' uniforms) and menu featuring items like a tart rhubarb fritter, sweet potato pierogi, cheek fried steak, and house meatballs, it is attracting both older diners nostalgic for meat and potatoes and younger customers wanting gourmet vegan food.

Though Selden Standard did not restore a building so much as repurpose it (it was a dry cleaner), the efforts the owners put in—an exterior finished in natural wood planks and dark gray brick, and a modern interior with a cedar dining room and bar—have transformed the street in Midtown Detroit. With a wood-burning oven behind the bar, the restaurant serves what they call "seasonal rustic" food, created from ingredients procured from nearly thirty local purveyors, including a grilled chorizo dish and a vegetable carpaccio.

The chefs at Wright & Company, Antietam, and Chartreuse, a beautiful farm-to-table restaurant with a flower garden literally growing out of one wall, all laugh at the constraints of space they face in their elderly buildings—small kitchens with little food storage. But they also say it has forced them to work with what they can buy fresh each day. Nor does it seem to be stifling their creativity. At Antietam, a plate recently emerged with delicately breaded frog legs served with a tangy sauce. It felt like a dish that might have been served in a Detroit jazz club in the twenties. At Wright & Company, a sirloin steak smothered with white cheddar cheese, bacon, and scallions could have been a meal for a *Mad Men* client dinner, and at Chartreuse, a dish of spareribs with a red potato and a seaweed salad in a soy glaze was Detroit street food at its most elegant.

Most recently, The Peterboro opened in early 2016 in what was once Detroit's Chinatown. Decorated in red, gold, and black—with hanging lanterns and a towering, dimly lit glass bar glistening with bottles— it is an elegant redefinition of a sixties Chinese restaurant. But it is the food that is truly signature. Not just their small plates of crisp pork belly, crab Rangoon, and salt and pepper shrimp but the almond boneless chicken, otherwise known as ABC. It is said to be a Chinese dish that originated in Detroit. The Peterboro's version is true to the recipe—deep fried in beer batter, drizzled with brown gravy, and served with almonds—but spruced up with added spices and flavors. In other words, a Detroit dish reinstated in all its wisdom and glory for a new hopeful era.

But perhaps Katoi, which opened in the spring of 2016 in Corktown, is truly capturing the essence of the city by not defining themselves. Located in a former garage they now call a "spaceship," what began as a food truck is now a three-room restaurant, boasting a bar, booths, a communal table, and even a live radio show on Saturday nights. The food—everything from duck noodles and chickpea tofu to stir-fried Nira flower and Panaeng curry—claims to represent not Detroit or Thailand but, rather, "everyone who walks through the door."

The building in 2013, before it was transformed into a restaurant using the signage of the pawnshop, Gold Cash Gold.

GOLD CASH GOLD

Once a pawnshop on a now-popular block of Michigan Avenue, Gold Cash Gold has retained the signage, but that's about it. There's very little indication of the history of the building left inside. As in all of his projects, Gold Cash Gold is another testament to Phillip Cooley and his team, which includes his sister-in-law, writer Megan McEwan, who have transformed the interior into a smart modern restaurant. Repurposed materials were used in the design in unexpected ways; the floors came from an old school gymnasium, and the ceiling's chevron pattern was made using recycled wood from the pawnshop walls. The whitewashed brick walls also give a handmade yet elegant feel to the place, and the menu follows course thanks to chef Josh Stockton. The dishes have a sophisticated American bent.

Interview with

PHILLIP COOLEY

FOUNDER, PONYRIDE, A START-UP INCUBATOR,
& CO-OWNER, SLOWS BAR-B-Q AND GOLD CASH GOLD

MICHEL ARNAUD: *When and why did you move to Detroit?*

PHILLIP COOLEY: I moved here in 2002. As a teenager I came down to Detroit from Marysville for the music, art, and food. When I turned eighteen, I went to Chicago, where I ended up going to school and getting a film degree. Then I worked mostly overseas for two years as a fashion model—a great travel experience, a chance to see the world.

Working in Europe and traveling made me less afraid of Detroit. It made me respect, understand, and appreciate the things that I loved about this town even more. I was reading Dave Hickey's *Air Guitar*. In it, Hickey talks about being part of a community where you can make a difference. To me, it was Detroit. I came here not knowing a single person.

MA: *Why did you choose to locate your businesses in the neighborhood of Corktown?*

PC: Corktown is the oldest surviving neighborhood in Detroit, and it's got some good bones. I believed it could be far more than what it looked like at the time. I felt Detroit was the place where I could participate. I felt Detroiters would be collaborative and would look to you as a neighbor versus a competition. That was one thing I was right about. We do so much more with less here because we have to, or are forced to. It's very purpose driven.

MA: *How did Ponyride come about?*

PC: I really believe in triple bottom line business. I love the environment and the social impact the entrepreneurs can have. When my partners and I looked around, we saw ourselves on a bit of an island. We started saying, how can we help others? I remember when we built Slows, the architect charged us $800 instead of $8,000. Our friends and family, who all had nine-to-five jobs, would come down and help. So many people supported us for free that we felt like we needed to support others in the same way.

The first project was Le Petit Zinc. Charles [Sorel] asked me to help him out. He was a black Jewish-French guy from Brazil who wanted to open a restaurant. In fact, he didn't need me at all, as it turns out. He'd already built everything except the tables. He just didn't know how to get set up legally. So we pulled his permits, did his architectural drawings, and built his tables. It was a lot of fun as people pitched in and helped. I realized it wasn't about me; it was really about how fortunate and privileged I was to be able to afford the time and space to be able to do something like that. I really want to live in a great and diverse community. Yet we have to combat the modernization process. I lived in a lot of cities where I would watch people getting forced out, neighborhood by neighborhood, pushed farther and farther out. For me, it was always about ownership.

To tell the truth, when Detroiters have the ability to work again, they will. And they will have the ability to innovate! That's what I am interested in. Instead of blaming Detroiters for the conditions that have been forced upon them. I think Detroit will be able to save itself, and it will do just fine.

"I FELT DETROIT WAS THE PLACE WHERE I COULD PARTICIPATE."

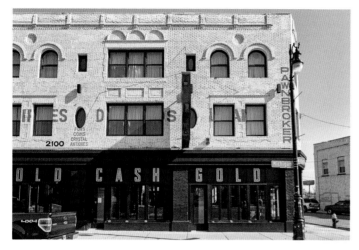

—

The newly painted restaurant kept some of the outdoor signage of the pawnshop.

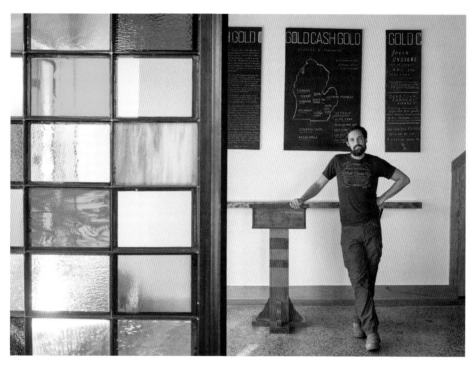

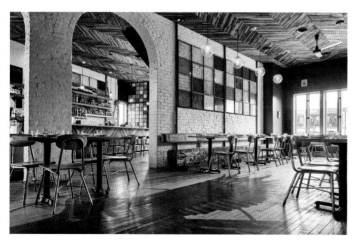

—

ABOVE

Co-owner Phillip Cooley, who did a lot the interior design work with his contracting team, stands at the entrance.

LEFT

The main dining room has a wooden floor recycled from a high school gymnasium.

LAFAYETTE GREENS

In the center of Downtown Detroit, there is an urban garden, Lafayette Greens, named for the building that once stood on the site. The nonprofit the Greening of Detroit has taken over the ongoing maintenance, which is supported by their staff and volunteers. The Compuware Corporation initially sponsored the garden and hired landscape architect Kenneth Weikal to design the plot. The plan uses a series of movable custom-designed raised beds and planters as the base and includes three freestanding sheds made with wooden pallets and aluminum sliding. The site drops three feet from north to south, so the designers put taller planters on the north side and shorter planters that were more accessible to children on the south end. To that end, the architects inserted a small children's garden near the back garden wall. Fruits, vegetables, and flowers are grown in the garden and donated to a local community food bank. The garden is open to the public so passersby and office workers can enjoy the outdoor seating areas built into the design.

—

RIGHT

The urban garden Lafayette Greens is downtown between Michigan Avenue and Lafayette Boulevard.

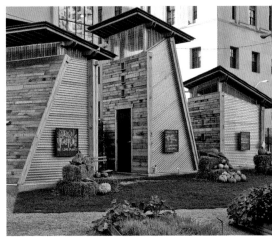

FAR LEFT

Hallmarks of the garden's design include gravel pathways, raised beds with aluminum siding, and minimalist bench seating.

MIDDLE

The three garden sheds were made using recycled materials.

LEFT

A living wall was placed against the brick wall of the building next door.

ANTIETAM

Artist-photographer Gregory Holm opened the restaurant Antietam—named for a nearby street—in summer 2014. Holm took over two small art deco buildings on Gratiot Avenue near Eastern Market a few years earlier and spent time renovating the exteriors, replacing the façades with new tiles crafted by local artisans. The interiors of the two dining rooms and bar have a similar vintage feel. Holm collaborated with artists and artisans to create the layered darkened wooden boards over brightly painted walls and used pressed tin on the ceilings. While the bill of fare, featuring sweetbreads and *entrecôte de boeuf*, has a decidedly French feel, the handcrafted dining experience is Detroit all the way.

—

The main dining room features a wall of black leather banquettes as well as lighting fixtures Greg made in collaboration with two artists—Katie Westgate made their porcelain bases, which are covered with copper-finished aluminum chain woven by textile artist Monica Hofstadter. The silver and rust-colored wall treatments are contemporary frescoes, which were created on canvas by Paul Seftel and adhered to the walls to give the sense of aged metal and stone.

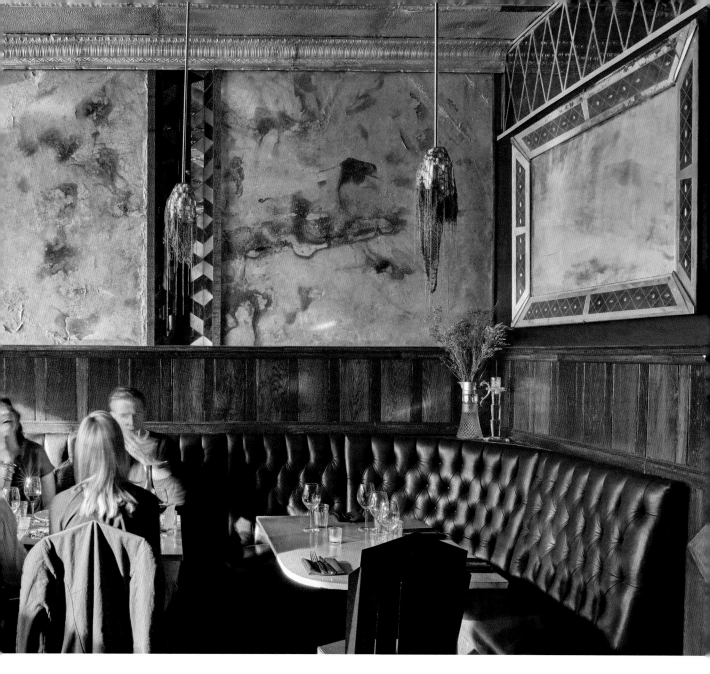

—
A view of the bar. The stepped-pyramid geometric pattern from the front façade is picked up in a ceiling detail.

The exteriors of the two-story building and the smaller structure next door were both replaced by owner Greg Holm. The geometric patterning of the details hints at the art deco designs inside.

The interiors have dark wood paneling over brightly painted walls. Holm kept
the roll-down security gate that once separated the two buildings and added
more delicate accessories, such as the brass sconce and mirror.

KUZZO'S CHICKEN & WAFFLES

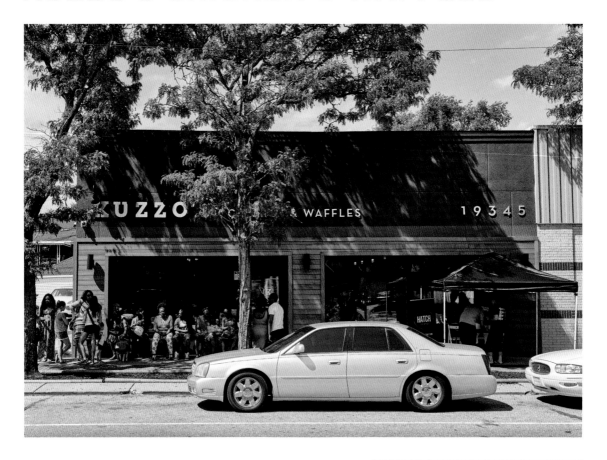

When the line to get into a restaurant stretches down the block, it's a pretty good indication they are doing something right. There is always a line at Kuzzo's Chicken & Waffles on Livernois Avenue, which opened in January 2015 and has been a partner in the neighborhood's revitalization. Owned by former Detroit Lion Ron Bartell, the restaurant is named after a term of affection for someone who is a cousin or considered family. There's an instant feeling of familiarity when reading the menu, which includes not only chicken and waffles but other home-style Southern comfort dishes—shrimp and grits, cornbread, biscuits and gravy. Work by local artists, curated by the Red Bull House of Art, adds to the joyful atmosphere.

—

ABOVE

One summer Sunday morning, people wait outside for a table at Kuzzo's Chicken & Waffles on Livernois Avenue.

BELOW

The restaurant's name is explained above the bar at the front.

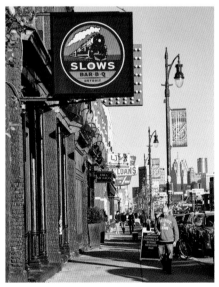

Some may argue that Slows Bar-B-Q started the now exploding food scene in Detroit. There were many interesting and fine dining restaurants in Detroit long before Slows opened in 2005, but it's true that it started a movement to repurpose buildings in Corktown as well as provide casual dining in a space that is both handmade and designed. Phillip Cooley and his family along with chef Brian Perrone were out to create a place where the food and the décor were well thought out, authentic, and accessible. More than a decade later, the combination is still a success.

—

ABOVE

A view of the bar area.

BELOW

Slows Bar-B-Q was one of the first restaurants to be renovated on a Michigan Avenue block in Corktown, Detroit's oldest neighborhood.

JOLLY PUMPKIN ARTISAN ALES

Although not native to Detroit (they have three other locations in Michigan), Jolly Pumpkin Artisan Ales has captured the Detroit vibe in their first brewery in the city. Owner Ron Jeffries and his team selected a Midtown location that was a former garage for the Willys Overland car company. 2Mission Design and Development created the design for the space. They decided to keep elements of the original building, including a wall of windows that looks out onto the alley next door. They also chose to leave exhaust pipe systems exposed and cover the walls with repurposed wood. Overall the space has a warm yet airy feel, given the twenty-foot ceilings. Craft breweries are not uncommon in the area—Motor City Brewing Works is right across the street, and HopCat is a few blocks away on Woodward Avenue. Jolly Pumpkin serves pizza and other light fare but is best known for its sour beers aged in oak barrels.

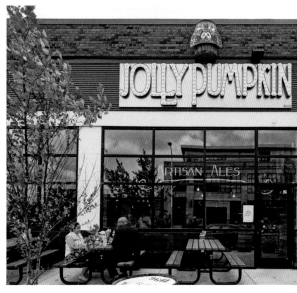

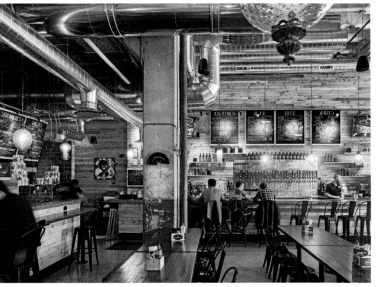

ABOVE

The entrance of Jolly Pumpkin. The space is a former garage that has a new life as a brewpub and pizzeria.

LEFT

The industrial elements, such as exposed concrete pillars and exhaust pipes, figured into the interior design.

FAR LEFT

There's outdoor seating at the West Canfield location in Midtown.

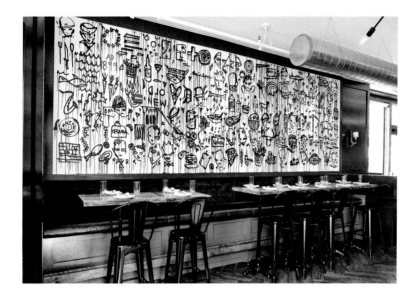

—
A painting of Detroit landmarks by Gregory Siff hangs in the bar area.

REPUBLIC TAVERN AT THE GRAND ARMY OF THE REPUBLIC BUILDING

The historic Grand Army of the Republic building on Grand River Avenue at Cass Avenue first opened in 1897 to serve as a gathering place for Civil War veterans of the Union Army. The land for the building was donated with the stipulation that the building would remain open to the public. Tom Carleton and his team's proposal to develop the building won the city's approval—a restaurant seemed like a great way to honor the public-access mandate. Working with Los Angeles designer Peter Gurski, Carleton decided to give the interior a nod to its former occupants, picking up a dark blue color scheme from the Union soldiers' uniforms. Other details also make a historical connection, such as the copper fitting of the bar. The menu is American contemporary with an emphasis on "tavern cuisine" and craft cocktails, which are served at the friendly bar at the entrance of the restaurant.

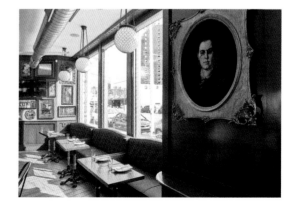

—
A view of the cozy bar in the front of the restaurant.

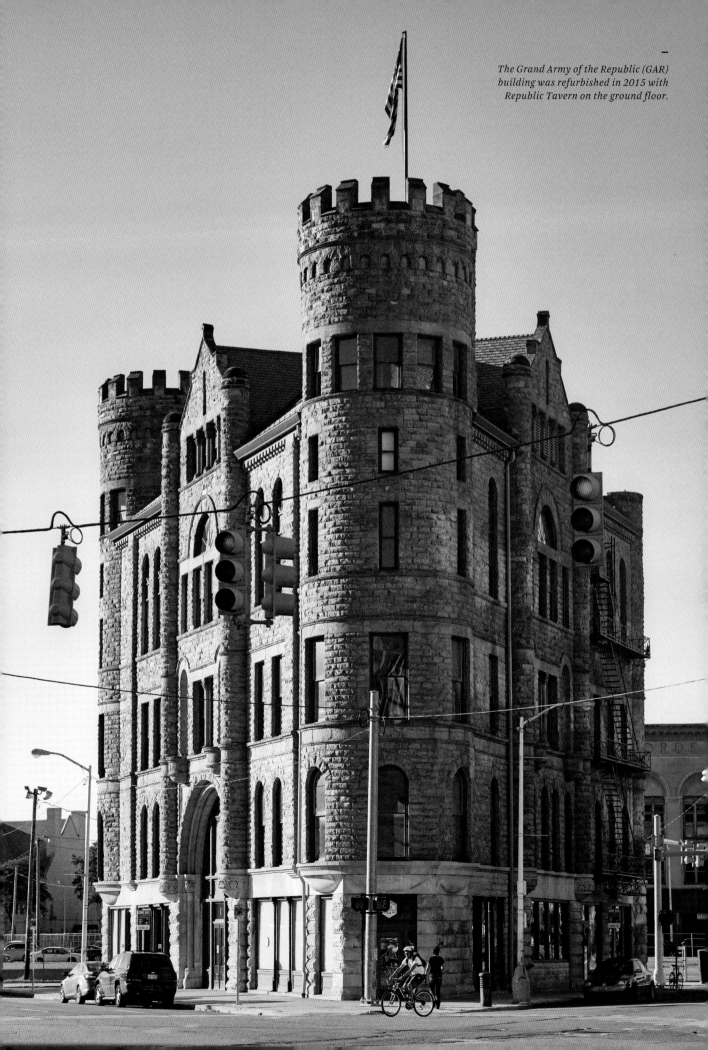

The Grand Army of the Republic (GAR) building was refurbished in 2015 with Republic Tavern on the ground floor.

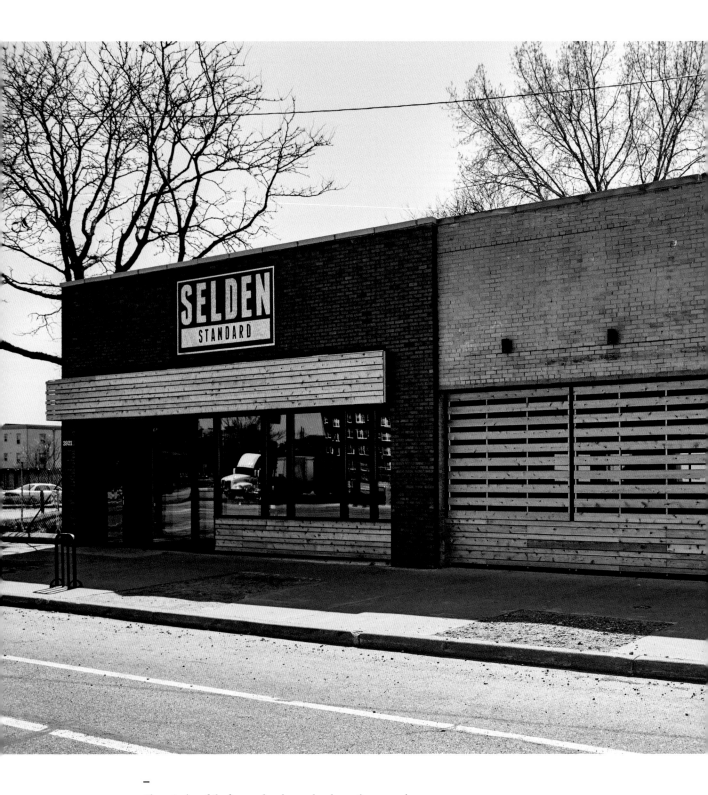

_

The exterior of the former dry cleaner has been given a modern treatment with recycled wood inserts and add-ons.

SELDEN
STANDARD

Partners Evan Hansen and executive chef Andy Hollyday met by coincidence. Each was looking to start a new food venture in Midtown. After a few failed attempts at finding the perfect space, they came across a low building that had been home to various establishments, including a dry cleaner and a church. Once the chef and his team had the kitchen design down, architects Tadd Heidgerken and Kristen Dean at et al. collaborative worked out several overall floor plan options. They, too, happened to be starting their firm at the same time and knew the owners through friends. The chosen result is a neatly arranged modern restaurant with elements of warmth, such as the recycled wood drop ceiling, the open pizza oven station, and a sunny patio in the back. Their menu is self-described as local and seasonal. Two James Beard Award semifinalist nominations for Chef Hollyday would seem to say they are spot on.

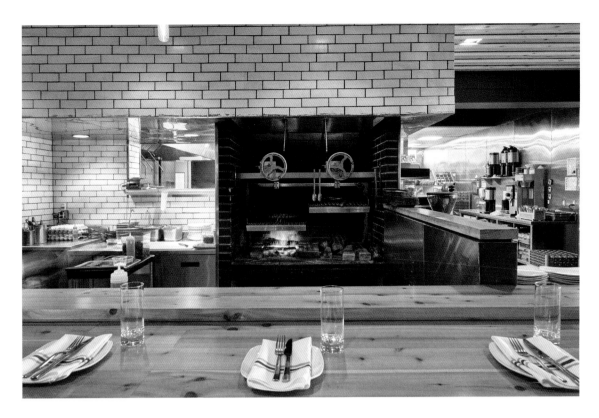

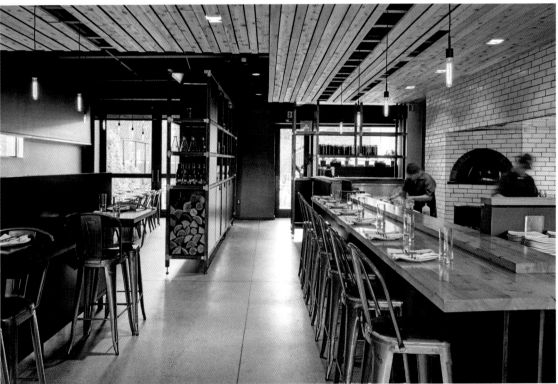

The wooden bar at the entrance, the drop ceiling of repurposed wood,
and the pizza oven create a homey feeling in the main room.

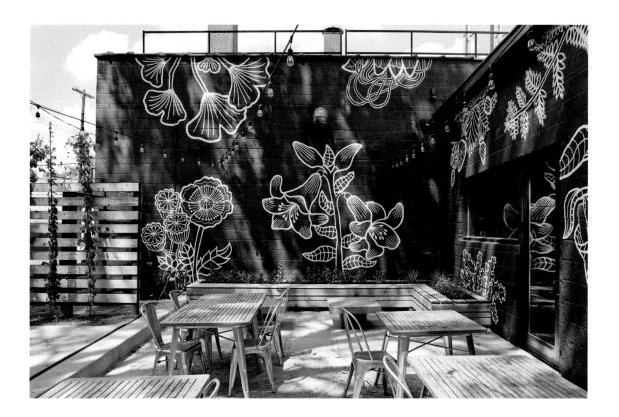

ABOVE

Artists Heidi Barlow and Shaina Kasztelan painted the mural on the back patio wall.

BELOW

The back garden also holds the restaurant's woodshed and is open for lunch and dinner as long as the weather permits.

WRIGHT & COMPANY

Dave Kwiatkowski and Marc Djozlija, a craft cocktail creator and an innovative executive chef, respectively, decided to combine their talents into one dining and drinking experience. Wright & Company opened in the spring of 2015 in an unconventional second-floor loft space downtown on Woodward Avenue. A long, elegant bar with a dramatic, mural-size seascape painting stretches down the length of the room. Double-sided leather banquettes with custom-made standing fans fill the center of the restaurant. An elegant crystal chandelier hangs over a large corner table in the front window that overlooks the street below. Djozlija prepares surprisingly complex and delicious small plates, which suit the after-work crowd of Detroiters, suburbanites, and tourists who pack the restaurant.

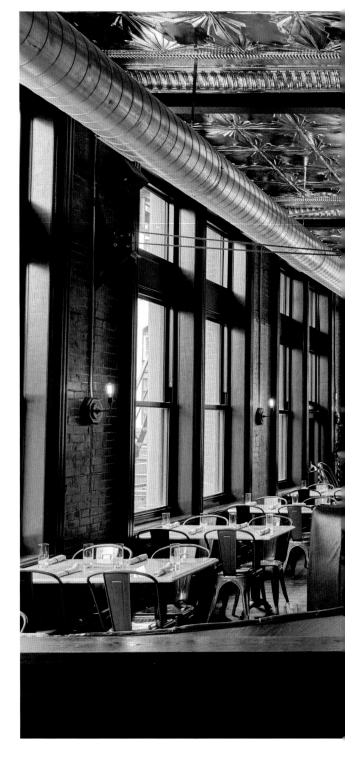

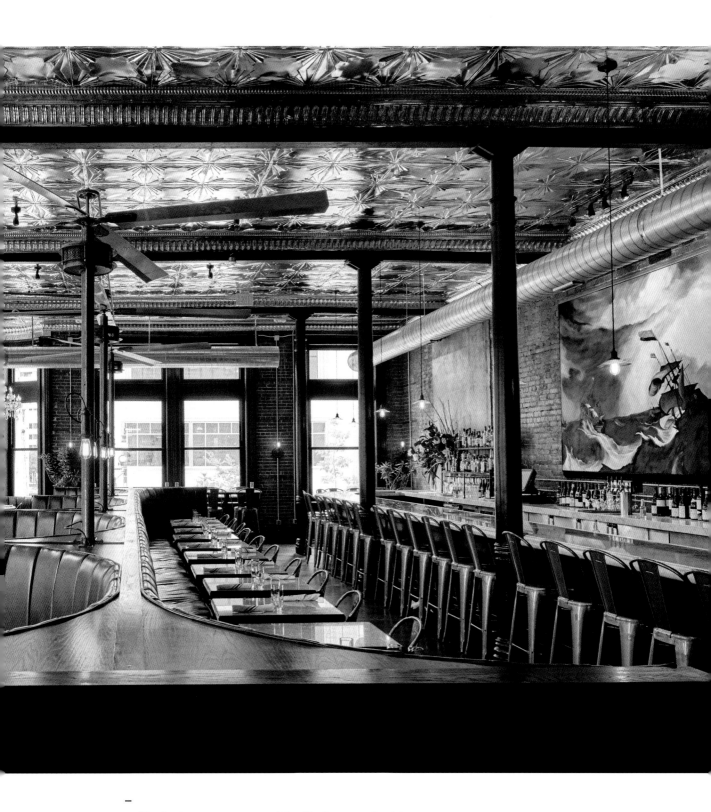

Red leather banquettes create an island in the center of Wright & Company's
main room in a second-floor loft above Woodward Avenue.

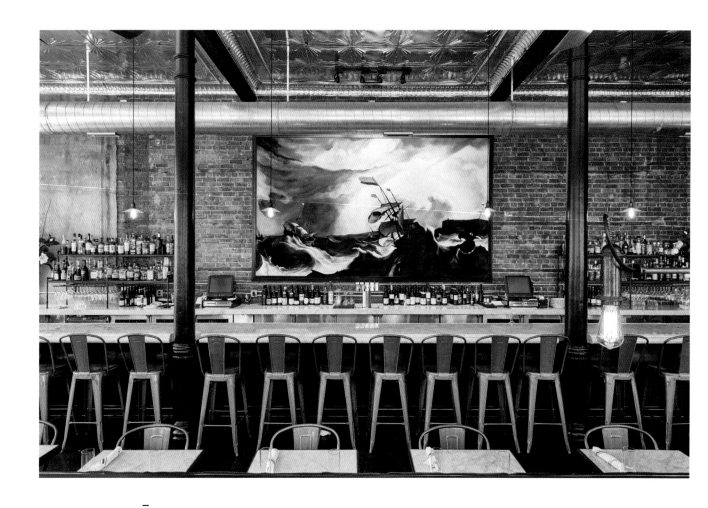

—

ABOVE

Exposed brick and ductwork, as well as silver pressed-tin ceilings, create the backdrop for the giant seascape painting over the marble bar.

OPPOSITE

Tucked in a corner is another curved banquette and chairs. The crystal chandelier above adds a touch of glamour to the industrial elements.

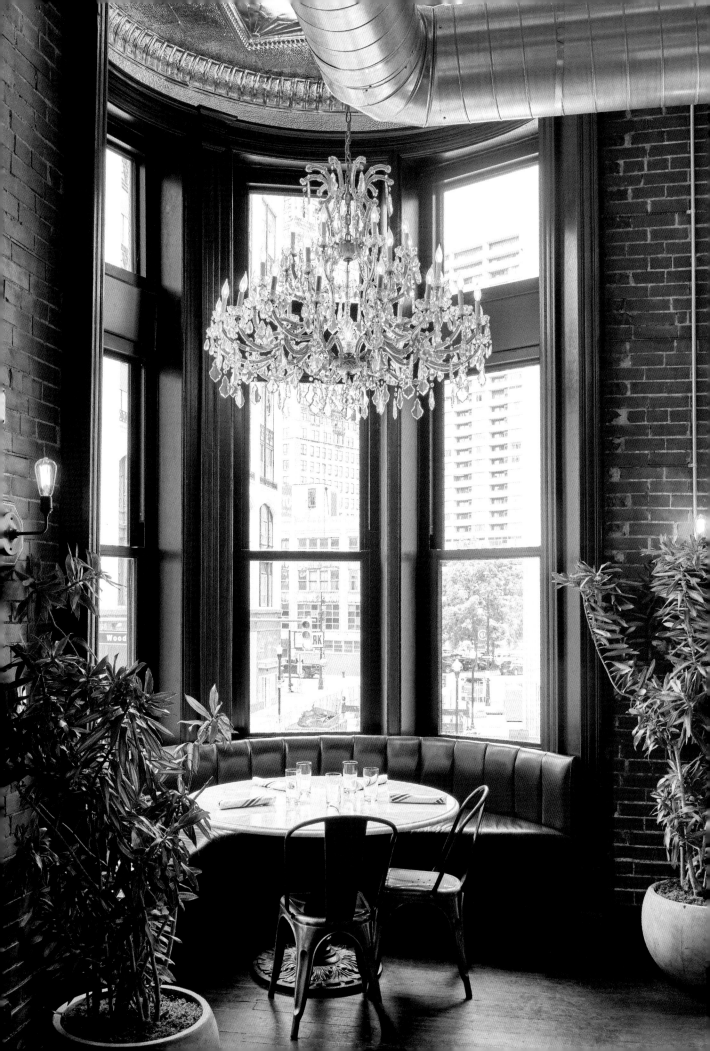

CHARTREUSE
KITCHEN &
COCKTAILS

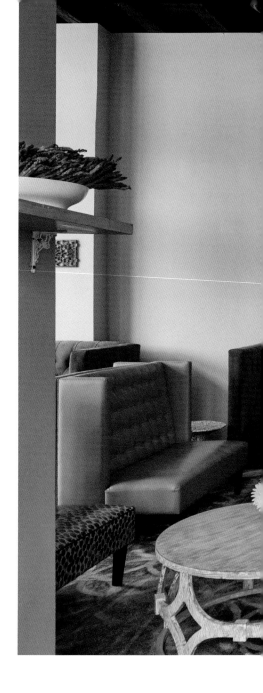

Chartreuse Kitchen & Cocktails is named for the famous French liquor made from over 150 herbs. The owners, Heather and Sandy Levine, have also used the liquor's ingredients as inspiration for the décor, food, and drink. References to flowers and herbs abound with a mural by Louise Chen, aka Ouizi; plant walls by Chris Best of Lady Lazarus; and hanging dried flower installations by Lisa Waud from pot & box. The walls are painted a yellowish green throughout the unusual multilevel dining room, which has a large, comfortable bar area at the entrance. The American farm-to-table carte du jour is filled with local and seasonal ingredients. The restaurant is located a block north of the Detroit Institute of Arts in the storefront corner of the Park Shelton condominium tower, which is where Frida Kahlo and Diego Rivera lived when Rivera was working on his famous Detroit Industry murals.

ABOVE

The chartreuse-colored walls featured throughout the restaurant are shown here in the front room with its comfortable seating area. A living wall installation by Chris Best of Lady Lazarus is by the front bar.

LEFT

A floral mural by artist Louise Chen, aka Ouizi, is at the front entrance.

OPPOSITE

A view from the upper level through one of Lisa Waud's dried flower installations that divide the two areas.

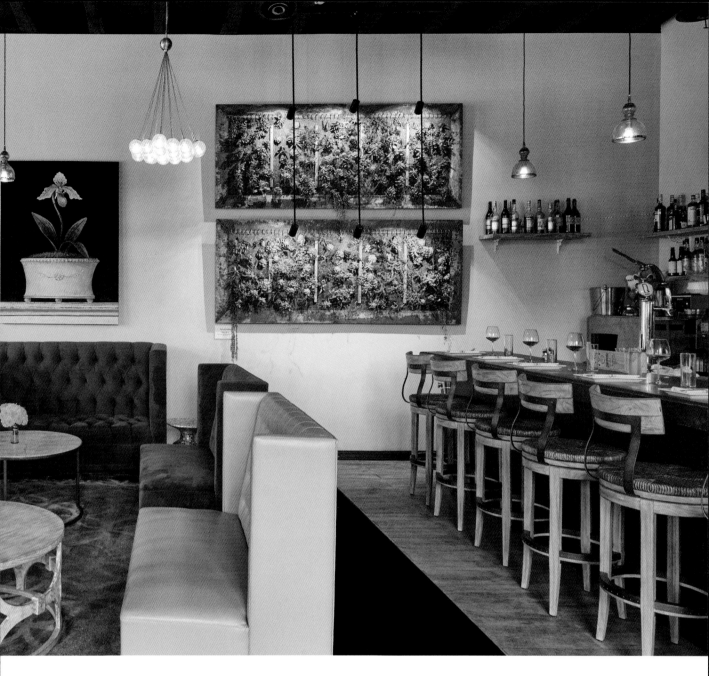

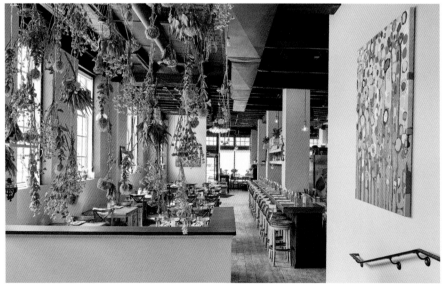

EASTERN MARKET

Eastern Market is the center of all things food in Detroit. Farmers and wholesale vendors from across Michigan bring their wares, produce, and food products to the market on Saturdays, and to a smaller version on Tuesdays, throughout the year. It is a testing ground for new foods and a direct connection to the public for many farmers and suppliers. There are five sheds, which have both indoor and outdoor features and are open according to the season. It is a rich cornucopia of regional harvests that has existed in the same forty-three-acre location since the late 1800s. The businesses that surround the market—meat processing plants and packinghouses, restaurants, clothing stores, galleries, and letterpress studios—thrive on the crowds that come to town on market days.

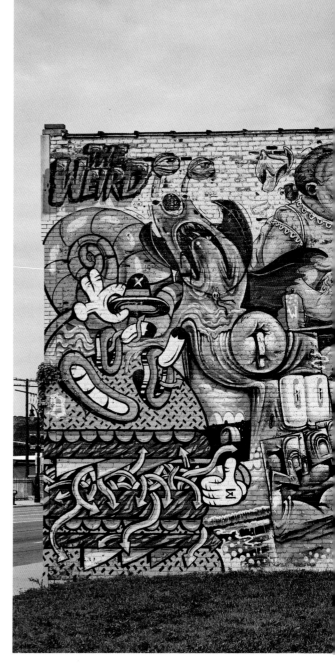

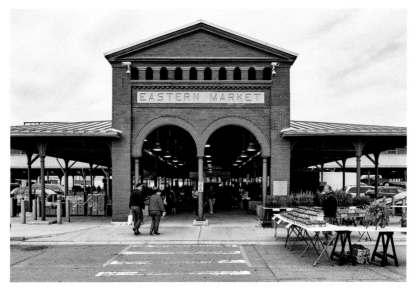

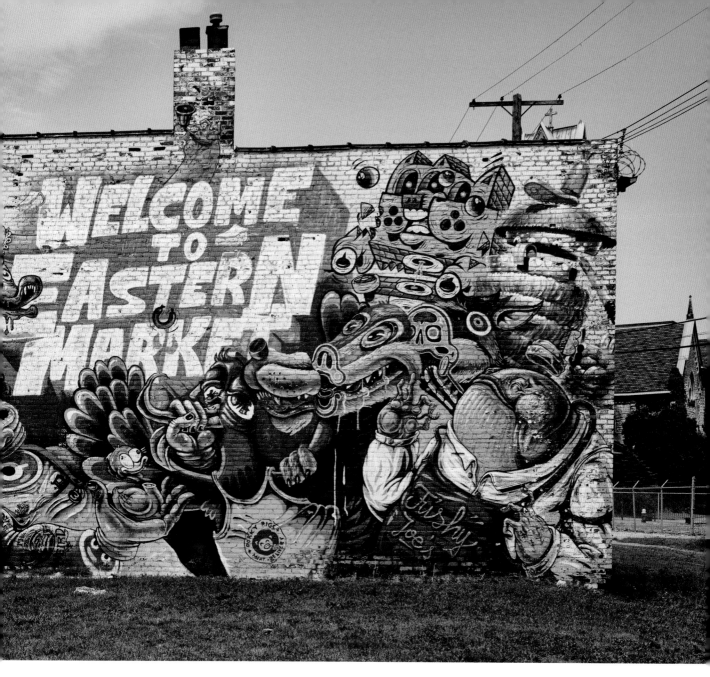

—

ABOVE

A mural by The Weird, a crew of artists from Germany and Austria, welcomes visitors to Eastern Market.

LEFT

Samples of produce sold on market Saturdays.

FAR LEFT

Shed 2 is an open-air, brick-and-wood building.

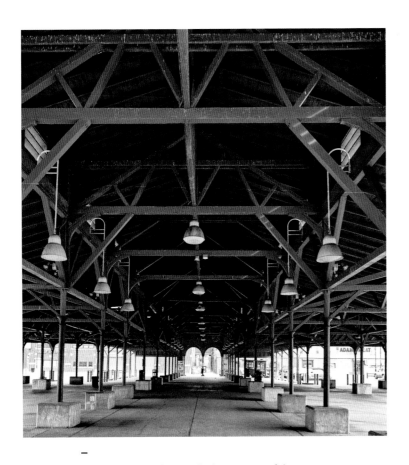

An off day in Shed 2 reveals the structure of the space.

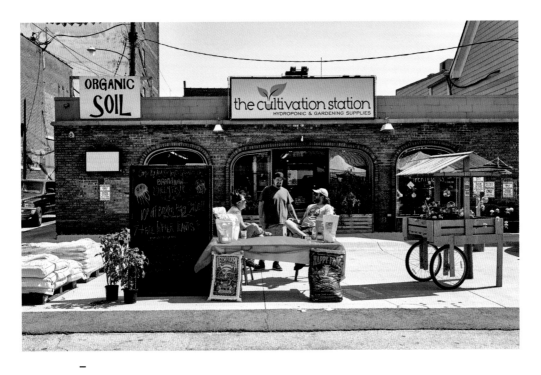

From restaurants around the market to the vendors and food trucks that park
between the sheds, Eastern Market is a hub of activity on the east side of Detroit.

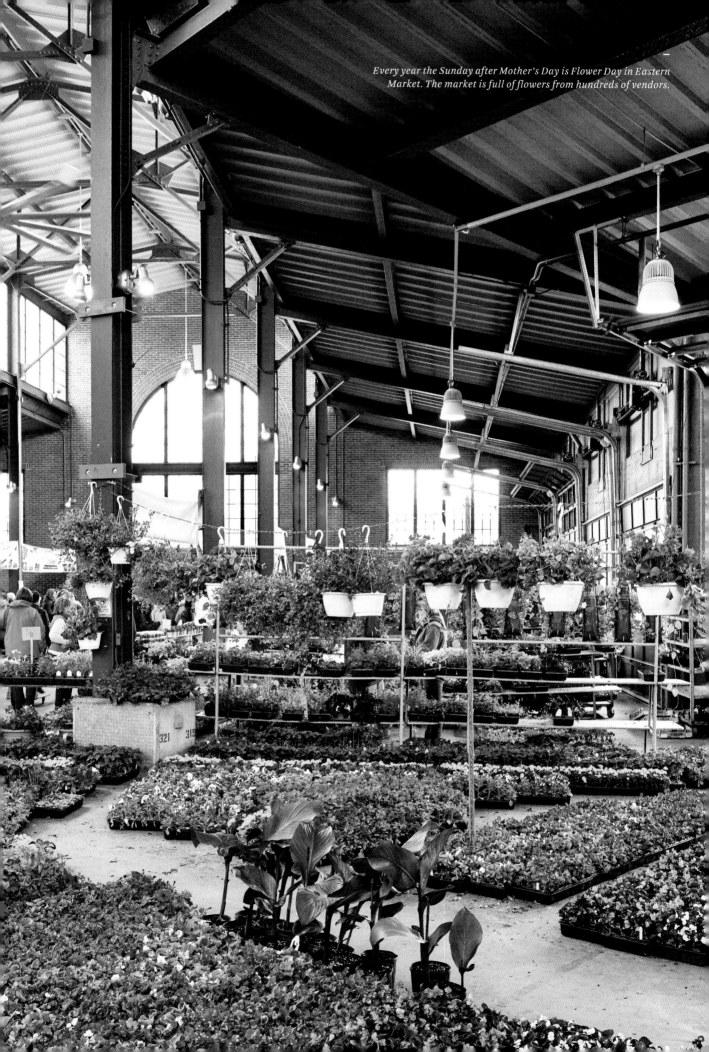

Every year the Sunday after Mother's Day is Flower Day in Eastern Market. The market is full of flowers from hundreds of vendors.

THE PETERBORO

Around 2013, restaurateur Dave Kwiatkowski was approached by a longtime friend, Charles Inchaustegui, with the concept for The Peterboro. He wanted to open a Chinese restaurant, and another friend, Matt Hessler, had recently purchased a building on Peterboro Street near Cass Avenue, one-time site of Detroit's Chinatown. It seemed like a perfect fit! While there had been a lot of American contemporary restaurants opening in Detroit around that same time (some of which were owned by Kwiatkowski), he was excited to be a part of something different. Chef Brion Wong, who worked at the restaurant Butter in New York, joined the team. Transparent and moveable screens divide the restaurant's interior equally between the bar and the dining room. The black walls were created using a Japanese technique called *shou sugi ban*. Metalsmith and artist Taru Lahti crafted the island shelving that the U-shaped bar centers around.

ABOVE

The exterior of the building. A red neon dragon hangs over the restaurant's entrance.

RIGHT

With the screens open, one can see through the bar to the dining area. Red paper lanterns and blackened wood are hallmarks of the design.

FAR RIGHT

A green tile wall extends through the bar and provides a background for the U-shaped bar that also accommodates diners on a busy night. The rustic stools are from Dot & Bo.

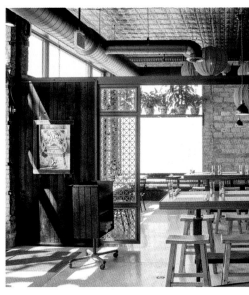

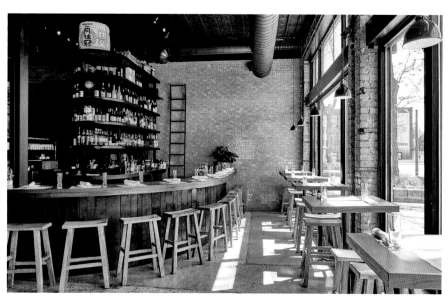

KATOI

Chef Brad Greenhill and Courtney Henriette started with a food truck serving Thai cuisine parked behind Two James Spirits off Michigan Avenue and were hugely popular with the bar's overflow crowds. When the opportunity to open a pop-up restaurant in Ann Arbor came their way, they took a chance, but their hearts remained in Detroit with the dream of finding and creating a restaurant there. Finally, with the help of their business partner, Philip Kafka, they opened their first official restaurant in a former service station on Michigan Avenue in Corktown, just down the street from where they originally set up their food truck. The small, white building with two shipping containers attached looks unusual, but inside, the dark interiors with shots of neon pink on the floral banquette cushions follow the fresh theme of Chef Brad's original Thai/Asian-inspired cuisine.

—

ABOVE

Low banquettes line the walls of the main dining room. Wishbone Chairs surround the community table. Skylights bring natural light to the space.

RIGHT

The bar is at the entrance of the building. The concrete walls were power washed and then left as the new owners found them, with their original patina.

FAR RIGHT

Katoi is located on Michigan Avenue, near where the owners first started their business in a food truck.

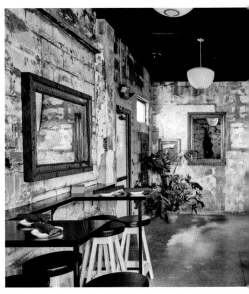

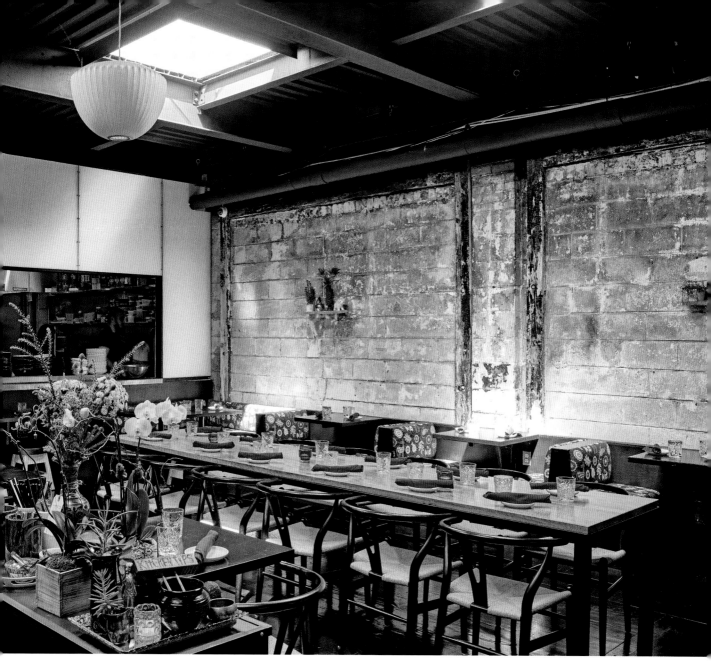

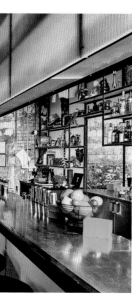

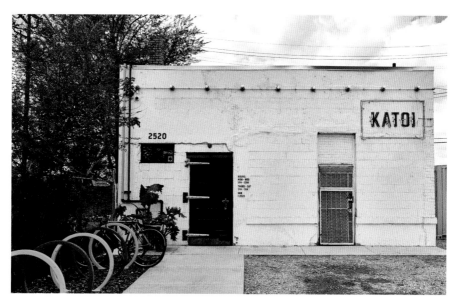

DROUGHT

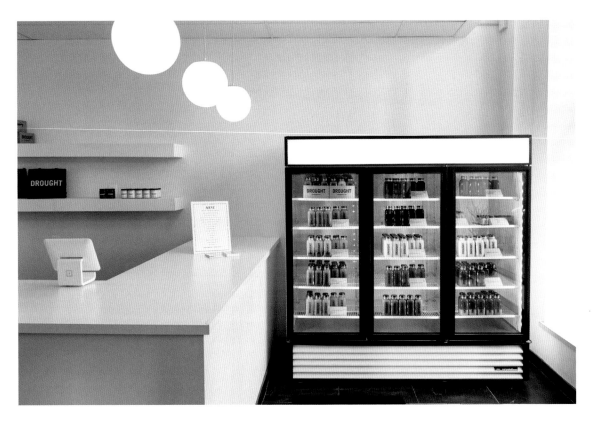

Four sisters from Michigan, Caitlin, Jessie, Jenny, and Julie James, were paying attention to the developments starting to happen in Detroit. They put their heads together to think of a business that they had not seen in the area. They moved back in with their parents to join forces to create an organic raw juice business. At first, their home kitchen was the laboratory for new flavors and recipes for juices. As the business grew, the sisters honed the clean look of the shops, their fixtures, and, of course, the bottles and branding. With six locations throughout the area, the company is looking to expand their distribution nationwide.

ABOVE

Drought's Downtown location has a minimalist aesthetic.

BELOW

The streamlined approach extends to the graphic design of bottles that contain the raw juices.

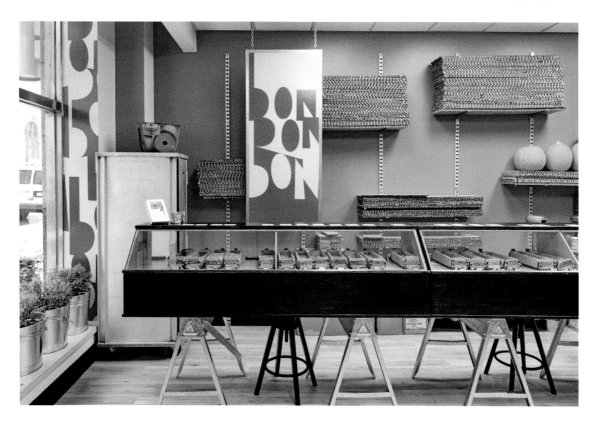

Candy in cardboard? That pretty much sums up Alexandra Clark's business, Bon Bon Bon. Yet it really doesn't describe the cleverly designed packaging handmade for each delectable, two-bite chocolate truffle made with unusual ingredients such as cayenne pepper, gin, and bacon. Nor does that simple explanation give you a hint at the well-thought-out aesthetic behind her shop located downtown in the Dime Building. Glass display cases are on aluminum sawhorses, and the stacks of flat cardboard that the boxes are fashioned from line the walls on open shelving. The contrast between the refined sophisticated product and its "rough" surroundings speaks to Detroit's raison d'etre these days.

—

ABOVE

The interior of Bon Bon Bon in the Dime Building has a DIY/"work in progress" appearance with the materials for making the chocolate's boxes on display.

BELOW

The packaging, made in-house, is unique.

SUGAR HOUSE

Sugar House is a craft cocktail bar in Corktown owned by Dave Kwiatkowski. The bar was a ruin before Kwiatkowski bought it and started the restoration process using materials that were already in the space, including the long bar. The romantic room with its dark wood and exposed brick walls has details such as a crystal chandelier in the front window, taxidermy hung on the walls, and an upright piano at the front entrance. Kwiatkowski became fascinated with craft cocktails, experimenting with his own recipes at home and blogging about them while bartending at one of Detroit's classic downtown bars before opening Sugar House. The cocktail list is indeed impressive, not only in length but also in the creative inspiration of its ingredients, among them Two James Spirits whiskey, made right across Michigan Avenue—the definition of local sourcing.

—
An upright piano is by the entrance. The bar gets decorated for special events and holidays.

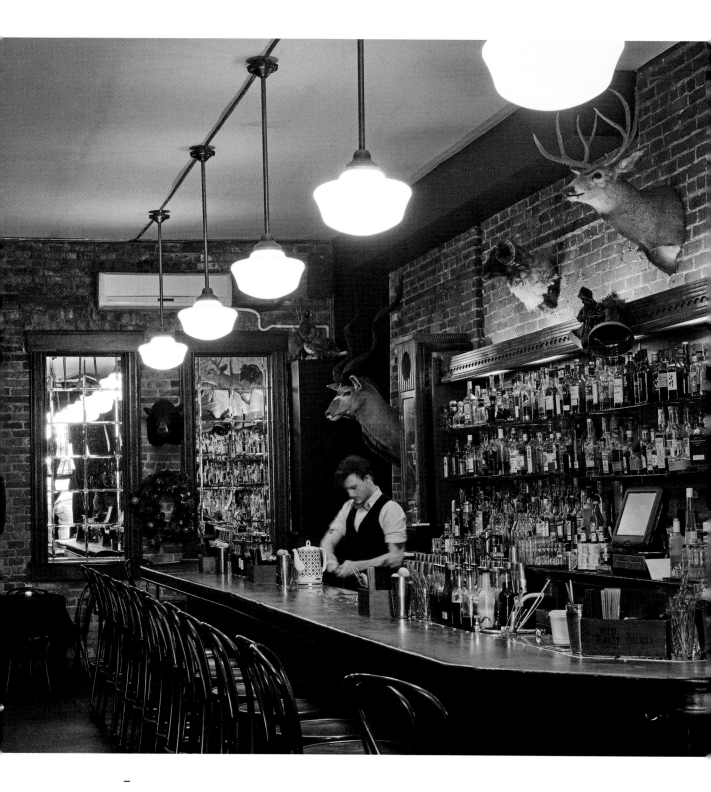

Sugar House is a craft cocktail bar with more than one hundred drinks on the menu. The décor of the bar has a retro feel.

PARKER STREET MARKET

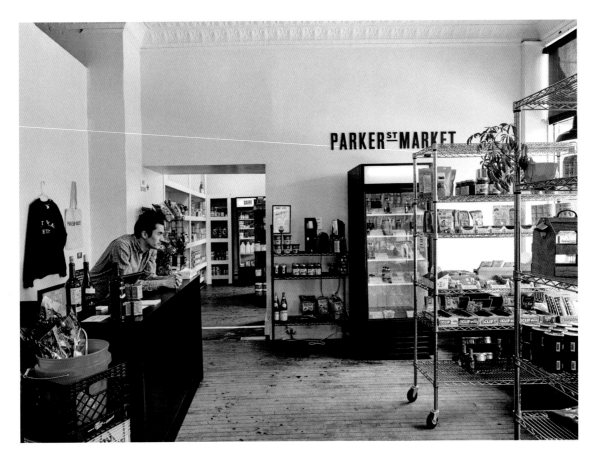

In 2014, David Kirby and Caitlin James moved from Brooklyn to Detroit. James's family was from the Detroit area. Together, David and Caitlin decided to open a small neighborhood grocery store, which sounds like a story from another generation. But they saw what was needed in their West Village neighborhood, where the nearest grocery store is miles away. The store expanded a year and a half after it opened and now holds a larger stock of fresh and organic produce as well as Detroit-based food products, such as McClure's pickles and small-batch Detroit Friends Potato Chips. With Sister Pie located directly across the street, there is a mini food revolution happening on the corner of Parker Street and Kercheval.

—

ABOVE

The market carries fresh bread from Zingerman's—an Ann Arbor–based company—as well as other local foods, wine, and beer.

BELOW

The expanded storefront of Parker Street Market in the West Village neighborhood on Detroit's east side.

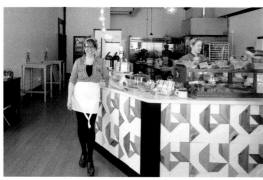

ABOVE

The bakery includes a community table so pie can be enjoyed on the spot.

BELOW

Owner Lisa Ludwinski on the opening day of the new shop.

Lisa Ludwinski opened her bakery on the corner of Parker Street and Kercheval in the spring of 2015. The small shop with windows on both sides has a community table in the front room and a large kitchen in back. She worked with the architectural design firm Laavu, with Kaija Wuollet at the helm. Wuollet came up with the plan for the mosaic counter in plywood. While Ludwinski's specialty is pie—sold whole or by the slice— she makes other baked goods, including savory hand pies, vegan brownies, and a selection of cookies. All of Ludwinski's products use natural ingredients and have unexpected flavor combinations. On any given day, you can find buttery shortbread cookies made with rose petals and pistachio or hints of grapefruit and pepper, or a salted maple pie.

TWO
JAMES
SPIRITS

Riding down Michigan Avenue, you can see whiskey barrels in the windows of a Corktown building. Peter Bailey and David Landrum named the business for their grandfathers, both called James. The distillery is located next to the empty Michigan Central Station and has a tasting room with a unique circular bar. A wall of wooden casks separates the front room from a processing center complete with stills and finishing tanks. They produce a series of spirits that includes a variety of whiskeys, a gin, and even a mezcal *joven* that is made in Mexico. They often invite a food truck to set up in their parking lot to supply a meal for the bar's customers.

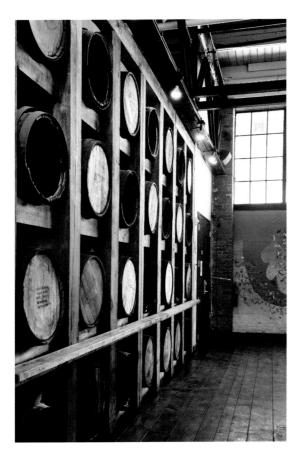

—
The building was a warehouse and is the first distillery in Detroit since Prohibition. A wall of cask barrels divides the tasting room from the distilling facility.

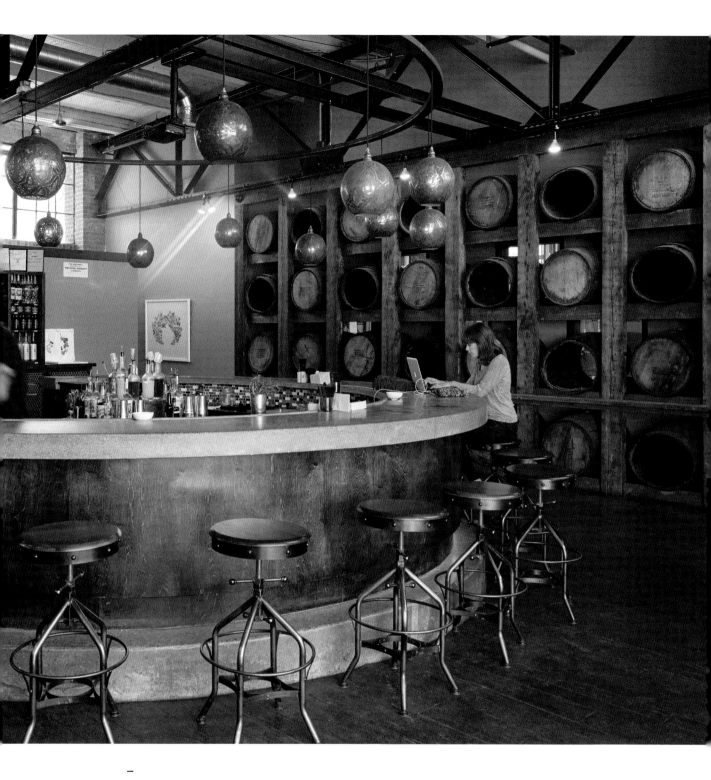

_

The unique circular bar in the tasting room of Two James Spirits.

SWEET POTATO
SENSATIONS

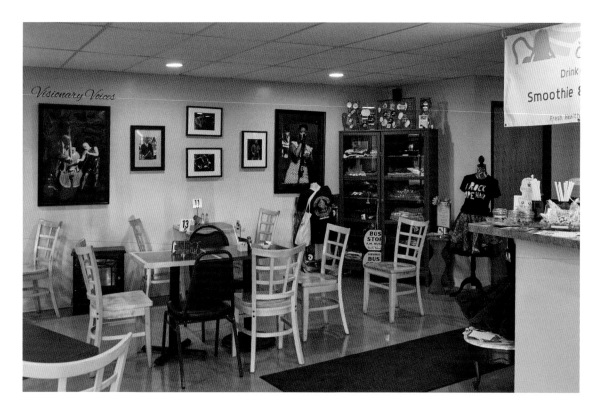

This family business started the way many do: with a fantastic product—in this case a sweet potato cookie that sold out at a neighborhood garage sale where it was offered starting more than twenty-eight years ago. Founder Cassandra Thomas hated candied sweet potatoes, but her husband was a fan, so she found a creative way to work the ingredient into her holiday celebrations—a cookie. Many years later, her shop, which she now runs with her daughters, Espy and Jennifer, serves sweet potatoes in a variety of recipes: cake, pie, cheesecake, muffins, and, of course, cookies. The bakery-café with its orange-painted walls has become a hallmark of the community, and the centerpiece on the charming block, which is also home to the Redford Theatre, Motor City Java & Tea House, and Public Art Workz.

—

Inside the bakery-café, everything is orange, including the walls, furniture, and floors—an homage to the main ingredient in most of their baked goods and pastries. Local artists exhibit their work there, too.

MCCLURE'S PICKLES

—

Jars of pickles on the processing line.

Pickle-making was a family tradition for the McClures when they were growing up in Michigan, and it still is. Brothers Joe and Bob were living in Detroit and Brooklyn, respectively, when they decided to start a food business using their family's recipe. Today both men are living in Michigan and running the business out of their main facility on Detroit's east side. The business has expanded to include relishes, Bloody Mary mix, and potato chips. Their stand at Eastern Market tests new products and is their direct connection to customers' feedback.

GOOD CAKES
AND BAKES

Owner April Anderson started her baking business in 2008 and later opened her store, in September 2013, on a bustling block of Livernois Avenue, also known as the Avenue of Fashion for its connection to the retail clothing industry. She left a career in social work to start the company and went back to school to get her degree in pastry. She makes cakes, cookies, and cupcakes. Her bestseller is a Lemon Gooey Butter Cake, which she made for Oprah and Bill Clinton, among others. Anderson is very attuned to her customers, who often make special requests, including one client who requested vegan cupcakes for her children. Together, Anderson and her client tested recipes and ingredients until both were happy with her now popular and delicious "I can't believe it's vegan" cupcakes. Most of her ingredients are organic and locally sourced. Anderson pulled together the decoration of the bakery resourcefully. She worked with REVOLVE Detroit and the Detroit Economic Growth Corporation, which—through ArtPlace America—put out requests for proposals to fill commercial spaces with art. A group of artists from all over the world created the murals for the new shop. Anderson bought vintage lime-green chairs from a restaurant in Ann Arbor for five dollars a chair. There is even a children's corner where little ones can play while their parents enjoy a cup of coffee or a piece of cake.

—

ABOVE

Anderson bought the green chairs from a restaurant that was going out of business. The mural was created in collaboration with artists from REVOLVE Detroit.

OPPOSITE, LEFT

Light fills the front windows of the Good Cakes and Bakes bakery on Livernois Avenue.

OPPOSITE, MIDDLE

The blackboard lists the day's specials, and the sweets are on display on the counter.

OPPOSITE, RIGHT

A view toward the entrance with artworks on the ceiling as well as the walls.

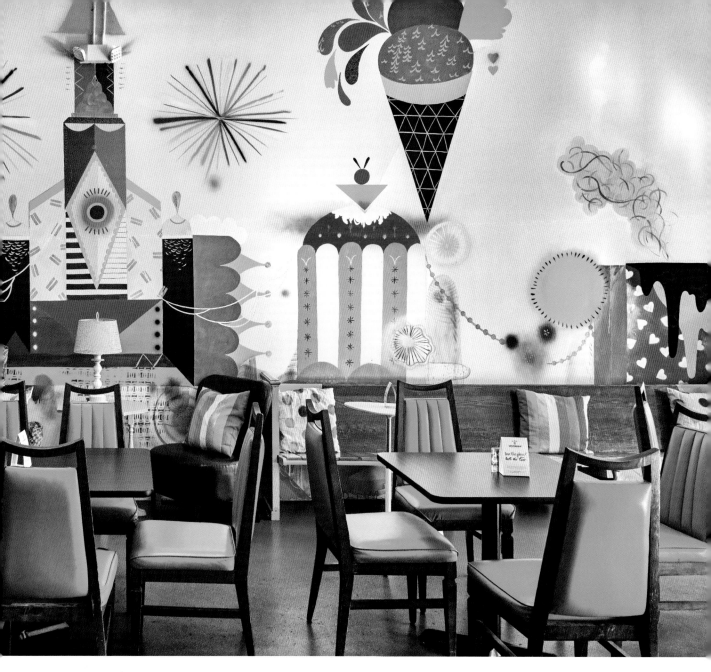

ROSE'S FINE FOOD

One of the first things that cousins Molly Mitchell and Lucy de Parry did when they leased the vintage diner on Detroit's east side was take down the steel bars around the windows. It was a sign they were open for business in more ways than one. The two women had worked in the Detroit restaurant scene and wanted to fill the simple need for a local diner. A Kickstarter campaign helped launch the dream, while family and friends pitched in with elbow grease to restore the diner's authentic vibe. Their fare focuses on old-fashioned foods. All their sweets are made from scratch in-house. The Crybaby doughnuts are the most well known. The pair sources many ingredients from local urban farms and Eastern Market.

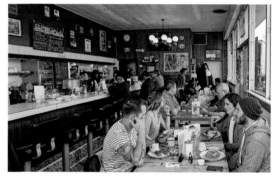

—

ABOVE

The two owners raised $19,000 to finance the opening of a neighborhood place.

BELOW

Molly Mitchell and Lucy de Pary cleaned up the interiors, keeping the original fixtures and adding their own touches.

URBAN BEAN CO.

Neatly tucked in next to a parking garage on a downtown corner of Grand River Avenue is a small glass building devoted to coffee. Urban Bean Co. has a modern vintage feel with its orange details both inside (the furniture on the top floor) and out (the glass panels at the top and bottom of the building). The company closed briefly during the recession and reopened in 2013. Josh Greenwood, the owner, is often found behind the curved, copper-covered bar making and serving each cup of coffee. A few chairs and tables have been placed outside, where clients enjoy their morning coffee and evening drinks.

—

ABOVE

Upstairs, a seating area overlooks Griswold Street and Grand River Avenue.

BELOW

Urban Bean Co. isn't part of a chain of coffee shops, which along with its unique design gives the place its special individual character.

ASTRO
COFFEE

Jess and Dai Hughes met working in a coffee shop in London. They chose Detroit to start their own business in 2011. Like so many coffee shops these days, Astro Coffee has become a meeting place, local hangout, and community center wrapped into one. Friend and architect Tadd Heidgerken designed the space, while landlord Phillip Cooley helped build the front display case and artist Louise Chen, aka Ouizi, drew the floral chalk mural on the back wall titled *Wake Up and Smell the Flowers*. The front windows have a view of Michigan Avenue and Michigan Central Station across the road. Dai and Jess are very careful in their selection of coffees and roasters. They work with local vendors to serve a selection of pastries and sandwiches. The combination of a welcoming atmosphere and interesting coffee and food makes Astro the go-to destination in Corktown.

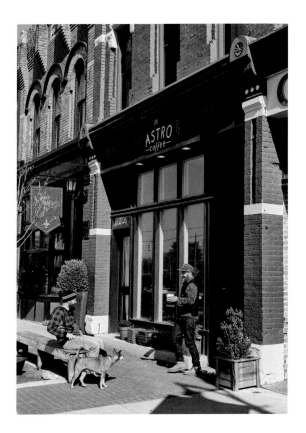

ABOVE

The front case is filled with breakfast treats.

LEFT

"Let's meet at Astro" is often heard in Detroit. The small shop has become a popular breakfast place.

OPPOSITE

A large chalk drawing by Detroit artist Louise Chen, aka Ouizi.

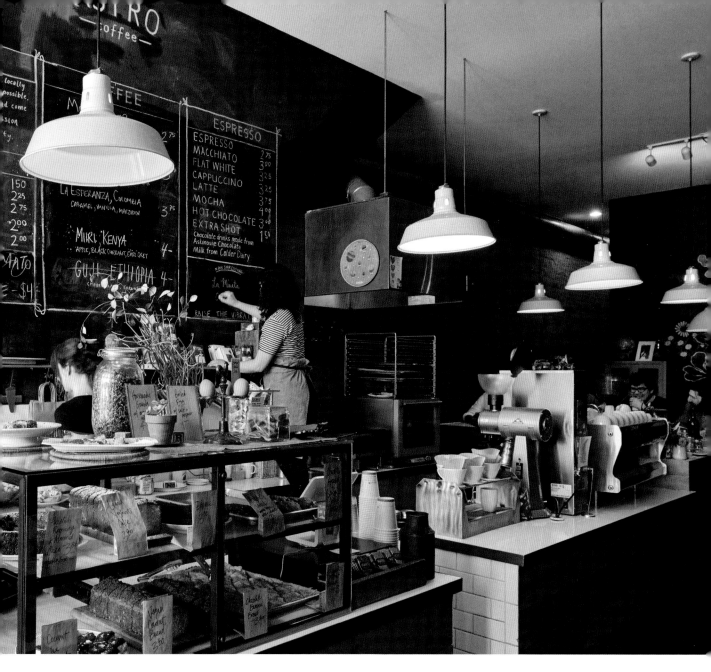

D-TOWN
FARM

D-Town Farm, a program of Detroit Black Community Food Security Network (DBCFSN), is located in Detroit's Rouge Park in the northwestern part of the city. The seven-acre farm has been in its current location since 2008. It operates three production hoop houses and a cob oven and plants over thirty-one varieties of vegetables throughout the year. The farm regularly hosts school trips and has a full program for children to actively participate in demonstrations. There is a full-time farm manager on site who helps to maintain the plantings alongside volunteers. DBCFSN started with the mission "to address issues of insecurity in Detroit's Black community," which it does through its agricultural, educational, and outreach programs. The organization sells its produce at local urban farmers markets, including Eastern Market. When walking among the rows of vegetables or down one of the tree-lined paths, it is hard to believe you are in one of America's largest cities.

ABOVE

The cob oven was created on the farm and is used for cooking demonstrations.

LEFT

Raised beds inside the greenhouse.

MIDDLE

The farm has a windmill that generates power to aerate the onsite water source—a pond.

FAR LEFT

One of the fields at the farm that is being prepared for spring plantings.

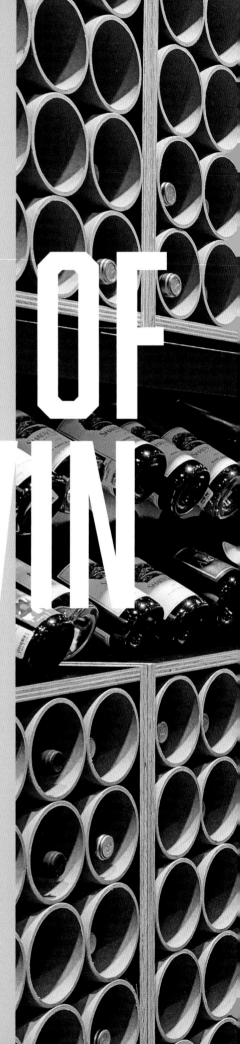

HOUSE OF PURE VIN

Three women, Regina Gaines, Terry Mullins, and Andrea Dunbar, opened a wine store in Downtown that aims to educate visitors to the city on the variety and quality of the state's wine production and provide a resource for locals. The owners are lifelong friends. About two years after completing their advanced degrees, they decided to pursue a passion and take a chance on Detroit's growth and fertile ground for new ideas. With experience in the wine and spirits industry, Gaines suggested a wine shop. Together, they met architect Christian Unverzagt of M1/DTW and master sommelier Claudia Tyagi—one of the few female master sommeliers in the country—and, with business plan in hand, opened a beautiful yet functional shop.

Industrial-size cardboard tubes are used to display and store the wine bottles.

–
The wall and cash wrap at the entrance were made from corks.

–
*House of Pure Vin on Woodward Avenue is part
of the downtown revitalization.*

"THE CITY IS
KEEPING THE
CHARACTER OF
THE PEOPLE."

Interview with
REGINA GAINES
CO-OWNER, HOUSE OF PURE VIN

MICHEL ARNAUD: *What was the impetus for the store?*

REGINA GAINES: I worked a long time in the spirits industry. My specialty was cognac and champagne, so I worked with a lot of wine shops. I went back to school, and I was looking for a job. I said to myself, "Something is going on in Detroit."

Michigan has close to 170 vineyards on the western side of the state. Michigan is number eight in the country in terms of the most vineyards, and number five in wine grape production. We have a growing wine industry that no one seems to know about. I thought, I'll start my own store and focus on Michigan wines. That's how we came up with the name, House of Pure Vin. "Pure Michigan" is the state's slogan, and "vin," the French word for wine, makes a connection to the many Detroit streets with French names.

MA: *When did the store open?*

RG: Our grand opening took place December 16, 2015. This whole journey has been amazing. We're just three middle-class women. Two of the partners are single mothers. We took advantage of every incentive program to come up with the capital. Luck, timing, passion, and the willingness to listen all played a part; at the same time, so did destiny and fate.

MA: *Why did you decide on a downtown location?*

RG: Promoting Michigan wines, we wanted to attract tourists. Being downtown, we wanted to participate in the revitalization of the city.

MA: *How did you find your architect? Did you have an idea of the store in mind?*

RG: Yes, I had an idea of what the store wanted to be, but when we entered into incentive programs, we met our architect, Christian Unverzagt from M1/DTW. We gave him images that inspired us. I was knowledgeable about what they were doing in wine shops in London, Hong Kong, and China. They're all going through a luxury phase, but we said our shop needs to have a blue-collar feel because it's in Detroit.

We're very fortunate to have a master sommelier, Claudia Tyagi. She's one of twenty-three women master sommeliers in the world. She knew what the store needed to have, and what we needed to do to show the consumer that we're serious about our wine. She said you've got to lay it flat. You've got to store it right. We brought her on to have the conversation before Christian was getting into the serious designing aspects.

MA: *How do you feel about the changes that are happening in Detroit?*

RG: It's a globally recognized city because of the auto industry, but I've never seen it prosper. It's been on the decline since I was born. It's great to see things happening in this city, and it's keeping its character. That's what I am liking about this revitalization—the city is keeping the character of the people.

MA: *There was a business element of Detroit that has maintained itself.*

RG: There are a lot of talented people who are doing things, making their mark. There was a time when the city wasn't inviting—they didn't allow people to make it here. Now we realize that we let a lot of great assets, people, leave. What the city is now saying is that we're not going to let the assets leave anymore. People are the assets, not corporations. If you're going to be great about innovation, begin with giving people a chance. There's room here. That's a great opportunity. When you have a great idea, you go hard for it.

Detroit is still hometown. That's just who we are. We're blunt. We're going to say it like it is. We're not scared to address those subject matters that most people are scared to address as a city, as a state. I'm glad people want to talk about the new narrative.

THE MICHIGAN URBAN FARMING INITIATIVE

Woodward Avenue runs down the center of the North End neighborhood that is home to a community farm called the Michigan Urban Farming Initiative (MUFI). Two University of Michigan students, Tyson Gersh and Darin McLeskey, founded the nonprofit in 2012. Today, the organization has an active board that includes community members, many of whom live in the North End. Part of its mission is to engage the neighborhood residents in the maintenance of a two-block garden that produces fifteen thousand to twenty thousand pounds of food a year. The produce is distributed among the people who live nearby on a pay-what-you-can model, and the rest is distributed to local churches, food pantries, and restaurants. In the summer, the neat rows of the lush garden and its brightly painted outbuildings—soon to be a community resource center—are a burst of vitality, with over three hundred varieties of flowers and vegetables grown year-round.

—

The garden's master plan includes transforming an abandoned building into a community resource center. The exterior features a farm-inspired mural by Ryan Herberholz.

Flowers are planted among the vegetables.

Across from the main garden is a smaller walkway with outdoor seating and several plant walls, which is the beginning of the children's sensory garden.

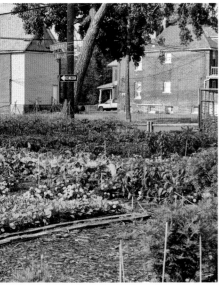

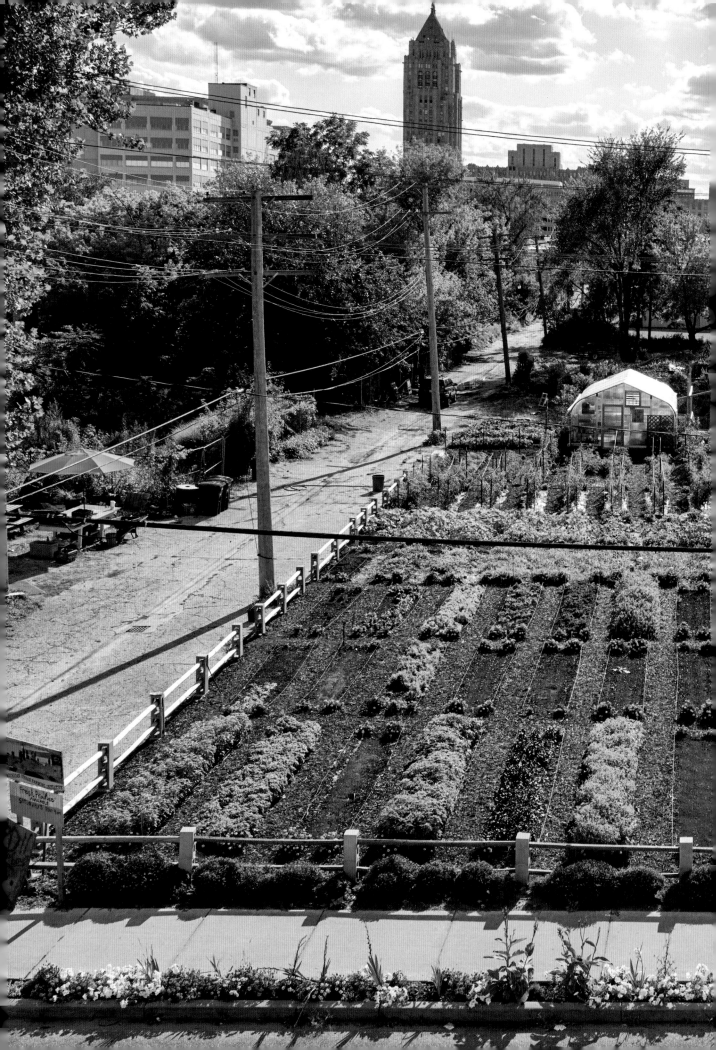

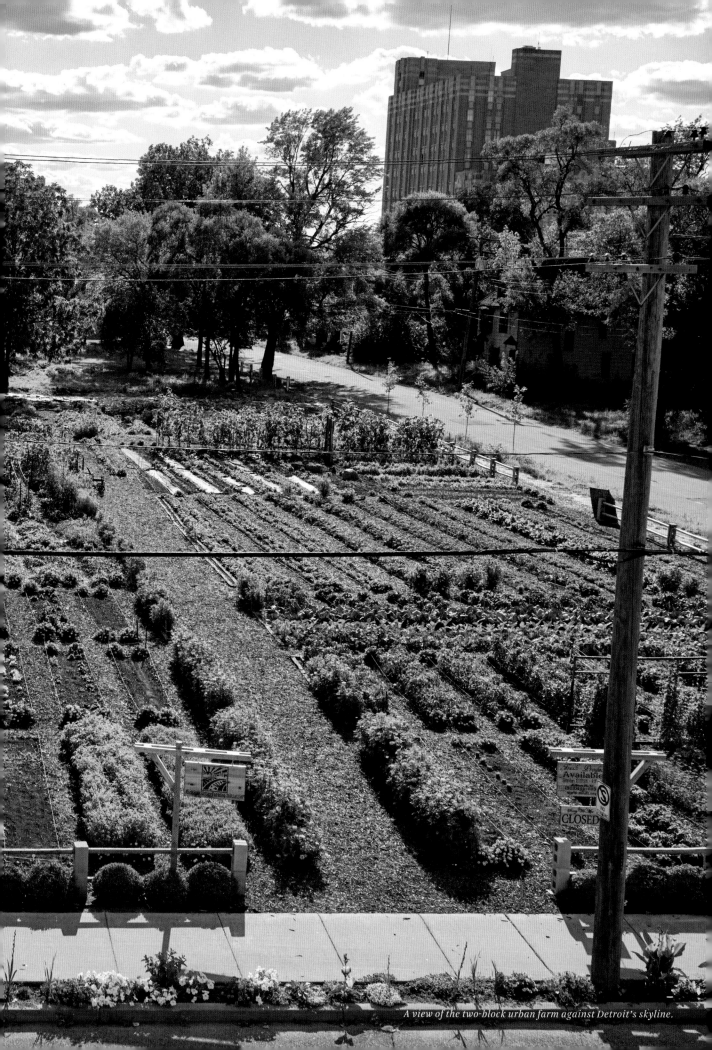

A view of the two-block urban farm against Detroit's skyline.

SELECTED SOURCES

CHAPTER 1: ALWAYS DETROIT

The Renaissance Center
100 Renaissance Center
Detroit, Michigan 48243

Belle Isle Park
2 Inselruhe Avenue
Detroit, MI 48207
michigandnr.com/parksandtrails/

Comerica Park
2100 Woodward Avenue
Detroit, MI 48201
detroit.tigers.mlb.com/det/ballpark/

The Fox Theatre
2211 Woodward Avenue
Detroit, MI 48201
olympiaentertainment.com/venues/
detail/fox-theatre

The Henry Ford Museum
20900 Oakwood Boulevard
Dearborn, MI 48124
thehenryford.org

The Guardian Building
500 Griswold Street
Detroit, MI 48226
guardianbuilding.com

CHAPTER 2: THE ART SCENE

Allie McGhee
alliemcghee.com

The Grand River Creative Corridor
4731.com/grccdetroit

Désirée Kelly
desireekelly.portfoliobox.me

Salt & Cedar Letterpress
2448 Riopelle Street
Detroit, MI 48207
saltandcedar.com

The Heidelberg Project
3600 Heidelberg Street
Detroit, MI 48207
heidelberg.org

Lisa Spindler
spindlerproject.com

Write A House
writeahouse.com
Floyd: floyddetroit.com
subtract: subtrakt.it

Scott Hocking
scotthocking.com

Leon Dickey
leondickey.com
Greg Bertera
ninobertera.com

*Steve and Dorota Coy and
The Hygienic Dress League*
hygienicdressleague.tumblr.com

Adnan Charara
adnancharara.com
Galerie Camille
4130 Cass Avenue, Suite C
Detroit, MI 48201
galeriecamille.com

Dabls's MBAD African Bead Museum
6559 Grand River Avenue
Detroit, MI 48208
mbad.org

Galapagos Art Space
galapagosdetroit.com

Murals in the Market
muralsinthemarket.com

The Detroit Institute of Arts
5200 Woodward Avenue
Detroit, MI 48202
dia.org

*The N'Namdi Center for
Contemporary Art*
52 E. Forest Avenue
Detroit, MI 48201
nnamdicenter.org

*The Museum of
Contemporary Art Detroit*
4454 Woodward Avenue
Detroit, MI 48201
mocadetroit.org

Simone DeSousa Gallery
444 W. Willis Street, #112
Detroit, MI 48201
simonedesousagallery.com

David Klein Gallery
1520 Washington Boulevard
Detroit, MI 48226
dkgallery.com

Wasserman Projects
3434 Russell Street, #502
Detroit, MI 48207
wassermanprojects.com

Taru Lahti
tarulahti.com

*The Seafoam Palace of Arts
and Amusements*
6460 Kercheval Avenue
Detroit, MI 48207
seafoampalace.org

City Sculpture Park
955 W. Alexandrine Street
Detroit, Michigan 48201
citysculpture.org

Young World International
youngworld.international

Tylonn Sawyer
tylonn-j-sawyer.com

CHAPTER 3: THE DESIGN SCENE

Donna Terek and Paul Ryder
PJ's Lager House
1254 Michigan Avenue
Detroit, MI 48226

Christian Unverzagt
m1dtw.com
Nora
4240 Cass Avenue, #109
Detroit, MI 48201
noramodern.com

Orleans + Winder
1551 Winder Street, #400
Detroit, MI 48207
orleansandwinder.com

Detroit Artifactry
2135 Michigan Avenue
Detroit, MI 48216
detroitartifactry.com

Linda Dresner
299 W. Maple Road
Birmingham, MI 48009
lindadresner.com

Détroit Is the New Black
1426 Woodward Avenue
Detroit, MI 48226
detroitisthenewblack.com

Abir Ali and Andre Sandifer
alisandifer.com

Art|Harrison Interiors (designers
of Joshua Ronnebaum and Boyd
Richards's house)
4339 Delemere Boulevard
Royal Oak, MI 48073
artharrison.net

The Social Grooming Club Company
5272 Anthony Wayne Drive
Detroit, MI 48202
atthesocialclub.com

John Varvatos
Wright-Kay Building
1500 Woodward Avenue
Detroit, MI 48226
johnvarvatos.com

dPOP!
711 Griswold Street
Detroit, MI 48226
dpopculture.com

Ponyride
1401 Vermont Street
Detroit, MI 48216
ponyride.org
Lazlo: lazlo.co
Detroit Denim: detroitdenim.com
Empowerment Plan:
empowermentplan.org

Shinola
441 W. Canfield Street
Detroit, MI 48201
shinola.com

Playground Detroit
1401 Vermont Street, #144
Detroit, MI 48216
playgrounddetroit.com

Leslie Ann Pilling
presenceiiproductions.com

The Dequindre Cut
detroitriverfront.org

CHAPTER 4: THE FOOD SCENE

Gold Cash Gold
2100 Michigan Avenue
Detroit, MI 48216
goldcashgolddetroit.com

Lafayette Greens
132 W. Lafayette Boulevard
Detroit, MI 48226
Kenneth Weikal: kw-la.com

Antietam
1428 Gratiot Avenue
Detroit, MI 48207
antietamdetroit.com
Katie Westgate:
katiewestgatedesign.com
Monica Hofstadter:
monicahofstadter.com
Paul Seftel: paulseftel.com

Kuzzo's Chicken & Waffles
19345 Livernois Avenue
Detroit, MI 48221
kuzzoschickenandwaffles.com

Slows Bar-B-Q
2138 Michigan Avenue
Detroit, MI 48216
slowsbarbq.com

Jolly Pumpkin Artisan Ales
441 W. Canfield Street, #9
Detroit, MI 48201
jollypumpkin.com

*Republic Tavern at the Grand Army
of the Republic Building*
1942 Grand River Avenue
Detroit, MI 48226
republictaverndetroit.com

Selden Standard
3921 2nd Avenue
Detroit, MI 48201
seldenstandard.com
et al. Collaborative:
etal-collaborative.com

Wright & Company
1500 Woodward Avenue
Detroit, MI 48226
wrightdetroit.com

Chartreuse Kitchen & Cocktails
15 E. Kirby Street, Suite D
Detroit, MI 48202
chartreusekc.com
Louise Chen, aka Ouizi:
louisechen.com
Lady Lazarus:
ladylazarusdetroit.com
Lisa Waud (pot & box):
potandbox.com

Eastern Market
2934 Russell Street
Detroit, MI 48207
easternmarket.com

The Peterboro
420 Peterboro Street
Detroit, MI 48201
thepeterboro.com

Katoi
2520 Michigan Avenue
Detroit, MI 48216
katoidetroit.com

Drought
719 Griswold Street
Detroit, MI 48226
droughtjuice.com

Bon Bon Bon
719 Griswold Street, Suite 100
Detroit, MI 48226
bonbonbon.com

Sugar House
2130 Michigan Avenue
Detroit, MI 48216
sugarhousedetroit.com

Parker Street Market
1814 Parker Street
Detroit, MI 48214
parkerstreetmarket.com

Sister Pie
8066 Kercheval Avenue
Detroit, MI 48214
sisterpie.com

Two James Spirits
2445 Michigan Avenue
Detroit, MI 48216
twojames.com

Sweet Potato Sensations
17337 Lahser Road
Detroit, MI 48219
sweetpotatosensations.com

McClure's Pickles
mcclures.com

Good Cakes and Bakes
19363 Livernois Avenue
Detroit, MI 48221
goodcakesandbakes.com

Rose's Fine Food
10551 E. Jefferson Avenue
Detroit, MI 48214
rosesfinefood.com

Urban Bean Co.
200 Grand River Avenue
Detroit, MI 48226
urbanbeanco.com

Astro Coffee
2124 Michigan Avenue
Detroit, MI 48216
astrodetroit.com

D-Town Farm
3800 Puritan Avenue
Detroit, MI 48238
d-townfarm.com

House of Pure Vin
1433 Woodward Avenue
Detroit, MI 48226
houseofpurevin.com

The Michigan Urban Farming Initiative
7432 Brush Street
Detroit, MI 48202
miufi.org

CONTRIBUTORS

MATTHEW CLAYSON is an attorney by trade and an entrepreneur at heart, who leads, launches, and scales outcome-driven organizations and enterprises. His work in Detroit includes scaling successful start-ups, supporting the launch of international consumer brands, and initiating programming to place Detroit among the world's preeminent creative and design centers.

LYNN CRAWFORD'S latest novel is *Shankus & Kitto: A Saga* (DittoDitto, Detroit). She is a 2016 Rauschenberg Writing Fellow, a 2010 Kresge Literary Arts Fellow, a founding board member of Museum of Contemporary Art Detroit (MOCAD), and serves on the advisory board of Cue Foundation (New York).

JENNIFER A. CONLIN has been a frequent contributor to the *New York Times* for more than a decade, writing most recently about Detroit's revitalization efforts. She is the founding editor of Creative Voice (creativevoice.buzz), a social media–based arts journalism source that produces and posts videos showcasing the arts and culture in southeast Michigan.

SARAH F. COX moved to Detroit in 2011 as the founding editor of Curbed Detroit. In 2013, she cofounded Write A House, a nonprofit that renovates dilapidated homes in Detroit and awards them to writers. Cox now holds a real estate license and works on building renovations in the city; she holds degrees from the University of Virginia and the School of Visual Arts.

ACKNOWLEDGMENTS

I fell in love with Detroit about six years ago. I have a fascination with postindustrial cities. It took three years to make the first scouting trip. In many ways, it was an eye-opening experience. With each visit over the last three years, my first impressions of an open, creative city were further inspired by the challenges of the people who live there and their incredible optimistic spirit, which I share.

First, I would like to thank all the people featured in this book and those I met along the way for their graciousness and attentive support. They led me in my quest to find multiple views of the city. Their generosity has made this adventure a labor of love.

In particular, I am grateful to Lisa Spindler and George N'Namdi, who opened so many doors for me; Linda Dresner for her warm hospitality; Leon Dickey, Gregory Bertera, John Kwiatkowski, Robert Elmes, and Philippa Kaye, who became friends.

It was an honor to collaborate with Matthew Clayson, Jennifer A. Conlin, Sarah F. Cox, and Lynn Crawford, and I thank them for their wonderful essays. They provided insights and kindly shared their knowledge of people and places to visit and see.

Conversations with Dai Hughes, Amy Haimeri, Robin Schwartz, Dan Shaw, Carleton Varney, Robin Osler, Peter Osler, Betsy Williams, and Carley Strachan were especially important in researching this book.

A very special thank-you to longtime friends Chris Gilbert and Ben Veronis, who shared that exciting first scouting trip and my enthusiasm for Detroit. Chris even came to help on some shoots. Mary Beaton also encouraged me and helped make some logistics easier. Lori Risley and Jenna Lepkowski looked after Will during shoots and editing, which was a huge help.

I thank Eric Himmel and Rebecca Kaplan at Abrams. They believed in the project from the start and shepherded it through the editorial process with their dedicated team, including John Gall, Devin Grosz, Emma Jacobs, Mary O'Mara, and Anet Sirna-Bruder.

Lastly, I want to thank Jane Creech, my wife and agent, who made this project not only possible but also a beautiful journey of discovery by her creativity, commitment, and hard work.

THIS BOOK IS DEDICATED TO WILL.

MICHEL ARNAUD is an internationally recognized photographer whose work has appeared in such publications as *Vogue*, *Architectural Digest*, *Harper's Bazaar*, and *House & Garden*. He is the principal photographer for more than twenty design and lifestyle books, including *Design Brooklyn: Renovation, Restoration, Innovation, Industry* (Abrams, 2013). He lives in New York City.

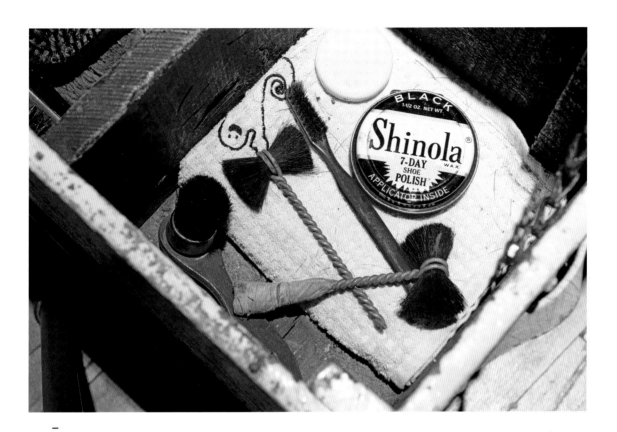

–

An old shoe shine kit—part of Lisa Spindler's collection.

EDITORS: REBECCA KAPLAN AND EMMA JACOBS
DESIGN MANAGER: DEVIN GROSZ
PRODUCTION MANAGER: ANET SIRNA-BRUDER

LIBRARY OF CONGRESS CONTROL NUMBER: 2016941958

ISBN: 978-1-4197-2392-6

PRINTED AND BOUND IN CHINA
10 9 8 7 6 5 4 3

ABRAMS BOOKS ARE AVAILABLE AT SPECIAL DISCOUNTS WHEN PURCHASED IN QUANTITY FOR PREMIUMS AND
PROMOTIONS AS WELL AS FUNDRAISING OR EDUCATIONAL USE. SPECIAL EDITIONS CAN ALSO BE CREATED TO
SPECIFICATION. FOR DETAILS, CONTACT SPECIALSALES@ABRAMSBOOKS.COM OR THE ADDRESS BELOW.

ABRAMS The Art of Books
195 Broadway, New York, NY 10007
abramsbooks.com